THE
BREATHING
BURREN

THE
BREATHING
BURREN

GORDON D'ARCY

The Collins Press

First published in 2016 by
The Collins Press
West Link Park
Doughcloyne
Wilton
Cork
T12 N5EF
Ireland

Hardback ISBN: 978-1-84889-268-2

Design and typesetting by Anú Design, Tara
Typeset in Akzidenz Grotesk
Printed in India by Replika Press Pvt. Ltd.

FSC
www.fsc.org

MIX
Paper from
responsible sources
FSC® C016779

Contents

3. Walking and Stalking

4. Burren Specials

5. Along the Shore

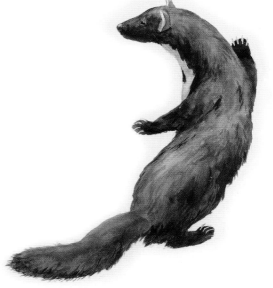

6. Into the Past

7. Musings

Introduction

I can't remember the exact year but it must have been in the early 1970s given that I was hitch-hiking and camping in the Burren. Cassidy's pub (half the size it is now), materialising like a mirage at the top of the hill in Carron, pulled my friend and me out of a downpour like bees into a hive. A warm fire, traditional music session and several black pints held us contented till closing time. When we requested permission from Bobby Cassidy (the present owner's late father) to pitch a tent on the grass in the shelter of the building, he answered, 'I wouldn't put a dog out in that weather.' Not only did he put us up for the night but he also furnished us with a full Burren breakfast in the morning before we left to explore Carron's flooded turlough. Money was not mentioned. I don't know now if this random act of hospitality inspired it, but I knew that I would be back, though I did not realise then that a decade later I would be setting up home as a Burren devotee. As is the case with so many distant memories, I am unable to recall the precise nature of my infatuation. The Burren presented me, a 'passage migrant' from the disturbed and stifled urban circumstances of Belfast, with a wonderfully contrasting alternative. Here was a landscape completely different from anything I knew: an unbounded, wild place that whispered, 'Come and explore' – simply my kind of place.

Thirty years a-growing in the Burren has allowed me to indulge my fascination. Art and books, books and art – these have provided

expression and output. This latest book is, like the others, concerned with nature but by no means confined to it. It is also a narrative of acknowledgement of the many Burren 'nature people' who, like me, have been drawn here and who, through various specialisations, have contributed to our knowledge and appreciation of the place.

The Burren has experienced an explosion in exposure since the 1980s. Simple tourist pamphlets have given way to glossy booklets and highly illustrated books, with diverse information catering for an increasingly wide range of interests. I have been fortunate to be part of this exciting body of work. It seems that every aspect of the extraordinarily rich natural and social heritage has now been covered in text and photography, most of it admirably. *The Breathing Burren*, though part of this, is different in that while it seeks to inform, it is essentially a work of salutation. While being careful to observe scientific rigour, I have not followed the usual scientific format in the ordering of the text. A compendium of personal experiences connected to natural history, derived mainly from diary extracts, the essays range from bird and animal encounters, through floral forays, to underground and night-time explorations and low-tide discoveries. They have been chosen not especially for their uniqueness but rather their memorability; they are mainly experiences that have struck a chord, which I feel enthusiastic about sharing. As a collection, they may be considered as mini-chapters since they are intended to convey something of the scope of experiences to be had by any nature enthusiast in the region. I hope they may act as a counter to the disappointment sometimes voiced by those who come 'green' to the Burren, expecting to find an Irish Serengeti. I have given space to the aesthetic, the apocryphal and the mildly philosophical, with most of my musings relegated to the latter. I hope they collectively represent a comprehensive overview of the wild Burren and my relationship with it.

In view of the fact that the Burren is, for the most part, privately owned, my opinion about its future might be considered by its

inhabitants as something of an impertinence. I very much hope that this is not the case since my reflections derive from a deep regard both for the place and its people. An outside view is, I feel, justified given the continuing vulnerability of other privately owned regions of outstanding natural heritage elsewhere in Ireland.

The book is unapologetically pictorial. With no disrespect to photography, I have chosen to illustrate throughout with my own watercolour images. There are two reasons for this: illustration, as distinct from photography, in my view better conveys a sense of affection, even intimacy. Another, more esoteric, reason concerns materials; the interconnectedness of water and colour is intrinsic to the Burren, thus constituting watercolours appropriate media for a book of this kind. Since the Burren is a compendium of habitats, as distinct from a monolith, the text is punctuated with ten double-page watercolours of representative landscapes.

I have been blessed in seeing the Burren in all its moods and seasons, rambling its length and breadth, getting lost in its wilder parts, leading groups of enthusiasts to its many 'hot spots', teaching in its educational facilities and befriending and being befriended by its multifarious inhabitants. Despite my search for 'other Burrens' elsewhere in the world, I remain captivated by Ireland's karstic jewel.

I have found, even after three decades, that this enigmatic place continues to reveal fascinating aspects of itself, year on year. It is, of course, like the rest of the planet, in the throes of change. In nature, species come and go; an island such as Ireland is more acutely affected by such two-way traffic than mainland. The Burren, an 'island' within an island, has seen its fair share of extinctions and new arrivals. The looming influence of climate change, however, with its gift of new species, mostly from southern or Continental regions, has already demonstrated its transformative potential. This, combined with the inexorable impact of invasive species and the steady reversion

of much of the Burren to scrubland, indicates that we will have to prepare for a novel Burren in the future.

How fortunate that, with the developmental changes undergone by rural Ireland since the heady and sometimes misguided grant-assisted days of the turn of the millennium, the Burren has managed (despite some peripheral damage) to maintain its integrity: it remains largely unspoiled and retains a great deal of its justifiably famous natural and social heritage.

Long may it continue to thrive, breathing unpolluted Atlantic air, whispering its welcome to all comers.

Acknowledgements

The following is a list of 'nature people' with whom I have had the pleasure to engage during my time in the Burren and who in one way or another have contributed to our knowledge and understanding of the region. Though all 'Burrenarians', to varying degrees, many remain anonymous or have had their contributions confined to arcane periodicals. A number have sadly passed on. I salute all of them and the others whom I may have ashamedly overlooked, forgotten or missed in the course of my Burren travels.

Aine Bird; Ann O'Connor; Bill Mc Inerney; Brendan Dunford; Brian Mc Gowran; Brigid Barry; Carleton Jones; Catherine and Brendan O'Donoghue; Charles Nelson; Cilian Roden; Colin Stafford-Johnson; Congella Maguire; Cyril and Kit O'Ceirin; Dave Mc Grath; David Cabot; David Drew; David Hely-Hutchinson; David Jeffrey; Derek Mooney; David Norriss; Eamon de Buitlear; Eamon Donoghue; Elaine O'Riordan; Emer Colleran; Emma Glanville; Emma Stewart Liberty; Enda Mooney; Fergus and Libby Kinmonth; Fergus O'Gorman; George Cunningham; George Keegan; Gerrit van Gelderen; Grace O'Donovan; Hugh O'Donnell; Hugh Weir; Ian Rippey; J. M. Barry; James Fairley; James Irons; Jenni Roche; Jeremy and Patricia Willder; John Considine; John Feehan; John Hayward; John MacNamara; John Murphy; John O'Donoghue; Julian Reynolds; Kate MacAney; Ken Bond; Liam Lysaght; M. E. Mitchell; Marion Dowd; Martin Byrnes; Martin Carey;

Martin Speight; Maryangela Keane; Matthew Jebb; Michael Longley; Michael Lynch; Michael O'Connell (Aran Islands); Michael O'Connell (NUIG); Michael O'Donohue; Michael Slattery; Michael Viney; Micheline Sheehy-Skeffington; Mike Brown; Mike Miller; Mikey Irwin; N. R. and R. T. Moles; Nigel Monaghan; Nikko Rippon; Noel Walsh; Nutan; Oscar Merne; P. J. Curtis; Paddy Madden, Paddy O'Sullivan; Paddy Sleeman; Patrick Mc Cormack; Paul Murphy, Penny Bartlett; Peter Vincent; Phil Brennan; R. F. Haynes; R. F. Ruttledge; Raymond Piper; Richard Mills; Richard Nairn; Robert Cassidy; Ronan Hennessy; Ruth Carden; Sabine Springer; Sarah Poyntz; Shane Casey; Sharon Parr; Simon Berrow; Stephen Mills; Stephen Ward; Tim O'Connell; Tim Robinson; Tom Ennis; Tony Kirby; Ute Bohnsack; Zena Hoctor.

I would also like to extend a general thank you to the Burren's farming community – 'naturalists on the ground' who, for thirty years, have generously tolerated my unhindered explorations of the land.

In particular, I would like to thank the following for reading and passing on comments about sections of the text: Dave McGrath, Cilian Roden, Micheline Sheehy-Skeffington, Lelia Doolin, Jenni Roche, Ian Rippey, Brendan Dunford, Susan Lindsay and my erudite and ever-generous wife, Esther-Mary.

Galway Bay

Black Head

Gleninagh

Fanore Dunes

Fanore

Ballyvaughan

Lough
Rask

Caher River

Aillwee
Cave

Slieve Elva

Burren

Poulacapple Hill
Lios Lairthín Mór

Poll na gColm

Kilcorney Cave

Ballyryan

Lisdoonvarna

Doolin

Leamaneh
Castle

Kilfenora

Clare Shales

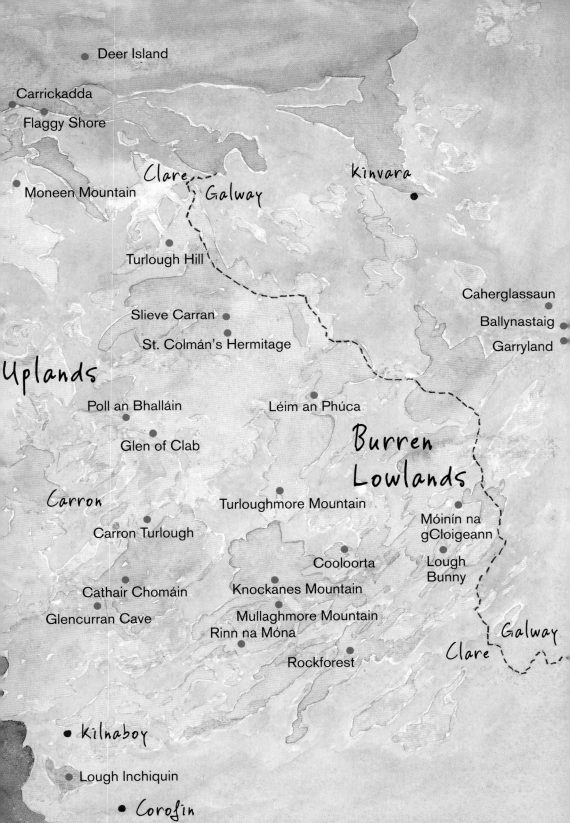

Deer Island

Carrickadda

Flaggy Shore

Moneen Mountain

Clare

Galway

Kinvara

Turlough Hill

Caherglassaun

Ballynastaig

Slieve Carran

Garryland

St. Colmán's Hermitage

Uplands

Poll an Bhalláin

Léim an Phúca

Glen of Clab

Burren
Lowlands

Carron

Turloughmore Mountain

Carron Turlough

Móinín na
gCloigeann

Cooloorta

Lough
Bunny

Cathair Chomáin

Knockanes Mountain

Glencurran Cave

Mullaghmore Mountain

Rinn na Móna

Galway

Rockforest

Clare

Kilnaboy

Lough Inchiquin

Corofin

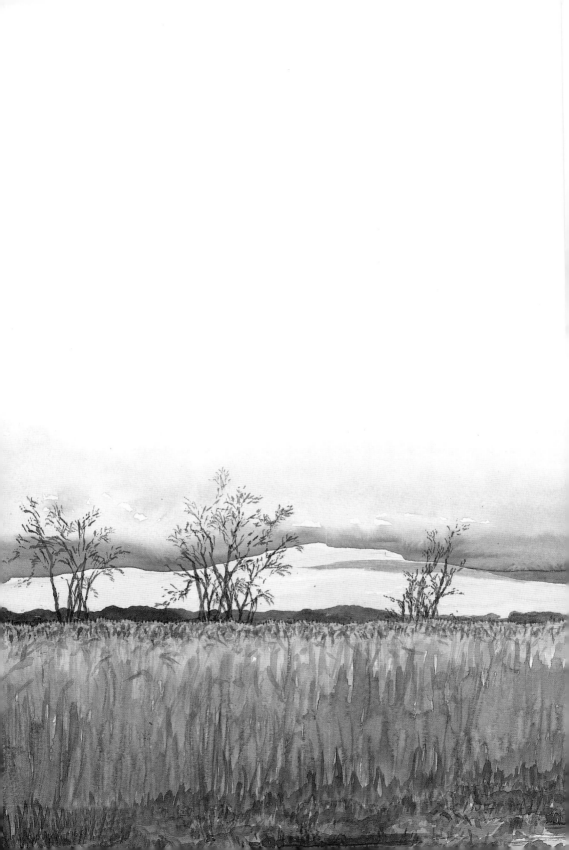

1

Nature Folk

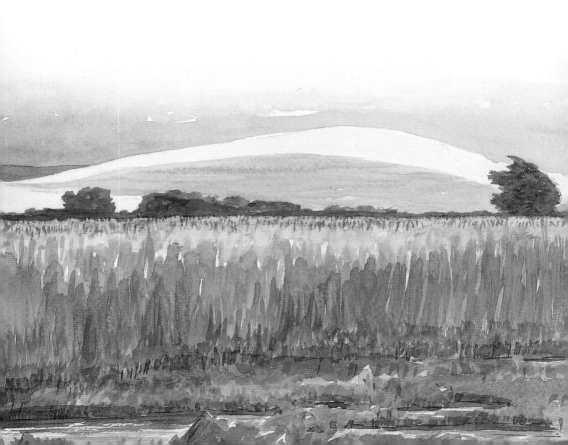

Halcyon Days

Initially it was nothing more than the merest of glances: an incongruous 'eye-catch' from the car window. On pulling in to the roadside I could see it better – a greyish, jackdaw-sized bird hovering above the placid water of Ballyvaughan Bay, a hundred metres away. Through the binoculars it materialised into an exotic creature, quite unlike any other found in the Burren. With its outsize shaggy head, heavy beak and Woody Woodpecker demeanour, it could only be one: a belted kingfisher – a bird I knew from the east coast of America. Much larger and greyer than our own kingfisher, its name derives from a belt-like pattern on its belly. The female (which this bird was) is double corseted, the lower part being rust-coloured.

Belted kingfishers are found throughout southern Canada and the northern United States. Most migrate south to the southern states and Central America for the winter. What, then, was this one doing here, thousands of miles away from its comfort zone? A straggler, a

vagrant, an alien blow-in from the other side of the ocean, no doubt: but so strange, so utterly surprising.

As I watched, it hovered deftly as though suspended from an invisible thread. Then, after plummeting into the shallow water, it sped off to perch on a protruding rock and swallow its catch. Clearly satisfied with its new hunting ground, it returned again and again, repeating the performance, uttering occasional bursts of its strange rattling call as it flew. The effect was of joyful enterprise: this was feathered personality, encapsulated.

The date was 28 October 1985. Esther-Mary and I had just begun our association with the Burren.

Back at Tigín, on the edge of Ballyvaughan (where we were living temporarily), I discovered in Major Ruttledge's *A List of the Birds of Ireland* (1975) that apart from two mid nineteenth-century records (both shot!), initially discounted then accepted, there were two other Irish records for this bird: the first in Ballina, County Mayo, in November 1978; the second at Dundrum Bay, County Down, in October 1980. Reading on, I was dismayed to learn that these too had been shot, the Mayo bird having remained for almost three months in the vicinity before falling 'fowl' of a local hunter.

Determined that the same fate would not befall the Burren bird, I decided that the best policy was to advertise it as widely as possible, thus reducing the potential for an 'accident'. A phone call to the Irish Wildbird Conservancy (now BirdWatch Ireland) augured well, with an enthusiastic response. From early the next morning, groups of combat-clad 'birders' – mainly youths with binoculars, telescopes on tripods and long-lens cameras – descended on Ballyvaughan like a squad of some subversive paramilitary organisation on manoeuvres. Locals, aware of the goings-on, stood open-mouthed and bewildered. What was this all about? Could these strangers be extras participating in a movie, perhaps? The spreading word that there was a rare bird at the pier brought smiles and light-

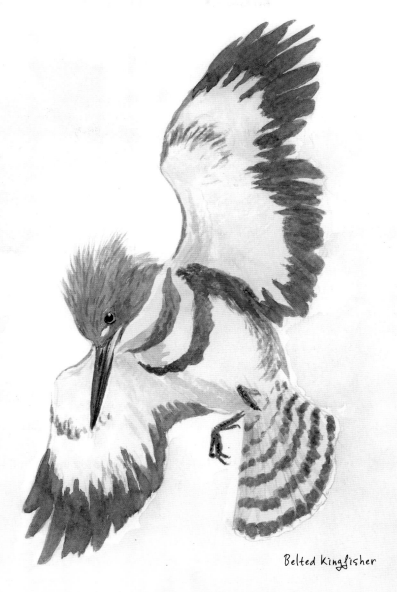

Belted kingfisher

hearted banter from the locals before they continued on their business.

There was nothing light-hearted, however, in the response of the birdwatchers. Those few who were lucky enough to have seen it ('dipped in', in birder parlance) before it proved elusive radiated relaxed satisfaction, in contrast to palpable disappointment among those who had 'dipped out' and, due to time or some other constraint, would have to return home. The successful could now tick it off their life list

and make plans for a sighting of the next rarity, somewhere else.

For those who had failed to see the bird but were able to stay on another day, Monks bar became birding headquarters, discussion chamber and watering hole. The air was rife with speculation as to the kingfisher's whereabouts. Had it flitted down the coast? Had it gone inland to one of the turloughs, perhaps? Had it decided to go back whence it came, unhappy with the glare of celebrity?

Days passed. The word had spread like wildfire. Birders from the UK and even further afield were flying into Shannon and heading upcountry as fast as possible. Ballyvaughan reverberated with strange accents. Unusual-looking individuals – some, from their garb and demeanour, 'alternative lifestyle' folk – strolled about the village or dropped into the grocery store for supplies. A brown-robed monk from a Limerick abbey was seen to fall on his knees, hands raised in supplication, in response to having observed the bird. Locals, unused to such extravagant activity, stopped and stared.

Mikey Irwin, farmer, proud rainfall recorder and owner of the village's only motorbike, became unofficial kingfisher guide, informing newcomers of the bird's last whereabouts, outlining its recognisable features and chaperoning unsure individuals to local places of refreshment. A borrowed pair of binoculars, initially held shyly in the hand, were, with growing confidence, now proudly disported around the neck. With the arrival of famous wildlife filmmaker and artist Gerrit Van Gelderen, a series of cartoons illustrating the bird and its impact appeared in Monks. One depicting birders flocking out of the bar in response to a reported sighting at the pier (with the unnoticed kingfisher perched on a half-finished pint) raised many a smile. When Mikey was presented with a Van Gelderen sketch, nothing would do until he was also presented with one of mine. Furnished now with newspaper clippings, photos and original artwork, Mikey had become the village spokesperson for the avian celebrity.

Suddenly, one day in early December, the unthinkable happened:

the kingfisher disappeared. Days passed without a sighting and the bird was declared well and truly gone. Ballyvaughan's little business community, which had been enjoying an extension to its tourist season, was now unceremoniously returned to normal winter mode. For over a month, the hotel, B&Bs, pubs and other services had enjoyed unprecedented turnover, with groups of birders refreshing, feeding, sleeping and occasionally carousing to the economic benefit of the community. In the process, they had pleasantly invigorated the otherwise quiescent location. This was ecotourism a quarter of a century before it had been invented.

Despite a number of unsubstantiated reports suggesting that the kingfisher was still about, the birders began to drift away. Mikey tried hard to keep hopes alive, but the euphoria had evaporated; the bird had flown. But to where?

Searches along suitable west coast habitats proved fruitless. Then, in February, a female (obviously the same bird) was spotted at Killaloe on the Shannon. It might have vacated its coastal resort and moved inland to escape the frequent westerly gales or to exploit more reliable catches. For a month it continued to capture imaginations and charm locals in its new hangout. Formerly disappointed birders and others intrigued at the prospect of adding to their list managed to 'dip in'. How obliging to provide a second opportunity!

With spring in the air, the kingfisher finally disappeared for good. Where did it eventually go? It might have continued eastwards, into the UK, or further into Europe. (One, which may have been the same bird, was, in fact, later seen in Europe.) It is generally agreed that it would not have made it back to the US; the prevailing westerly winds that brought it to Europe in the first place would militate against it returning whence it came. It may have arrived during a storm; it certainly caused one among the birdwatching fraternity. How gratifying, all the same, that it did not end up (as had all the others) a stuffed specimen on a mantelpiece.

According to Greek mythology, the 'halcyon days' are idyllic days in the latter part of the year, associated with an avian harbinger – the kingfisher. For Esther-Mary and me, the belted kingfisher, thirty years ago, marked the beginning of our own halcyon days in the Burren.

Dawn Chorus

Planning and leading field outings for decades has convinced me that their outcomes are as unpredictable as the nature they are designed to find. Some, despite preliminary advertising and organisation, have been painfully disappointing – poorly attended or failing to materialise altogether. (Even ideal weather is no guarantor of success.) Then there are those that, for reasons beyond my ken or for some particular combination of circumstances, take off and generate their own momentum. I am inclined to remember the latter and put the former down to experience.

International Dawn Chorus Day is the day (broadcast by *Mooney Goes Wild* on RTÉ radio) when intrepid birders forgo a Sunday morning lie-in to indulge in our wonderful heritage of birdsong. I organised one such event in the Terryland Forest Park in 2004. As this was in the heart of Galway city, I expected a good turnout. Six hardy souls turned up. This was definitely one for putting down to experience.

A Dawn Chorus outing in Ballyvaughan the following year had me, understandably, less than optimistic.

It was still dark on the May morning when I arrived drowsily at the prearranged venue – in front of the local supermarket. A handful of early risers lurking in the shadows at the side of the building lifted my spirits. Thankfully it was dry. We chatted and joked casually, in the knowledge that the weather would probably hold for the duration of the outing.

By 6 a.m., the advertised time of departure, dozens of people had arrived and an air of conviviality – more like at a wedding or some such joyous social event than a country ramble – filled the street. Participants had arrived overdressed, in weatherproof gear and sensible shoes and boots, prepared for the worst. As I scanned around, I became aware that this would be no minor event: I was surrounded by a sea of heads, of all ages – encouragingly, many of them children – with more arriving as I watched. My brief introductory comment that we would need to be attentive (and therefore as quiet as possible) was greeted with the same indifference as I had come to expect from a sixth-class group restless to kick off the dust of the classroom. I knew that any learning that was to be done would be by an earnest group who had already taken up position beside me. Then, with a few minor adjustments to backpacks and binoculars (and realising that it was now too late for me to back out), our noisy ninety-five strong caravan was ready and off we set.

A whitethroat's chattering song flight appropriately set the scene as we marched out of the village towards Lough Rask. When someone reported a cuckoo, all stopped to confirm the far-carrying human-sounding call and, one by one, smiles of recognition lit up the now attentive faces. As though primed, the birds obligingly did their stuff from rooftop and tree all along the minor road of our route. Long before reaching our prearranged venue, we had identified and enjoyed the avian music of a dozen different songsters.

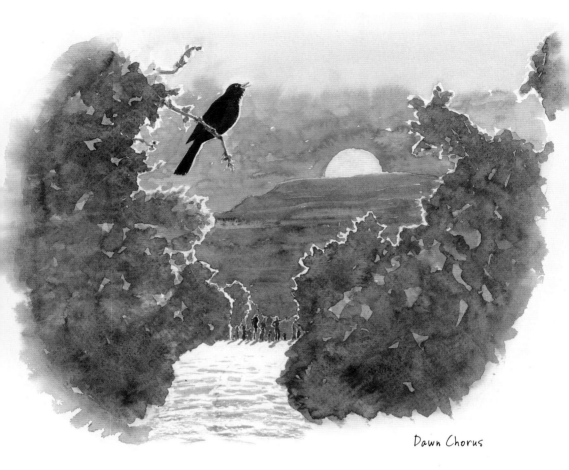

Dawn Chorus

'It is the male you hear,' I said, 'a territorial declaration, or a mate-attracting exercise. Each bird has its own specific song, which can be recognised and distinguished from others, with practice …'

We listened to and watched robins, blackbirds, song thrushes, chaffinches, wood pigeons – even a raucous pheasant. We stood in thrall to the beautiful fluty notes of a song thrush. Then, with binoculars, verified our identification, satisfying ourselves that we could connect songster with song.

'I try the association of word or phrase to help clinch identification. The thrush, for instance, choses a theme, then repeats and repeats. The associative word, therefore, is "repetition". The blackbird's song is deep

and fluty. The willow warbler's song lilts and cascades, while the wren sings with high-pitched energy and a trill. The dunnock's whistle, on the other hand, is coy and rather tuneless – like a bird learning to sing.'

Hedge-school teacher and naturalist Humphrey O'Sullivan, acutely conscious of birdsong, recorded in his diary on 8 February 1828: 'There are many words [in Irish] for the whistling of birds: the fluting (*scolgaire*) of blackbirds, the crowing (*glaodhach*) of the cock, the cackling (*gragadghail*) of the hen, the cawing (*grág*) of the rook, the cuckooing (*cuachaireacht*) of the cuckoo.' His list emphasises the onomatopoeic basis of many of the Irish names. With others, which do not echo their names either in English or Irish, he invents his own interpretation – 'I hear the quail crying "*fuid fuide*" and the corncrake "*aic aic*".'

When I began the Dawn Chorus I believed (naively) that, once made aware, everyone would be able to distinguish between the song of a thrush and a blackbird. It is clear, however, that many people, despite their best efforts, hear birdsong only as a jumble of undifferentiated tunes and are unable to do this. Those with 'a musical ear' may, it seems, have an inherent advantage. Several songbird CDs (available from BirdWatch Ireland) may be used in the home, before or after an outing, to help with the identification of songs and calls of our native species. Since Ireland has fewer than thirty songbirds (of which only about two dozen are relatively common and widespread), it is quite possible with practice to learn to recognise them all.

Lough Rask, a turlough-like wetland surrounded by scrub and trees, is a natural amphitheatre, a focus for sound. As we tramped clockwise along the trail, our voices seemed amplified, eliciting a mild admonition from me for extra quietness.

On previous visits, I had heard interesting wetland birds – sedge warbler, reed bunting and water rail – singing and calling from the fen vegetation. I was unaccompanied, of course. On this occasion, none of these species registered their presence, though a trio of courting mallards flew overhead quacking skittishly, a moorhen croaked

invisibly from the sedge, and swallows dived and twittered cheerily. We came in search of songbirds, but it was a colony of garrulous grey herons that caught our attention. Three or four pairs had built their nests in a line of sycamore trees at the back of the lake. As we approached, circumventing the lake, they flew up like disgruntled spirits and squawked above our heads. Obviously unused to so many intruders, they continued to barrack the procession passing beneath. Eventually, realising that we meant no harm, they returned to their untidy stick platforms in the canopy.

I regaled the group with the story of the Hag of Lough Rask, the repulsive, hunch-backed crone of the lake who forewarned Conor O'Brien of his impending doom should he continue on his journey to the north of the Burren to confront the rebellious O'Lochlainns. All in vain: a case of advice spurned, resulting in disaster at the wood of Suidine near Bell Harbour. The O'Briens were routed and Conor was killed. The irascible, unwelcoming herons provided a suitable backdrop to the story.

By the time our procession had departed the lake, the sound of cars could be heard on the road beyond. People remarked on the difference between man-made mechanical sounds – cars, lawnmowers, chainsaws – and natural sounds, the latter eliciting lyrical descriptions of nature's agreeable tones: 'uplifting', 'stimulating', 'refreshment for the soul'. On returning to the village, 'ordinary' people were going about their morning business. There was a sense that they had missed out on something special.

We returned to Hylands Hotel for breakfast and refreshment for the body.

Our tally of songbirds came to sixteen, considerably more than half of Ireland's common songbirds – not a bad total, we agreed, for a wetland oasis on the edge of a village and a rocky desert. Our group expressed satisfaction at having engaged as we did with our songbirds and doing so at sunrise – on the birds' terms.

Ballyvaughan's Dawn Chorus Day, listed and advertised in the itinerary of the Burren in Bloom festival, is now an annual event in the Burren calendar of activities, and one that, both because of and despite its popularity, I look forward to every year.

Unfortunately, over the course of the past few decades, the Burren has lost two of its most distinctive songbirds: the nightjar and the corncrake. I recall many evenings out listening for the unmistakable purring of a nightjar on the northern slope of Moneen Mountain. For several years into the early 1990s it continued to sing its bizarre mechanical song. Ecologist Paul Murphy, having located a pair holding territory, suspected breeding – one of only a handful of breeding pairs left in the entire country. By the mid 1990s, the mountain fell silent during the summer dusks and despite my many sorties to suitable habitats elsewhere hoping to seek it out, the extraordinary *tuirne lín* had vacated the Burren.

The corncrake had disappeared from the Burren much earlier. The song was still heard in meadowland near Lisdoonvarna when *The Atlas of Breeding Birds in Britain and Ireland* was being compiled in the early 1970s, though not a decade later. The loss of this iconic songbird from an ideal habitat – several years before the widespread abandonment of hay for silage – is something of a mystery, suggesting extraneous pressure (early signs of climate change?) or some other such factor in its disappearance.

Given that other Burren songbirds such as the yellowhammer are also less common than they were at the end of the millennium, now is the time to take note, and to try at least to protect their pressurised habitats.

Birdsong has long been a source of creative expression throughout the world, inspiring numerous romantic poets, classical composers and traditional Irish tunes such as 'The Lark in the Clear Air'. A fresh take on the subject in 2015 was a series of spring concerts presented by singers, musicians and a scattering of singing circles

in venues throughout the country. No doubt the organisers, Michael Fortune and Aileen Lambert, are hopeful that (like the Ballyvaughan event) it will become an annual celebration of birdsong, recognising its delightful but often unsung contribution to human wellbeing and culture.

An early photograph of the market square in Kinvara shows tiny birdcages on the walls outside dwellings. They contained wild songbirds such as linnets and goldfinches. Since the Wild Birds Protection Act 1930, it has been illegal to catch and cage wild birds in this way. Reprehensible as this formerly widespread practice now appears, it demonstrates the affection that people once had for birdsong and its role, prior to the advent of piped music, in providing everyday psychological uplift.

Butterfly Men

The Burren has attracted butterfly enthusiasts almost as long as it has attracted flower admirers. After the discovery of the Burren green moth in 1949 by W. S. Wright (sometimes incorrectly attributed to E. S. A. Baynes, I am told), the pursuit was elevated to a new level; butterfly seekers, particularly from England where there is a long tradition of the gentle activity, came regularly to Ireland to see what other marvels were on offer. Pioneers including Norman Hickin and R. F. Haynes, Englishmen with a deep knowledge of Lepidoptera in Britain, carried their enthusiasm and curiosity in the 1970s and 1980s to relatively unexplored outliers like the Burren.

Since the early 1990s, other individuals such as Ian Rippey from Portadown have continued to contribute to our knowledge and understanding not only of moths and butterflies but also of other 'showy' insects like dragonflies and damselflies. I associate Ian with the long tradition of amateur naturalists from Northern Ireland that emerged

from the post-Enlightenment period and produced such notables as John Templeton and William Thompson. In the late nineteenth century, the Belfast Naturalists' Field Club attracted luminaries such as S. A. Stewart, W. Gray, R. L. Praeger, R. Bell and many others, like moths to a lamp. Nowadays, Ian and co-workers from the Ulster Museum and Butterfly Conservation, along with others from the Dublin Naturalists' Field Club, continue to operate nationwide, recording and mapping Lepidoptera distribution throughout the island.

The declaration in my book, *The Natural History of the Burren* (1993), that the Burren held 'at least twenty-nine butterfly species, more than anywhere else in Ireland' was what precipitated my initial meeting with Ian Rippey. When I also informed him of my discovery of one of Ireland's scarcest and most beautiful species – the purple

Lackey Moth Tent

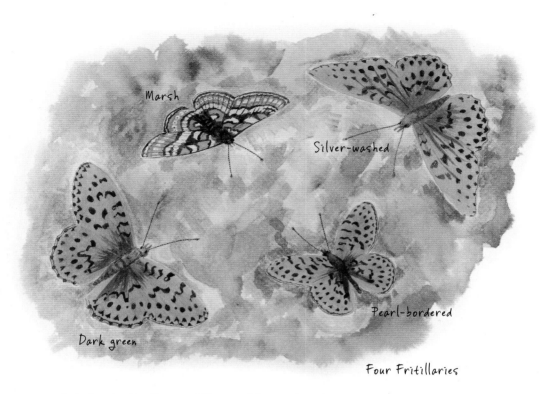

Marsh

Silver-washed

Dark green

Pearl-bordered

Four Fritillaries

hairstreak – in the east Burren, I knew that the region was about to come under the meticulous scrutiny of this avid lepidopterist.

To describe Ian's methods as thorough is to understate them entirely. In identifying a score of moth species in my wildlife garden (most of which I was not aware of), he refused the offer of a warm bed, preferring to snatch short periods of shut-eye in his car, to be on the spot for attending to his mercury vapour lamp in the undergrowth. I would not be surprised if the emergence of the piercing white light from the undergrowth has spawned numerous fables in my neighbourhood, verifying that 'D'Arcy is definitely away with the fairies.'

Rippey's voluminous follow-up emails, itemising in detail the species, its sex and maturity, the date and location of observation, comparisons with other related observations and habitats, and ancillary information concerning weather conditions and time of day, constitute a masterclass in scientific rigour. There is simply no

room for imprecision or ambiguity. Doubt over identification, where it does (rarely) occur, is dealt with candidly and dispassionately. These reports thus represent a most reliable and valuable databank for contemporary consultative documents and future reference.

Follow-up phone calls from Ian tend to take the form of reportage of other flora and fauna, noted in the course of his sojourns up and down the country. His observations of scarce plants such as orchids, expanding our store of knowledge as regards distribution, are welcomed by botanical recorders working in the Burren and further afield.

By taking on that winged bewilderment that is the subgroup micro-moths (comprising hundreds of tiny species), the butterfly men have shown that the Burren is endowed with a disproportionate number for its area. This is surely due to factors such as its geographical remove and its wide range of undeveloped and uncontaminated habitats. One such rarity, the Irish annulet, has been found and captured by Rippey on several occasions in the greater Burren region. In attempting to understand the Irish range of other lepidopteran anomalies, it is the aspect of geographical fidelity that is initially striking. The Burren green, for instance, is found nowhere else in Ireland and Britain; the Irish annulet is similarly restricted; the pearl-bordered fritillary is more or less confined to the region (the Burren being the only place in Ireland where all four of our fritillary butterflies can be found); the brown hairstreak's limited Irish range is centred in the region; and a species of wood white, *Leptidea sinapis*, found in the south of England but retreating rapidly there, is located in the Burren but nowhere else in Ireland. Remarkably, a new species of wood white, *Leptidea juvernica* (separated from its close relative by the shape of its genitalia), is not found in the UK but is found throughout the rest of Ireland in suitable habitat. The isolation of the Burren population of *Leptidea sinapis* cannot be explained on the basis of availability of food plants, since its caterpillar can exploit a variety of plant species, including vetches and bird's-foot trefoil, which are found commonly throughout the

country. The mystery remains. For moths and butterflies, the Burren is decidedly a place apart.

While nothing in nature is static, the stimulus for current fluctuations and influxes of many species is now firmly associated with climate change. Showy birds such as egrets and largely unseen marine fauna such as boarfish and their zooplankton food are clear indicators of this trend. Among the insects, new Odonata such as the spectacular emperor dragonfly, the migrant hawker and various damsels are now, as a result of northward spread, found in several southern counties. Four new species of dragonflies have been recorded in Ireland since 2000. Through painstaking investigation, Ian Rippey has recorded the rare Irish damsel (not found in Britain) and noted the presence of many others of the family in the greater Burren region. Migrant butterflies, mainly from the Continent, are coming in increasing numbers and are staying longer than before; the red admiral, which formerly died off before winter, is surviving in hibernation in some places, along with the small tortoiseshell and the peacock – Irish residents – thus surviving to rear a new generation in the following season. New butterflies – two species of the moth-like skippers, and the comma – have taken up residency in Wexford and may well spread more widely in time. Indeed, the comma and the long-established south-coast resident, the gatekeeper, have recently been reported from the Burren. Who knows, then, what the Burren insect population will be like in a decade or so.

In 2014, Ian Rippey counted thirty-two species in an east Burren 10-km (6-mile) square, corroboration of my initial statement about the Burren being the best place in Ireland for butterflies. Butterfly enthusiasts importantly open our eyes to nature's subtle changes. By focusing on the more 'showy' of our insects, they have pointed to the health of the wider invertebrate community. Indeed, in the context of insect dependency on plant variety, they are also making a most valuable ecological statement about many of our relatively unspoiled places. Long may they continue to contribute in this way.

A Day in the Life

The typical spring day of 20 May 2004 began as any other in the Burren: blue-skied, sunny, with high white clouds being pushed in from the west by a gentle breeze. Pockets of mist lingering on the lowlands evaporated gradually as the day developed.

I was accompanied by Jeremy Willder, a retired secondary school teacher, and his wife Trish (creator of the finest marmalade west of the Shannon), who live, appropriately, in a restored schoolhouse in Connemara. Conscious of the many contrasts between these closely situated west of Ireland locations, I quipped that while the Burren is invariably dry underfoot at this time of the year, waterproof footwear is mandatory in Connemara at any time. To say nothing of the midges.

Our stroll along the side of Lough Bunny (the name has nothing to do with rabbits), one of the prime floral spots of the Burren (see 'Flowers, Flowers, Flowers', p. 60), revealed the anticipated bounty of wild flower gorgeousness, with magenta bloody cranesbills and a

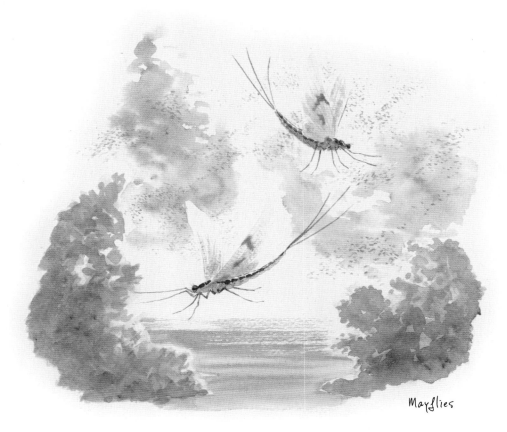

Mayflies

few late bluer-than-blue spring gentians catching the eye. It was too early for the local rarity, dropwort, to show off its candyfloss heads, but the spikes of various colourful orchids had us training our gaze on the grassy, trail-less fringes of the lake. Birds in song made their presence felt – a yellowhammer with its incessant call of 'a little bit of bread and no chee-eese', in tandem with a whitethroat emitting its rattling flight song. On higher vegetation at the water's edge, we were aware of other territorial declarations, those of a stonechat and a sedge warbler. Far off, a cuckoo called out for a mate: it was one of four we were to hear that day.

The sun had also brought life to the lakeside insects. Butter-yellow brimstone butterflies flitted amid the prostrate buckthorn, their caterpillar food plant, while unobtrusive dingy skippers and day-flying

speckled yellow moths hopped and skipped in front, disappearing wonderfully into the textured background of lichen-covered rocks and withered moss: all delightful, all normal.

It was as we made our way back to the parked cars that the remarkable happened. Lakeside whitethorn bushes, most still laden with their creamy blossoms, transmogrified as we watched. What we took at a distance to be a foggy aura materialised into a series of wavering columns around and above the bushes. We stood transfixed, watching the columns grow and grow as though they were stimulated by gaseous pockets within the limestone. What was the nature of this haze rearing up genie-like before our eyes? Held immobile in its spell, we watched as the sky gradually darkened, occluding our view of the Burren hills.

At first, I assumed it to be a mist of flying insects – midges, blackfly; it was too early for winged ants. I had witnessed a blackfly phenomenon like this at Lake Mývatn, in Iceland. The massing insects created a dusky fog, reducing vision to a few yards and demanding cautious progress through to clarity on the other side. Dead blackflies were everywhere; they filled every exposed orifice and fold, despite efforts to exclude them with face covering. Car traffic was reduced to a crawl, with people walking in front of vehicles to guide drivers. On another memorable occasion, while birdwatching at Lough Neagh, I noticed columns of what I took to be smoke rising from the lakeside willow scrub. For hours, the midge mists grew and grew into the still summer air, creating a surreal scene like a prelude to a grand theatrical performance. Towards evening, swifts and swallows gathered in huge flocks to feast on the bonanza.

But this was different. The Lough Bunny spectacle was distinctly denser, more opaque than the others, clearly comprised of larger insects. What could they be – one of our large mosquitoes, perhaps? Not likely, given the relative scarcity of these insects in Irish wetlands. It was not until we returned swiftly to the cars, careful to exclude

them from the interiors, that I was able to establish their identity. The windscreen was an invertebrate graveyard; a thousand delicately coloured insects with shimmering gauzy wings and three-spined tails covered it like so many laboratory specimens: these were mayflies. We had been privileged to see the celebrated, once-in-a-year mass-hatch of the species. Dragging their weakening inch-long bodies across the glass surface, piling up on top of one another, we could, at our leisure, examine the exquisite detail of their imago, or mature, form.

These remarkable invertebrates begin life as eggs in the shallows of Lough Bunny. On hatching, they spend at least a year, often two, burrowing and foraging as nymphs in the calcareous sediment. Spring warmth triggers the nymphs to swim to the surface to begin the next phase of their life. Performing an initial moult, they develop into short-lived 'sub-imagos' – winged insects that are not yet adults – now referred to as 'duns' due to their dull colouration. In this state, they are covered entirely with a thin, translucent skin. Shortly afterwards, they embark upon their denouement moult into the final, imago, stage. Mayflies are the only insects known to develop like this, from an initial first-winged stage to a second in adulthood. They are then recognisable in their delicate beauty – cream-and-olive-coloured body and iridescent wings. These are referred to as 'spinners' by the angling fraternity who use them (or their facsimiles) in fly fishing. Within minutes of being airborne, the males attract and mate with females on the wing, which subsequently lay their eggs in the water's edge, thus completing the cycle.

The whitethorn bushes at Lough Bunny had become gathering posts, meet-and-mate venues, for inestimable numbers of the imagos.

Unable to draw myself away from the spectacle, I stepped outside again. The columns had grown into dense clots high above the lakeside. As I watched, they took on a new life, pulsing and moulding into gracefully changing shapes like careening flocks of starlings,

before swooping down to roost in a reed bed. The column dynamic was being created by millions of pairs of mayflies performing their unique mating dance. I was reminded of the communicatory dance of bees at the hive and the delightful one-on-one aerial display of mating butterflies. This was a mad orgy in comparison. The dancing continued, the participants twirling, swirling, spiralling crazily, until, overcome by exhaustion, their spent, still moving bodies littered the ground and the water's edge. And, finally, death. How appropriate is their scientific name, *Ephemeroptera*, and the adjectival derivation, 'ephemeral'.

As we drove away, we were full of the experience, agreeing that we had never before seen such a mesmerising insect display. It was the epitome of unexpectedness in this place of constant surprises.

Orchid Hunters

No other floral family attracts more advocates than the Orchidaceae. Orchids are pursued single-mindedly, in the manner of rare birds, by 'twitchers'. There are those who are satisfied simply to identify and enjoy their distinctive symmetry and others, 'extremists', who must capture them in some permanent fashion or other. Unfortunately, this sometimes extends to picking them for the purpose of flattening them individually between the pages of a book, or worse, digging them up for the usually unsuccessful process of transplanting them in the garden or polytunnel.

Nor is the attraction purely aesthetic. Orchids, at the acme of plant development, symbolise evolutionary perfection, a trait many plant seekers would identify with and admire. There is also the sexual connotation, the superficial resemblance of the plant's twin tubers to human testes, known and remarked upon since the time of the ancient Greeks, the resemblance having found its way into medicine

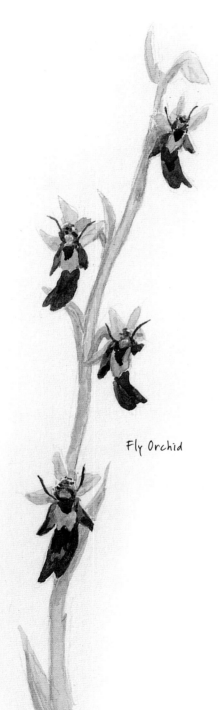

Fly Orchid

in the form of a surgical procedure (an 'orchidectomy' being the removal of one or both testes). The multitudinous tiny seeds let loose on the wind also suggest reproductive profligacy, stemmed only by a combination of specific factors to facilitate reproduction. Superficial considerations – pink, feminine frilliness and 'girly' names such as Lady's Tresses and Lady's Slipper, suggesting strange but fascinating ambiguity – add to the allure. Orchids thus radiate desirability, particularly (it seems to me) among males of the human species.

Orchid hunters come in three types. First, as casual flower enthusiasts who seek them out in preference to other floral attractions. They (often elderly couples) can be seen on bright summer days, a stone's throw from the parked car at the roadside, in the rocky hinterland amid a forest of pink spikes. They pick their steps gingerly across the limestone, stooping and crouching occasionally at one delightful discovery after another. They are unconcerned with specific identification; the orchids are captured in photographs to show later to indifferent friends and relatives. To the passing motorist, these orchid seekers, engaged in their joyful pursuit, convey a charming sense of rediscovered childhood.

Orchid seekers in the second category know what they are looking for. From my

experience, they constitute a motley group – botanists, photographer botanists and simply photographers. Each summer they appear, usually solitary individuals, timing their visits to coincide with favourable weather and light, and the seasonal emergence of the various species. I have known and admired many in their determination to acquire 'that shot'. The late Michael Slattery was one. An obvious lack of athleticism did nothing to deter this gentle nature lover from hauling 10 kg (22 lb) of photographic gear up and down the Burren hills in pursuit of images, many of which he passed on to me for use in the lecture theatre. I have fond memories of him enthusiastically pointing out some irregular orchid feature or other, his broad head beaded with sweat from his solitary endeavours.

A number of others, including regular visitor Nikko Rippon, produced images good enough for profit. For years he made his orchid images into postcards for sale at retail outlets, with cards of the trio of remarkable insect-duping species – the bee, butterfly and fly orchids – being perennial favourites. Gerrit Van Gelderen, the Dutch filmmaker and artist, reproduced orchid images as paintings and in animated form for his films and TV programmes, and used his precise watercolour illustrations to highlight the threat to the plants from random picking by visitors. His erstwhile Burren companion Dick Deegan had the ambition to photograph every Irish orchid; he hardly needed to leave the Burren to pursue his ambition. Ornithologist Tom Ennis is one of many enthusiasts from the north of Ireland not only to produce beautiful photographic images of orchids, but also to study them in taxonomic detail. Obtaining a complete pictorial record of the Burren's entire suite of Orchidaceae (more than two dozen species), however, requires not only considerable effort in terms of travel, but also a measure of dedication to the cause over a protracted period. Even then, one is not guaranteed to find them all, due to their fickle reproductive rhythm, dependant on a specific mycorrhizal root fungus. Some seekers (including me) return again and again to a

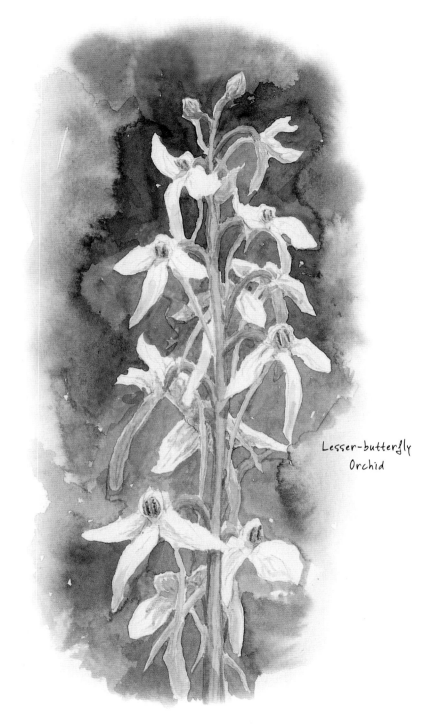

Lesser-butterfly
Orchid

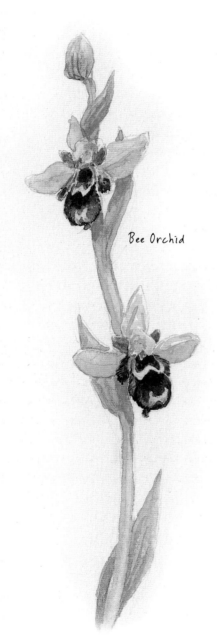

Bee Orchid

former flowering site only to be frustrated by the refusal of a particular species to show. Elusiveness, of course, as with the interaction of the sexes in humans, may well intensify the effort.

The third category of orchid hunter comprises those who have been smitten by the allure – the downright obsessives. One such individual, an English botanist, learning of my interest in the Burren, came to stay with me in the early 1990s. He had spent years travelling the length and breadth of Britain hunting down and photographing each of the forty or so species found there. He was clearly obsessed with cornering and capturing each one on celluloid. Having succeeded in the UK, he had now turned his botanical radar on Ireland. His 'pimpernel' was *Neotinea intacta*, the dense-flowered orchid, a rare southern European species and a Burren speciality. When I informed him that it was to be found on an esker within a mile of my house, his face lit up in anticipation. The next day, on being led to a few spikes of the diminutive plant, he fell to the ground and began photographing them from every conceivable angle and with all the equipment at his disposal. He spent all day prostrate before the tiny plants. After several days tracking down other *Neotinea intacta* sites, taking scores of shots in all lights and circumstances, he

departed the Burren and Ireland. I never heard what he did with his Burren portfolio, though I imagine that the best of his photographs must be decorating one or other of the library of orchid books to have emerged in recent years.

The ultimate orchid obsessive, in my experience, was the affectionately remembered Belfast artist Raymond Piper. In his case, the outcome was to be a series of paintings rather than photos. 'Paintings' inadequately describes his exquisitely detailed, life-size images, each clearly a labour of love – each a masterpiece. Piper's orchid paintings have set a standard to which most botanical artists can only aspire. In his latter years, his obsession intensified and the Burren, so well endowed with the botanical family, became his happy hunting ground. In the course of his many visits throughout the 1990s, this genial eccentric stayed regularly at our home, Tigh-na-Riasc, where he regaled us with his life's work as a portrait painter and illustrator, his friendship with the writer and traveller Richard Hayward, and his efforts to 'save' endangered plants by installing examples in his Belfast conservatory. One of Raymond's talents, most evident at the dinner table (where he invariably had a captive audience), was to bring the subject of general conversation – whether relevant or not – seamlessly around to orchids: an archaeological discussion concerning the protection of a particular site would be defined on the basis of a nearby orchid habitat; a motor rally through the Burren would be denigrated due to the possibility of orchid trampling by spectators; colours of house plants, picture subjects and curtains alike were compared to the colours of certain orchids. Tedious in the extreme for some, his conversational manoeuvrings were for me a constant source of entertainment. In his frequent, enthusiastic soliloquies, he revealed an encyclopedic knowledge of European and tropical orchids, which he sought out on foreign excursions.

On one memorable evening, a Benedictine monk from Glenstal Abbey who, along with Raymond, was dining with us was heard, on

departing early, to swear uncharacteristically, having been 'subjected' to one of Raymond's orchid monologues.

Throughout the 1990s, there was talk among the orchid hunters of a formerly undescribed variety, akin to the famous white O'Kelly variant of the common spotted orchid. Raymond was at the forefront of this intrigue. For a while his conversation was full of specifics concerning structure, colour and arcane details regarding the components of the inner flower and spur shape. Gradually, however, his enthusiasm for *Dactyloriza piperius* began to wane due, it seemed, to lack of agreement among the experts. Though he did not express it as such, he was finally confronted with an irrefutable botanical fact: orchids are not at the top of the plant tree for nothing. Their facility for variation, hybridisation, insect duping, alluring looks and scents – in short, their capacity for evolutionary advancement through deception – is what makes them what they are.

A group of (mainly young) conservationists from Galway, concerned about the fate of a botanically rich habitat in the face of the imminent construction of the Gort bypass, elected (in summer 2014) to transplant dozens of individual orchids of several species to safe habitats close to Galway city. The natural orchid meadows of Renvyle Park featured as a destination in the operation. Although the conservationists took considerable care to relocate the plants to unfertilised terrain similar to that from which they came, success could in no way be guaranteed due to the fickleness of orchid regeneration. Whatever about its ultimate success, this voluntary effort adequately demonstrates the high esteem in which orchids are generally held and the lengths to which enthusiasts are prepared to go to try and conserve them.

Gentian

'They're out, they're out. I saw them yesterday,' came a small voice from the back of fourth class in Kilnaboy National School.

'They're all over the side of the road in my granny's land,' came the voice again.

'Are you sure?'

'Yes, sir, it's definitely them,' reiterated the little girl, looking intently at the large blue image on the white screen.

It was time, of course. It was now mid April. It had been a very late spring: raw easterlies and sporadic northerly fronts had sent spring back into hibernation.

Where were the swallows? One or two had appeared all right, but the advance wave, twittering and swooping around the barns and outhouses, was still somewhere to the south of Ireland. Swallows were later than any year in the past quarter century, according to my diaries.

And what had happened to the blackthorn, that other, normally reliable, seasonal marker?

It had appeared all right, but only in sheltered hollows, or cowering prostrate on the limestone pavement, or emerging from a deep crevice – far removed from the glorious white-blossomed spectacle I had become used to. There were the other spring flowers – celandine, primrose, violet, anemone, sorrel – but they had to be sought out, they weren't yet flaunting their spangled colours in the hazel scrub or on the south-facing banks of the bohereens. The glorious stands of early purple orchids, prologue to a splurge of others, were no more than a memory from last spring: warm southern plants. What about the promise of planetary warming?

Slide show completed, quiz answers collected, goodbyes said, I decided I would have to go and see for myself. My route home would take me past one of the great floral locations in the Burren – Lough Bunny. If the spring gentian wasn't there, it simply wasn't out yet and the little girl had been imagining things.

The cold east wind straightened me as I stepped out of the car and I was reminded of the arctic conditions that during the Ice Age had transported the little gentian seeds to the Burren from Alpine regions far to the east. There is always the question with the Burren about floristic origin. How did such and such a plant get here? Was it the result of accidental spread, along newly constructed roads, or dumped along with other seed debris from a garden centre? Could it have been deliberately planted? In the case of the gentian, we know that, despite the paucity of hard palaeobotanical evidence (though its pollen has been detected in prehistoric sediments), it is undoubtedly an ancient native and part of the Ice Age legacy of the Burren.

As I carefully picked my steps across the broken ground, favouring the flat slabs of limestone over the grassy hollows where coarse grass and creeping briar can bring grief to the unsuspecting rambler, I reflected on the midsummer splendour of the place. It is resplendent

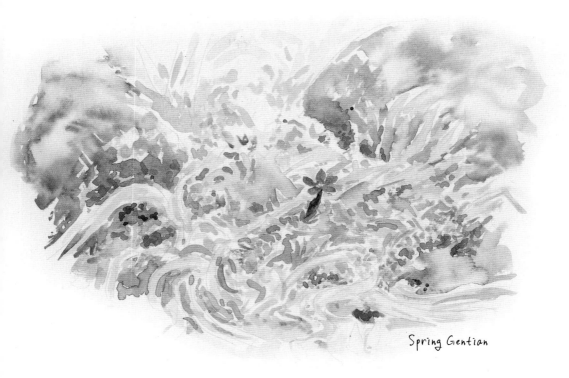

Spring Gentian

in that season with bewildering texture and colour – purple violets, magenta cranesbills, azure harebells, cadmium trefoils and orchids of a variety of tints and hues. It has its rarities too – dense-flowered orchid, dropwort, turlough dandelion – though these would not normally be numbered among the region's beauties. Creeping shrubs – willow, thorn, stone bramble, dewberry – drape the crag near the water's edge. Here too is purging buckthorn, with its scarce neighbour, the delicate alder buckthorn.

The Lough Bunny complex (as it is sometimes dispassionately called) is one of the Burren's special places, a true floristic paradise (see 'Flowers, Flowers, Flowers', p. 60). But reflection on past glories was not going to help me to locate the gentian. I would have to do what I am forever urging schoolchildren to do on our regular nature

outings – become a nature detective! It is not easy to scrutinise the ground while carefully picking one's steps. However, one gets into a kind of focused rhythm of 'step and look', and soon the bright tiny flowers reveal themselves as familiar spots of colour against the straw-coloured background of dead grass.

I walked for what appeared to be ages in the bitter wind, conscious that, in my shirtsleeves (a must in overheated classrooms), I was inadequately clad for the job. I nevertheless plodded on, visiting the grassy patches between the rock outcrops, places where I had seen spring gentians 'pinned like tiny blue brooches', as Stephen Mills so eloquently put it, to the close-grazed turf.

Overcome eventually by the negativity that only chill can instil, and possessed by the niggling need to be home to mark exam papers, I had given up and was actually returning to the car when I almost stumbled on it: just one, a blue micro-beacon in the midst of ochre dieback. The tiny floral propeller head cast its colour up at me like a laser, stopping me in my tracks as surely as someone calling my name. I crouched to indulge in its perfection: a rosette of green leaves; a stout, purple-suffused stalk; a flower head of the most intense blue imaginable. That first glimpse of the gentian, whether after a long grey winter or for the first time ever, demands undivided attention. It is one of those benchmark events in nature, like early leaf burst on an ash or the call of the first cuckoo.

Having indulged in the company of the floral gem, I strode purposefully away, eyes fixed on the car, afraid that I might locate another. In some perverse, romantic way, I had decided that my encounter was special, loaded with meaning and privilege. I could not countenance its diminishment by coming upon another. The little girl was right: they were 'out' – so much for my scepticism.

Though the spring gentian is by no means confined to north Clare, being found in the limestone country of several western counties, it has become synonymous with the Burren. Its distinctive form

decorates writing paper, postcards and books, brooches and earrings, the walls of cafes and restaurants, and, in gigantic replication, the wall of the visitor centre at Kilfenora. In the manner of the shamrock for the whole island, it has become the undisputed floral emblem of the Burren.

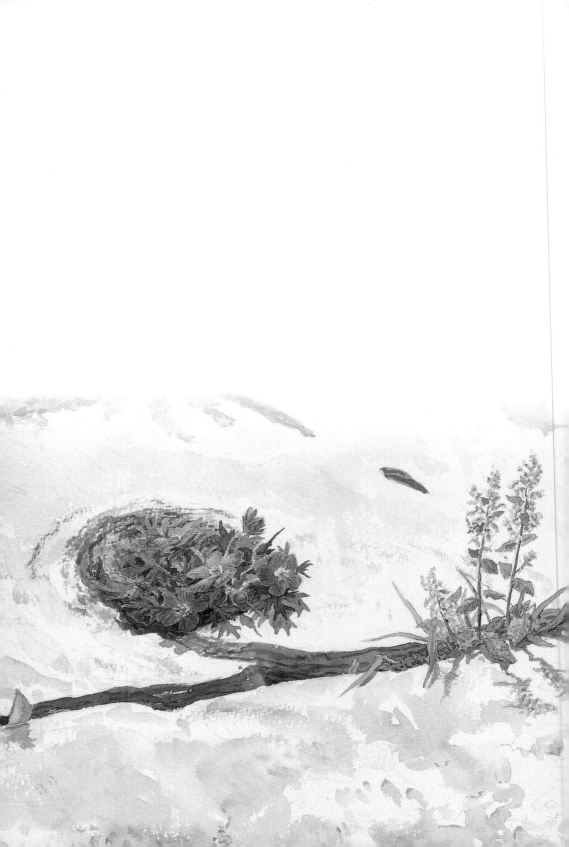

2

Petra Fertilis

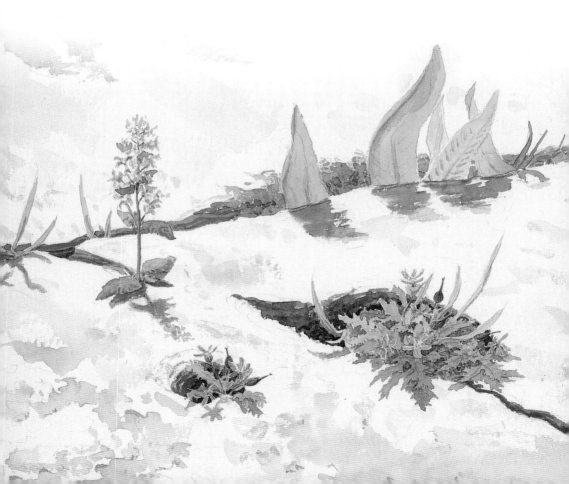

Flowers, Flowers, Flowers

A naturalist but not a gardener? Sounds like a perfect oxymoron. I have to admit to a tendency to switch off when the conversation comes round to manicured lawns, herbaceous borders, trellised arbours, shrub tubs, trained wall creepers … basically all that goes with the universal cult of decorative cultivation. I put this down to a genetic connection with hunter-gatherers; my friends put it down to laziness.

While I am abundantly aware of the skill and art of gardening, I find it impossible to get past the barrier of wilfully managing and controlling growing things. My own half acre on the edge of a wetland is an area of natural accommodation. For years, I have enjoyed watching the incursion of wild plants into the edge of the domestically defined 'ecological buffer zone' formed of the gravel driveway and the tiled patio. My only concession to cultivation has been the planting of native trees – more than twenty species over the past thirty years – an endeavour I can legitimise under the admirable process of ecological restoration.

There is something about the way nature
– whether flora or fauna – organises itself
(as distinct from the way we like to organise
it) that I find endlessly appealing. I love untidy
corners of fields, overgrown hedges and
waysides, riverside tangles, plant-invaded
building sites and so on. Botanists describe
this ongoing process as 'succession' and
the transitory organisation of groups of
plants as 'association'. This scientific
approach was first applied to the whole
of the Burren's plant life by two botanists,
Ivimey-Cook and Proctor, in the 1960s.
Their painstaking fieldwork resulted in the
mapping of a fertile mosaic that reflected
topographical variation such as local soil
conditions, availability of nutrients, degrees
of wetness and so on. Given that the Burren
(like almost everywhere else on the island)
has been 'worked over' by the indirect or
direct hand of man for millennia and is
subject nowadays to the rapidly increasing
impact of invasive species, it is debatable
whether such a neat organisational format
still holds. While I am aware of and enjoy
recognising the nuances giving rise to floral
variations in the field, I am quite happy in
this case to sublimate the science for the
sake of aesthetics. Indeed, the variations
of species, with their textures and colours,
often speak to me with more immediacy
than does the botanical text.

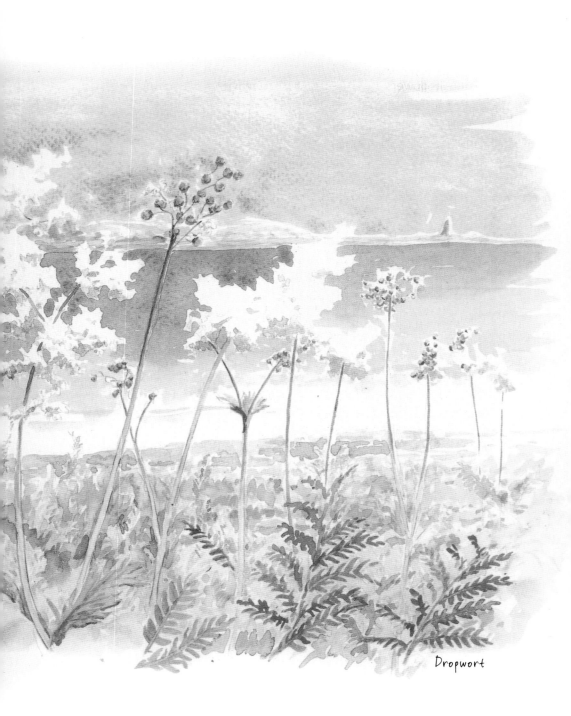

Dropwort

Ask an outsider about the Burren's fame. The response is sure to feature its flowers. There has, in fact, been so much commentary and so much has been written about them as to render description hackneyed. 'Floral haven', 'rock garden', 'botanical paradise', 'fertile rock' … such lyricism, however apposite, is studiously avoided by Burren devotees. At its optimum, the floral display defies description: responses such as those conveyed by art, photography or simple unanalysed admiration may well constitute the most satisfactory comment. Words are necessary, however, if only to set the scene regarding the amazing variety on show and the best time and place to experience it.

Those used to the gaudy exuberance of well-tended gardens, hanging baskets and window boxes may express disappointment at the rather sporadic distribution of the Burren's colourful species and their diminutive size. Flower seekers more in tune, perhaps, with unmanicured circumstances marvel at other factors – the setting, the strange juxtaposition of geographical origins, the climatically induced superabundance, the impact of grazing … It is this background knowledge, combined with the subtle tones and textures of the mix, that renders the floral experience so special. To those, add another, often understated factor – joy-filled surprise.

I have been fortunate to have met, learned from and enjoyed the company of so many floral buffs down the years that it would be impossible to list them. They come in all types, from (often rather uncommunicative) academics to (often loquacious) amateurs and flower-stricken enthusiasts. Not many actually combine deep botanical knowledge with simple aesthetic appreciation. Dr Cilian Roden (polymath and gardener) is one of these and a trip with him into the Burren during the flowering season is invariably rewarding. Over the years, I can recall dozens of such sorties, drawn by some floral query or broader ecological issue – always intellectually stimulating, always great fun.

For me, a handful of well-scattered localities hold the key to the Burren's floral riches. They do, however, need to be visited at the

optimum time to experience them at their best, to properly indulge in their magic. The following are some of these.

Black Head

Our floral indulgence begins casually at the light station below the road of the headland (which is black because of the blackish magnesium and calcium carbonate minerals in the rock) in late May or June. Though the magnificent seascape of the wide Atlantic, with the flatlands of south Connemara and the Aran Islands on the edge of things, constantly distracts, it is the flowers that are the more immediate and irresistible draw. Cushions of sparkling white campion and pink thrift, growing randomly on the limestone terrace, decorate a visually pleasing foreground against the Prussian blue background of the ocean. In the shadowed grikes, the plastic-looking green fronds of sea spleenwort reach upwards towards the salty air, and yellow and orange lichens dapple the outcrops and low cliffs. Here and there, small boulders of granite lie incongruously atop the limestone where they were dumped by ice during the last glaciation. They are splattered with olive and grey crustose lichens like paint stains. As one walks east, the terracing narrows, causing one to focus again on the sea and the black guillemots flying out in mated pairs from the low cliff below. This is the place to stop and take stock of the beauty, at this point enhanced by bouquets of the rare red-stemmed Irish saxifrage, which seem to emerge from every hollow in the rock. The view back across the slick limestone surface, punctuated by the flower sprays, is as appealing as it is quintessentially 'Burrenesque'. Such inspiration is all the flower seeker needs to take on the climb, to scale the steep incline above the road in search of other harmonies.

The glacially scoured and smoothed limestone, belied by its appearance from the road, converts into a retreating stack of

escarpments surmounted by plant-rich terraces packed with bewildering floral fecundity. As each terrace comes into view, a multicoloured spectacle of shimmering blue gentians, silvery mountain everlasting, purple orchids and yellow bird's-foot trefoil light up the grey rock as if planted to delight the climber. In all lights, the floral display is haltingly beautiful but, transmogrified into a dazzling blur under the influence of wind and an oblique sun, it is positively stunning. In places, the predominance of a particular blossom over others conveys a hue like the infusion in a watercolour painting. Influences such as exposure to wind and rain and variation in the mineral content of the rock are probably responsible for this. But who needs science now? It is quite impossible to be unmoved by the show, so intense and imposing in its wild setting.

On the grassy Famine road (in fact the original route around Black Head), an intermediate 'must-stop' location on the climb, blue moor grass (now ochre-tipped with pollen) and cream and yellow-centred mountain avens take over, decorating the rock in every direction. One is now aware of the zonation attendant on altitude. Zonation, whether with lichens on the shore or violets in the turloughs, is a constant phenomenon in the Burren created by fluctuating elements – particularly water. On the Black Head slopes, altitude is the main factor as water comes only from precipitation. On the uplands, zonation is manifest in the increasing dominance of hardy, woody species over the more delicate flowers. At the stone fort of Cathair Dhúin Irghuis, another breath-restoring stop, the earlier growth gives way to the crouching greens of crowberry and bearberry, and the lilac and deep-green suffusions of ling heather. There is a lesson in this landscape. This suite of heath plants speaks of tundra at the end of the Ice Age. The absence of boulder clay suggests ice-scoured conditions and the subsequent development of woody heath plants – not trees. It presents a bare picture at odds with that painted for the otherwise tree-covered Burren of the early Holocene. Beyond the fort, wide expanses of fissured limestone pavement have

reduced plant growth to insignificance: pockets of stunted heath and the sparkle of a few herb Roberts cowering in the fissures are the only signs of defiance. By the time one attains the true summit at Carn Suí Finn (or Dobhach Bhrainín), at 300 m above sea level, the landscape has become a moonscape.

Now the compensation for tired limbs and lungs lies entirely in the unparalleled view. Galway Bay, reduced to a rectangular inlet from the Atlantic, sweeps eastwards towards Galway city. Connemara opening up to the north is bounded by the blue ridges of the Maumturks and the dinosaur back of the Twelve Pins. To the west, the Aran Islands appear as flat-topped stepping stones to the great beyond.

If one is out for the day and intent on further exploration, the trek along the whaleback of Gleninagh Mountain and Aghaglinny will eventually bring one to the saddle between the hills and the exhilarating descent along the mass path towards Gleninagh's ruined medieval church. The walk back along the road, though busy with traffic at this time of the year, has a unique compensation: it invites contact with the finest of our ferns, the maidenhair, dangling from the roof and sides of the damp little roadside rock orifices.

If time is an issue, better to return downhill for an invigorating reprise, to delight once again in one of Ireland's foremost floral spectacles.

The National Park

Floral forays in the Burren National Park, in front of Mullaghmore Mountain, in July, are often as much about sharing as discovery. Regular guided tours run by the staff from the Clare Heritage Centre in Corofin provide visitors with a unique opportunity to sample first-hand the wonders of the park. There is ample space to remove oneself from the tours and head off alone (if one must). It is interesting to watch the enthusiasts, whether alone, in pairs, or guided groups as

they wander the open karst. They walk slowly, reverentially, heads down, eyes scanning the ground at their feet. Some, with guidebook or camera to hand, dally or kneel at a particular spot or other. Vocal exchanges are whispered, as though paying homage to the imposing presence of the strange otherworldly mountain.

Tramline grikes offer up quivering stems of quaking grass, wall lettuce, wood sage, and colourful posies of violets, yellow trefoil and pink and white orchids. Purple-pink cranesbills emerge from algae-created cup holes in the rock while pristine white burnet roses decorate the shattered rock and perfume-scent the air. Tall blossoms of hawkweed, yellow-wort and ox-eye daisy seem to grow directly from the rock itself. Most captivating are the dancing heads of harebell, sky-blue 'pixie caps', which grace the swathes of dry grassland like no other growing thing. So attractive are they that parents must constantly warn children against the temptation to pick them. A series of longitudinal blackish outcrops – fossil reefs from a time when the grey limestone was mud, hundreds of millions of years ago – catch the eye. Formed of countless microorganisms in the Carboniferous sea, these geological incongruities present acid conditions supporting a dense mantle of ling, a plant that tends to avoid the limy rock.

Gealáin turlough, an extensive mirror in winter reflecting the bizarre folds of the mountain, is now no more than a shard. Contrasting with its cerulean shallows, its navy blue centre – a deep and dangerous collapse hole – is a warning to unsuspecting paddlers. Entering the water is thus frowned upon by park officials. The turlough's zoned flowers, from the tiny china blue violets in the base to the splendid ring of yellow-flowered shrubby cinquefoil around the flood level, are actually more accessible in Rinn na Móna, Gealáin's sister turlough. These plants grow in profusion in the Burren's unique temporary lakes, but are decidedly rare outside the limestone region, not only elsewhere in Ireland but in Europe. Crimson marsh orchids, honey-scented meadowsweet and a variety of prostrate shrubs – blackthorn,

buckthorn and holly – must be negotiated on the outer fringes of the turloughs. It comes as a surprise to visitors to find waterborne debris at a level above the road, where it has been deposited by winter floodwater that regularly links the two turloughs and cuts off the way to vehicular traffic. This deposition is a stark reminder of the expansive capacity of these unique natural reservoirs.

Between the turlough and the base of the mountain lies a delightful little wetland of no more than a hectare. This is not a miniature version of Gealáin, however, it is a flooded doline clogged with fen vegetation. A variety of sedges are on show together with other emergent aquatics. In summer it is one of the best places to see dragonflies, including the scarce, powder-blue-bodied skimmers.

Beyond, under the western shoulder of Mullaghmore, a small woodland grows in the protection of the park. The species list is long: ash, hazel, holly, birch, elm, oak, aspen, crab apple, yew, blackthorn, whitethorn, buckthorn, spindle, guelder rose … Its value lies in its pristine state; it is far enough away from introduced trees and is thus 'uncontaminated' by planted, non-native species. It has simply developed unaided, revealing to scientists the characteristics of arboreal succession, an important ecological consideration in a region that was once replete with native trees.

Pollen from the muddy bed of a small wetland close by reveals the first Holocene tree colonisers; a thousand-year post-tundra spell dominated by birch was succeeded by Scots pine, juniper and hazel. Elm, oak and alder followed, but ash and yew were apparently not present until the arrival of the first farmers, some 6,000 years ago. The increase of these 'lime-happy' species in abandoned parts of the Burren today raises questions about the relative impacts of climate change and human activity. It is interesting also to note that the majority of the species of trees noted in the pollen record are found now in the developing wood close to the lake and under the shelter of the mountain.

It is impossible to ignore the tracts of formerly cleared and open land in and around the park that are being engulfed by native shrubs (predominantly hazel), a prequel no doubt to a return of ash woodland. This development presents an ongoing challenge to the personnel of the park, conscious of the need to protect all things natural and to facilitate natural processes where possible, but aware also of the need to maintain that which has made the Burren internationally famous – its flora. It may be fine to allow part of the Burren to revert to woodland – as it once was – but it is important to keep in mind the high-priority conservation value allocated to the flower-rich limestone grassland under the EU Habitats Directive.

Lough Bunny

This substantial lake on the Burren's south-eastern corner is both visually beautiful against the low-profile backdrop of the limestone plateau and mysterious in its hydrological circumstances. Though associated with a network of turloughs, it is not one itself. It never completely dries up even though hydrologists have shown it to be connected to the Burren's complex groundwater system. It is in fact the natural headwater reservoir to the River Fergus, which links with the Shannon.

The name Bunny, a corrupted version of the Irish *Buinne*, clearly has nothing to do with rabbits. Dinneen's Irish–English dictionary suggests several (widely differing) translations of *Buinne*, including a flood, a wave, a torrent, a pouring forth; a border or edging; a musical pipe – any of which might or might not apply. However, in association with the word bog it translates as bulrush. This botanical connection is perhaps the most apposite, given that bulrush grows abundantly today at the south-eastern end; this aspect of its identity may have had a strong significance in past centuries when bulrushes would have been particularly valuable for thatching.

At its north-eastern end lies the village of Boston, appropriately named *Móinín na gCloigeann* (the meadow of the harebells) in Irish. With its former school, church and six houses, Boston must rank among the smallest of Irish villages. Local lore has it that the Burren's Boston connects in a poignant manner with the famous New England city. Tradition remembers it as a gathering place of post-Famine emigrants bound for a better life in the US, and as being in no way connected to Boston in England, after which the US Boston is named. But if this explanation is true, why is it so far from the sea and the departure points for America?

A visit to Lough Bunny and its unspoilt hinterland is a treat at any time of the year, but in August it is so floristically alluring that hours spent strolling along its edge go without notice. The high candyfloss tops of dropwort, decorating the flats like hundreds of welcoming flags, and the equally profuse purple, single-headed meadow thistles are immediate attractions. Dropwort, an east Burren speciality found nowhere else in Ireland, gives little clue in spring to the surprise it offers later in the year. The ground is dotted now with orchids, particularly the pink-spotted species. The insect-mimicking fly and bee orchids are also to be found amid the low grass and herbs, but they take time to locate. Blue harebells, indigo scabious and blue-tufted vetch emerge at this time, adding dabs of lively, cold colour to the otherwise warm habitat. Pockets of acidic soil support the heath plants, ling and bell heather – purple haze. Closer to the water's edge are the stunted shrubs – guelder rose, rowan (already in berry), blackthorn and whitethorn – and the scarce prostrate alder buckthorn, recognisable by the neat symmetry of its tiny leaves. Two relatives of the familiar hedgerow briar grow in the rock fissures. The stone bramble, with its small three-leaved format and fine prickles, is like a shy version of its familiar, aggressive relative. The dewberry also bears a fleeting resemblance to the fruiting bramble, but in fruiting produces only a few dark red drupes in autumn. Here also

grows the rare turlough dandelion, its
deep red stalks and strap-like leaves
distinguishing it from its common relative.

A stroll to the south-western end of the
lake brings one into the realm of aquatic plants.
Dense stands of deep green bulrush evoke the
Irish name of the lake. A variety of sedges flank high
beds of reeds, while tangles of impenetrable saw-sedge
add subtle ochre tints to the scene. Here and there, the tiny
pea-like yellow flowers of sub-aquatic bladderwort protrude above
the water's surface.

This fenland and the small islands in the lake support a variety of
nesting waterfowl. There are always a few coot families, but mallard,
tufted duck and red-breasted merganser also occasionally breed
here. Until the turn of the millennium, a substantial colony of black-
headed gulls nested at the eastern end. The gulls, however, have
abandoned the site, for reasons unknown.

Beyond (and at the north end), at high water mark, stands of the
yellow-flowered shrubby cinquefoil (rare outside the Burren's turlough
country) illuminate the lake's subtle green and brown fringes. In dry
summers, the bright pink-flowered spikes of amphibious bistort decorate
the exposed limy sediments. Their long creeping stems and floating
leaves permit uninterrupted flowering during late summer floods.

St Colmán's Hermitage

St Colmán's 'pattern day' is in October, but the best time to go on
floral pilgrimage to his hermitage is in spring, especially in May. At this
time, the open limestone is a riot of colour. Gentians, violets, cat's foot,
mountain avens, early purples, bird's-foot trefoil, wild thyme, milkwort,
scented lady's bedstraw and squinancywort spangle the green turf on

and around the trail, from the bell-mouth entrance to the scrub fringe in the shadow of the high cliff of Slieve Carran, more than a kilometre away. Distractions are everywhere: drystone walls hide fresh green fronds of spleenwort and rusty-back ferns; pock-holed clints hold tiny saxifrages, herb Robert and nostoc algae; the grikes shelter cushion mosses and emergent herbs; blue moorgrass grows in steely-tipped pin cushions from thyme-topped hummocks; sweet vernal grass and quaking grass quiver in the breeze. This is the place to look for that rare parasitic species, thyme broomrape, a cuckoo of a plant; completely lacking in chlorophyll, it resembles a small orange orchid atop cushions of its purple-flowered host. At this time, the display of bloody cranesbill has to be seen to be believed. Close up, it litters the limestone like red confetti. Distantly and most appealingly, it merges into a magenta haze against the blue-grey backdrop of the limestone.

As the vertical escarpment of Eagle's Rock looms ahead and the trail leads through a once cultivated grassy hillside (a legacy of Famine cultivation), diversity diminishes radically, and knapweed, plantain, yellow rattle and coarse grasses replace the biodiverse flora of the limestone grassland. Soon, however, one is engulfed by banks of multi-stemmed hazel coppice. Sunlight penetrating the thickets picks out white wood anemone, sorrel, and dog and wood violets. One does not have to look too hard to find the small white-topped umbellifers of pignut and (later in the year) burnet saxifrage. Here and there, too, are clusters of demure sanicle and the gracefully nodding hoods of water avens. Barren and wild strawberry are still in bloom, the former distinguishable from the latter by its smaller size and slightly indented petals. On the understorey fringe, countless stems of enchanter's nightshade display their tiny delicate flowers: well named – the experience of wandering through these hazel thickets in early summer is indeed enchanting.

I know few other wild places so richly endowed and so accessible as this particular walk.

The sanctuary glade, surrounded and shadowed by the scrub, is a

feast for the senses. Eyes move from the ancient ruined church and its plinths to the saint's elevated cave and the pilgrims' destination – the holy well and its rag tree, festooned with votive offerings. Ears, tuned now to delicate natural sounds, pick up the almost imperceptible tinkling of water issuing from the rock near the well. Here, the olfactory sense overwhelms others as one becomes aware of the monoculture of white-flowered wild garlic beneath the scrub. A cheese sandwich enhanced by the inclusion of a couple of 'straps' of wild garlic, a draught of icy, unpolluted water from the spring and the pleasant accompaniment of birdsong echoing from the cliff behind can serve to remind the modern-day pilgrim of compensations experienced by Colmán on special days during his long period of seclusion.

The trunks of three tall, venerable willow trees, draped with lichens, invite touch. These trees were clearly planted to delineate the sanctuary, perhaps during Penal times when the Burren's peasantry held Colmán in higher esteem than today. The lichens are scarce, sensitive species, dun-coloured lungwort (*Lobaria*) and grey *Parmeliella*. They grow vigorously on the willow bark, a testament to the unpolluted air of the sanctuary site. Dog lichens, like bits of grey leather, coarse counterparts of their arboreal relatives, cling to the rocks beneath the trees. Here, too, are the small yellow stars of yellow pimpernel and wood avens.

Off to the left and elevated some metres above the ruined church is St Colmán's cave. Not a true cave, but a remarkably dry one-man recess in the bottom of a pile of huge scree boulders, this cave is reputed to have been the saint's bed for the period of seven years that he lived here at the end of the sixth century. An occasional candle stub inside the cave indicates that the odd brave heart comes here to experience the overnight hardship as the saint once did. Nowadays one must share the dark space with a couple of large *Meta* spiders and their beautiful silk-woven cocoons.

Wood mice clearly like the location: accumulations of end-opened

hazelnuts, sometimes as many as a score together, can be found in winter caches amid the moss at the bases of some of the hazel trees. The characteristic curled droppings of pine martens deposited on one or two prominent rocks near the bullaun stone indicate territorial marking. An overnighting pilgrim would be aware of the squeaks and rustlings of mammalian activity, since the saint's sanctuary is nowadays also a wildlife sanctuary.

Fanore Dunes

The dune system at Fanore, though discrete compared with its spacious counterparts in Donegal and Kerry, is an important floral habitat and the home of plants not found elsewhere in the Burren. Despite being partially given over to a substantial caravan and mobile home resort, the system remains largely undeveloped and unspoiled. The greatest internal threat to its integrity comes, in fact, from rabbits, which undermine and erode many of the sandhills with their tunnelled homes. Externally, it is constantly vulnerable to the erosional potential of storms from the west.

A meander through the dunes in June, away from the excitement of beach revellers, is an exercise in peaceful indulgence. The close-cropped turf near the car park is usually full of cowslips and orchids, particularly the glowingly red-spiked pyramidal species. Others, including the pink spotted orchid and its variant, O'Kelly's orchid, catch the eye amid the marram grass. In the frequent bare patches where sand has been blown away to reveal slabs of limestone bedrock, dense rugs of wild thyme, milkwort and delightful white-flowered eyebright roll out in front. Here, also, the rare parasitic dodder creates red-stemmed matrices of its creeping suckers. Botanical opinion remains undecided as to the provenance of this strange plant. Is it, as was formerly thought, native or could it have been inadvertently

transported to the Burren in association with one of its host plants? In the hollows between the dunes, pink centaury twinkles in the shadows and yellow clusters of lady's bedstraw add a pleasing perfume in the sheltered air. In some of the sandy bowers, the bedstraw is so prolific as to render the air heavy with its scent. Here and there, single plants of yellow wort, immediately recognisable by waxy cup-shaped leaves pierced by the stem and topped by a cluster of bright yellow stars, demand one's attention. With their drought-resistant, water-retentive form, they look perfectly designed to cope with the elemental rigours of their dune habitat. Swathes of yellow-flowered kidney vetch carpet the machair beyond the marram fringe extending towards the car park. On the seaward side, the dunes give way to exposed rocky terraces, and cast-up seaweed, rock samphire and sea spurge grow side by side; rock samphire is a sought-after, delicate culinary treat, while sea spurge is a poison. Attractively flowered pink-and-white sea bindweed, bizarrely beautiful sea holly – grey-green with velvety lilac flower heads – and sea pink, draped over and between boulders, add splendid soft colour to the zone immediately above high tide. With their robust leaf structures, all are especially adapted to life in this unprotected habitat.

High up on exposed south-facing dunes is the habitat of the delightful little sandhill pansy. In other locations elsewhere in the country, this viola occurs both in yellow and blue form, but in the Fanore dune system it is yellow. The other colour phase may occur, but I have never seen it here. They are vulnerable to disturbance; the National Parks and Wildlife Service's prohibition on recreational activity within the Fanore dunes is well founded.

Fanore's nectar-bearing flowers are well served by insects. Squadrons of bees, hoverflies, day-flying moths and butterflies are in constant attention, especially in the windless dune hollows. The red and black six-spot and transparent burnet moths are so abundant in some summers as to draw attention away from the flowers. Common

blue and small heath butterflies are often to be found in conjunction with yellow bird's-foot trefoil, while flutterings of small blues (actually slate-coloured rather than blue) often lead one to patches of kidney vetch, their caterpillar food plant.

Birds are busy in the dunes at this time of the year. Skylarks and meadow pipits seem to take turns at filling the sky overhead with their songs. Their nests, however, are well hidden in sheltered tussocks away from the tracks. Wheatears and stonechats, showy birds in the main, call periodically from the tops of boulders or feed offspring with grubs on the ground. In most years, a pair of ringed plovers nest on the exposed limestone within the dunes, their camouflaged eggs laid

Dune Pansies

casually in a scrape. The newly hatched chicks run the gauntlet of grey crows scavenging along the beach.

This isolated dune system facing out to the broad Atlantic is particularly susceptible to the ravages of the elements. Recent storm damage, which caused large quantities of sand to be cast out over the beach, has been curtailed with restorative work by the National Parks and Wildlife Service. Protective fences have been erected in vulnerable areas and planting of dune-stabilising marram grass has been undertaken as a counter measure. In addition, much of the system has been fenced-off from the public. Since dunes of this nature are mobile habitats, it is questionable if these measures will succeed indefinitely. However, ongoing conservation efforts are undoubtedly worthwhile and deserving of public support for the sake of this enclave's existing botanical richness.

Ballyryan

Ballyryan, at the south-western edge of the Burren, is a remarkable 1,000 hectares (2,470 acres) of unfenced flatland bordered on one side by the sea, on the other by the stepped terraces of the limestone and beyond by the shale outliers of Blake's Mountain. Its surface is a mosaic of ice-scoured, slick limestone pavement, patches of limestone grassland (some of it quite heathy) and moraine – rounded hillocks of glacial sand and gravel. Despite an episode of grant-assisted reclamation in recent times, this strip of moraine, a halting site for a glacier at the end of the Ice Age, retains a fascinating suite of plants redolent of colder climes.

In May, carpets of Arctic/Alpine mountain avens, interspersed with spring gentians, grow almost down to sea level. The delightful lemon-tinted hoary rockrose features patchily throughout the district, its stronghold in Ireland. A rare speciality (which can take some finding)

is the pyramidal bugle. This diminutive, blue-flowered, woolly cone of a plant is unfortunately vulnerable to trampling as it occurs only at Poulsallagh, a favourite stop off for passengers aboard tour buses. Mediterranean plants, including maidenhair fern and dense-flowered orchid, may also be discovered here, though it may be necessary to inspect the tramlines of grikes across the wide limestone clints to find the former.

As one walks back inland away from the influence of the sea spray, one becomes aware of an incredible floral variety. Bird's-foot trefoil and bloody cranesbill create a pervading yellow and pink hue. Though nearly all the common Burren flowers appear to be represented, some seem more locally abundant than elsewhere. Tiny sparkling eyebrights of several species grow in profusion in the close-cropped turf; Irish eyebright with its tiny holly-like leaves is especially notable. Several species of yellow-flowered St John's wort are also to be found, the largest, tutsan, sheltering in the grikes. Common bugle, tall relative of the rare pyramidal species, grows in sheltered nooks. Limestone grasses of many kinds occur, with the fine husk-like heads of quaking grass evident everywhere. The candlestick forms of carline thistles punctuate the flatland like waymarkers. Both ling and bell heather and scrawny tussocks of purple moor grass grow in the more acid patches of heathy ground. In contrast to the veneer of limy earth of much of the region, the acid soil – supporting heath – may well be accumulated loess, wind-blown material deposited after the end of the Ice Age.

Soft herb cushions overgrown by thyme suggest welcome seats for tired walkers, but they are a must to avoid since they are usually the disguised homes of (biting) red ants.

It is clear from its rich biodiversity that Ballyryan and its hinterland is to all intents and purposes unmodified. The species-rich flora has its counterpart in the wealth of insects to be seen. Most noticeable are the day-flying moths and butterflies, but in the still air (away from the

Sheep Gap and Flower Meadow

sound of vehicles) one is aware of the constant hum of bees, hoverflies and grasshoppers. Most are the green and field grasshoppers, but doubtless there are other less common species, too. In places like Ballyryan one is inclined to take bewildering variety as normal; in the intensively cultivated regions of much of the rest of the country, however, such diversity is nothing more than a fond memory.

By late summer the open landscape of Ballyryan takes on a different hue, with the herbs and grasses creating tints of olive and umber. New plants have begun to appear, changing the floral landscape. Their dominant colours are yellow and blue. Dandelion-like mouse-eared hawkweed, tormentil and late lady's bedstraw constitute the yellows, with devil's bit scabious and harebell dominating the blues. Many of the orchids are still on show, including the easily overlooked frog orchid. This is also the place and time to seek out the uniquely

formed autumn lady's tresses (*Spiranthes*). This, the last flowering Burren orchid, is unmistakable, with its spire of tiny white flowers on its single stalk. It grows in profusion, almost at the side of the coast road, but like all orchids it may not emerge, sometimes for years after being originally found. It is nevertheless always worth a stop to look, if passing in late August and September.

Even if *Spiranthes* is nowhere to be seen, there is some compensation in the much more reliable autumn gentian (although a rather coarse understudy of its dazzling spring relative) and one of the finest of the orchid relatives, the dark red helleborine. This beautiful tall plant may take effort to find, favouring the areas of shattered limestone occupied earlier by the burnet rose, but when in full bloom it is definitely worth the exploratory effort. Another late summer plant exclusive to this part of the Burren is an unusual stunted variety of goldenrod. It glows brightly against the grey rock, replacing the yellows of earlier flowering hawkbits and hawkweeds. On the moraine, the mountain avens flower again, though much less prolifically than in May. The singular tufted and twisted seed heads now decorate the banks along the side of the coast road, turning the heads of intrigued visitors on the tour buses.

Flaggy Shore

The road west from Lady Gregory's beautiful summer home of Mount Vernon, with Galway Bay to one side and the karstic terraces of Cnoc an Bhoirnin on the other, is one of the best known and loved of the Burren's many walks. Connemara's southern shoreline frames the scene to the north, with Galway's low-profile suburban development backed by the high silver fence of wind turbines and, beyond, elegant blue mountains – the Maumturks and the Twelve Pins. To the south and west, the smooth upland profiles of Cappanawalla and Moneen

constitute a gentler edge. The eponymous 'flags' of the Flaggy Shore are in fact the distinctive stepped limestone terraces on the seaward side. Their upper surface is a time journal, carrying the multitudinous traces of corals from the Burren's Palaeozoic beginnings and the long-preserved telltales of the more recent Ice Age, in the form of glacial scratches or 'striae'. The Aughinish headland to the east is also of glacial origin – a drumlin. Worn away by thousands of years of erosion by the sea, it continues to deposit its boulder clay core onto the shore below, leaving a series of caves at the high-tide horizon. It's not uncommon for walkers to identify what look like plant fossils in the limestone surface. They are mistaken, however, since the limestone was formed entirely beneath the surface of the sea and though some traces – particularly those of crinoids (otherwise known as stone lilies) – can look like fragmented plant remains, they are simply bits and pieces of the homes of primitive microscopic marine animals.

If one can resist the draw of the distant perspective and the intriguing evidence of past cataclysms, and concentrate instead on the floral border just above high tide, one can delight in the colour and texture of a botanical strip unlike any other in the Burren. Here, a suite of plants with particular salt-resistant characteristics grow in abundance. In early summer, vibrant clumps of thrift dominate the zone, their bright pink flowers decorating the grey limestone in a most pleasing fashion. Photographers and artists stop off here in May to capture this brief display. In places, the thrift is accompanied by startlingly white sprays of bladder campion, set against a seemingly endless border of yellow-flowered sea radish, higher up the shore. This plant, forming a yellow-topped monoculture alongside the road, creates a metre-high bank between walker and the sea throughout the early summer. Scurvy grass, with its tiny cross-shaped clusters of white flowers, cowers in cracks and fissures where even savage winter storms have failed to dislodge it. Other salt-resistant species – starwort, sea spurry, sea beet, sea blite and rock samphire – are more

recognisable by their tough shiny leaves than their insignificant flowers. Sea beet, with its large shiny leaves, is particularly distinctive. Many of these plants are edible. In a salad, with perhaps edible seaweeds and a nice dressing, they are both interesting and nutritious. That is not to say that they should be stripped willy-nilly from their natural repository by culinary exploiters, which is more or less what happened to a once-vibrant colony of purple sea urchins that lined the tidal reach of this shore until the 1970s.

Every year in late April and early May the Flaggy Shore is graced with the temporary appearance of one of the Burren's iconic birds. The whimbrel, having overwintered in the muddy creeks of West Africa, is on its return journey to nest in Iceland. A smaller relative of the well-known curlew, with a similar down-curved beak, its arrival is heralded by its beautiful tremulous whistle, which is every bit as evocative as the plaintive call of the curlew. Tired from their long migration, a flock of a dozen or so will allow close approach, but will fly up from the shore to the grassy terraces if disturbed. Watching the birds at close range through the car window as they forage for sandhoppers in the seaweed then head off north in confident lines, one is treated to an ancient avian passage predating cars and human voyeurs.

The karst on the inland side of the road has an excellent array of the Burren's favourites: milkwort, bloody cranesbill, cat's foot, burnet rose, dog violet and, in season, spring gentian growing right down to the roadside verge. A variety of orchids, including the alluring bee orchid, grow here besides. With some searching, the barbed-leafed madder can be located growing at the bases of some drystone walls. A wild relative of dyer's madder, it was also once used as a substitute to create a dark brown dye for wool. The cracks and crevices of the exposed limestone levels support an extraordinary array of prostrate shrubs such as holly, blackthorn and whitethorn, hazel, spindle and guelder rose. There are also occasional yews and even mature ash trees, their upward growth stunted by the effects of salt spray carried

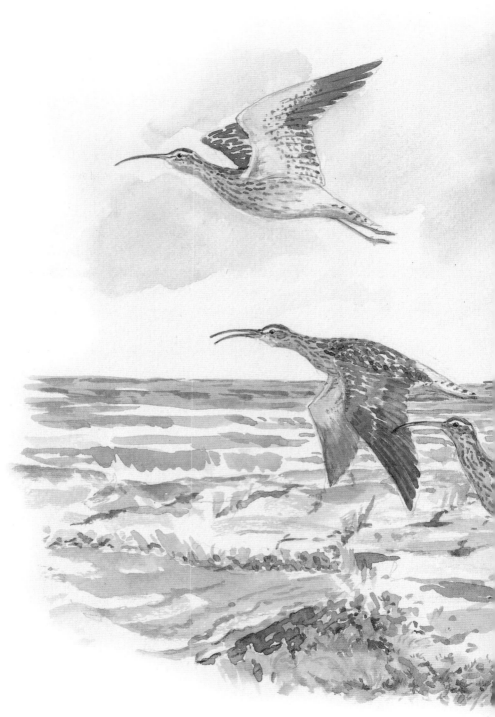

74 The Breathing Burren

on the wind. Some of the yews growing squat and thick have the appearance of planted bonsais.

Lough Murree, the brackish lake immortalised by Seamus Heaney in his poem 'Postscript', is botanically notable for its fringe of saltmarsh sedge, a local plant in the west of Ireland. Unfortunately, due to many years of eutrophic run-off from adjacent farmland and the devastating incursion of seawater from storms, the once rich aquatic ecology of the lake has been greatly reduced. A sub-aquatic lagoon survey, however, has shown that certain unusual stoneworts still survive. The reduction in the number of swans over the years is testament to the reduced availability of lake-floor food plants for these attractive vegetarians.

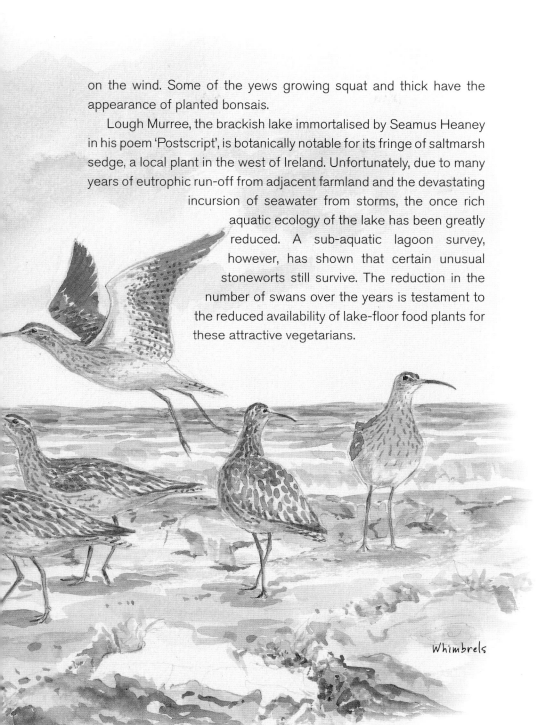

Whimbrels

Found and Lost

It was the Burren botanist Mary Angela Keane who discovered it first, in the spring of 1980. There it grew, a beautiful white-belled anomaly, amid blue moor grass and mountain everlasting. A subsequent rigorous search revealed it to be the only specimen of the narrow-leaved helleborine (*Cephalanthera longifolia*) in the Cooloorta region and apparently the only one in the whole Burren. Year after year, it would reappear exactly where it was first found, flowering in early May and bowing out as the summer progressed.

From the mid 1980s, I checked the locality every spring, usually at the start of May. I could make out its distinctive upright and white-flowered spike from the road and recall well the mixed feeling of delight and disappointment on seeing it. Delight in its singular beauty, disappointment that it was always alone; my hopes that it might one year be accompanied by its progeny – even one other plant – assuring survival into the future, were never realised. Then, in the year

Narrow-leaved
Helleborine

2000, quite without warning, it refused to appear. It was as though a higher power had made a decision to withdraw it. It had done its bit in enhancing the barren landscape: it had heralded in the new National Park; now it was a case of 'farewell and good luck'. On the threshold of the new millennium, a successor would have to be found to carry on the tradition of beauty icon for the place. Despite regular checking, *Cephalanthera longifolia* has not been seen since.

That this relative of the orchids should find a home in an area of open limestone heath in the first place was out of character, it being normally a plant of damp, scrubby woods. Its nearest station to the Burren is in just such a habitat in Woodford, south-east Galway, and it is found in similar situations in its handful of sites elsewhere in Ireland. Rare, therefore, in Ireland, it is scarce or local throughout Britain and is absent from a good part of Western Europe.

How did it come to be in one of the most exposed places in the west of Ireland? While helleborine seeds (and those of orchids in general) are tiny and travel easily on the wind, why did one alone germinate in the south-east corner of the region, in far from typical circumstances? Perhaps there are others as yet to be discovered. The Burren is a big place and no doubt there are other rarely visited suitable habitats yet to be checked. According to *Flora of Connemara and the Burren* (by D. A. Webb and M. J. P. Scannell, 1983), there is an old record from 'Hilly woods near Ballyvaughan, 1912'. New stations of other showy plants, like the bright yellow Welsh poppy *Meconopsis*, a rare survivor from colder times, have been discovered in the region in recent years. Nevertheless, given the assiduous annual searching by orchid seekers, the discovery of another *Cephalanthera longifolia* location seems unlikely. Another possible explanation for its isolation is that the habitat has changed (or been changed), causing the once widespread plant to have declined to the point of extinction. There may indeed have been extensive orchid-supporting hazel scrub in the Cooloorta valley in the distant past, but not in recent centuries. Hazel and other scrub species would have been at a premium, for instance, for cabin construction and fuel by the poverty-stricken unfortunates who lived here and worked on Rockforest's relief road during the mid nineteenth-century Famine. Decline of the plant, therefore, due to habitat destruction, seems highly unlikely. We can similarly dismiss the suggestion that the plant was deliberately (or even accidentally) planted by human hand since

helleborines are not easily transplanted and would not have been so to such a remote locality.

Botanical rarities are frequently tiny unobtrusive 'excuses' for plants, their specialness suggested by their geographical remove alone. Not so *Cephalanthera longifolia*. This plant's specialness lies both in its rarity and in its classical beauty. Like others of the family, it is tall – up to 30 cm (12 inches) in height – and upright. The stem is slightly 'off-straight', following a series of subtle directional changes along its length. The pointed spear-like leaves (which give it its name) emerge at each of these 'wobbles'. The white flowers are flask- or bulb-shaped with point-ended petals. Even when fully open, the flowers retain their bulbous shape but reveal yellow pollen-laden anthers within. The flower cluster is 'open plan' compared with the dense cluster of most other Burren orchids, but is similar in arrangement to the other Irish species – the dark-red, green-flowered, broad-leaved and marsh helleborines. All display structural elegance. As with others of the Orchidaceae, people argue over their favourite based on aspects of colour or form; my favourite is the marsh helleborine, *Epipactis palustris,* which lights up its sombre habitat of rush and sedge with flowers of bright but subtle pastel shades. All pale in significance, however, in comparison to the stunning red helleborine *Cephalanthera rubra* (a continental species unfortunately not found in Ireland), which would win any floral beauty contest.

Despite the constant disappointment, the search for *Cephalanthera longifolia* continues. With the reinvasion of hazel scrub, now covering hundreds of hectares of agriculturally abandoned Burren land, it is not beyond the bounds of possibility that one day it will return to find sanctuary in typical habitat, more suitable to its survival. It will certainly come as a treat to whomever discovers it, as it undoubtedly was to its original finder.

Lost and Found

'So this is what all the hoo-ha is about.' I knelt on the smooth limestone surface to get a better look at the tiny white-flowered plant, growing feebly from the damp solution hollow.

'That's it!' replied botanist Cilian Roden, '*Arenaria norvegica*,' as if its Latin name suggested some academic significance that was visually lacking.

From my reverential position I scanned the immediate landscape. Here we were, high up on the north-west corner of the Burren overlooking the Atlantic, surrounded by massive slabs of limestone pavement. Deep fissures, sharp-edged as if formed by an enormous pie-cutter, led off at angles towards the horizon. Here and there, shallow dish-shaped hollows, the product of centuries of erosion and solution, peppered the rock surface close to a tiny water source. It was in one of these that our plant grew. The only other visible vegetation, a tussocky bank of hardy grass and small colourful flowers, delineated

the view where the land rose in a series of pronounced terraces. Each of these giant steps, a tome of sedimentary bedding planes, spoke of the Burren's geological history, from marine mud to rock – millions of years of deposition, induration and uplift. A more recent chapter, the Ice Age, declared itself in the graceful sweeping curve of the upland profile. The limestone surface beneath my knees represented an ongoing erosional narrative. Year by year, chemical solution – rain on lime – had defoliated the otherwise stubborn surface, carrying the story inexorably back in time.

The tiny white flower grew utterly alone, its scale accentuated by a pair of enormous crumbling boulders on either side: glacial bookends.

A shout from Cilian told me that he had found another flower – and another, not far away.

Suddenly I became aware of the true significance of this vegetative snippet.

Originally a titbit of wind-blown detritus deposited by a glacial breeze on what was then bare tundra, this Arctic sandwort, one of a small colony, established itself and continued to grow here as it had done for 10,000 years. It had presided over the steady disintegration of its neighbouring glacial megaliths, static victims to alternate periods of cold, warmth and increasing wetness. It would have witnessed peregrinations of reindeer and Irish elk, perhaps even been trampled by their hooves, but rebounded and reseeded year after year, to outlive its animal contemporaries by an age. It may have been nibbled by hares, survivors of the cold seeking winter sustenance, but revived and regenerated, regardless. It might have witnessed the arrival of the first men, in hide boats, and later their all-devouring goats. This little vegetative fragment had seen and survived it all.

The Arctic sandwort is one of an elite group of plants – the 'cold suite' – for which the Burren is famous. It includes a number of iconic, colourful species, such as the spring gentian, mountain avens and Welsh poppy, and a couple of delightful saxifrages, among others.

Often referred to as Arctic plants (though one or two are decidedly Alpine rather than Arctic), they are Ice Age relics and highly interesting as such. They are often contrasted to the southern 'warm suite', such as orchids, for which the Burren is equally renowned. The bizarre juxtaposition of both groups in the strange un-Irish landscape of the Burren is one of the great attractions for flower-lovers everywhere. People come in droves each year to see the shining limestone further illuminated with this disparate flora, and to experience the uplifting spectacle it presents.

Despite being synonymous with the region, many of these Arctic/Alpine plants are found outside the Burren, in remote stations on mountaintops and cliffs elsewhere in the north and west of Ireland. However, they grow in such profusion in north Clare as to be regarded as 'Burren specialities'. Not that all of them are found in the region. A few are strangely absent and one, the purple saxifrage, a quintessential Arctic/Alpine plant (known from pollen evidence to have been a Burren inhabitant during the Ice Age), is not found there now.

What distinguishes the Arctic sandwort from the others is that when it was discovered it was not known elsewhere in Ireland. Since it was first discovered by a trio of British botanists in 1961, it was not

Arctic Sandwort

re-found subsequently, and was declared extinct – considered by some to have reached the end of its thread of survival, hastened there, perhaps, by the onset of climate change. Its apparent disappearance spawned a series of questions. Why should it have been confined to just one site – here in the Burren? What happened to it elsewhere? Surely, as in the case of the other 'cold' plants, it must have grown widely at one stage. Could the Arctic sandwort still survive in other suitable localities and just not have been discovered there yet? Its sheer inconspicuousness strongly suggests that this could well be the case. (It has since been found on precipitous cliffs on Benbulben Mountain in Sligo.)

The story has been compared to that of the inconspicuous mountain ringlet butterfly, discovered on a couple of Mayo mountains in the nineteenth century, but not seen since 1901. Still found in the English Lake District and the Scottish Highlands (as is the Arctic sandwort), it is the only Alpine butterfly in these islands. Was its disappearance yet another indicator of climate change? Or is it yet fluttering unseen in high summer on some remote heathery mountain in the west of Ireland?

The rediscovery of the Arctic sandwort in the Burren by a visiting botanist in spring 2008 sent shockwaves through Ireland's botanical circles. Barely had a spring passed in recent years without someone looking for the elusive plant, a search being an essential part of the Burren itinerary for visiting flower-hunters. The vagueness of the description of its location in botanical references – 'at an altitude of *c.* 800 feet on the south side of Gleninagh Mountain overlooking Caher lower' – did not help. Though D. A. Webb, in *Flora of Connemara and the Burren* (1983), did discuss the possibility of confusion of Gleninagh with Carnsefin, another name for this particular upland, there remained a certain vagueness as to its site.

The plant appears, in fact, to have been relocated within shouting distance of the original site – on the shoulder of Murroughkilly Mountain, close to the old Black Head road (or track), frequented by

all sorts, including botanists. Doubtless it has been there all along. The fact that it had remained unnoticed for so long is undoubtedly more to do with looks than locality: besides being incredibly small, it closely resembles a well-known and common Burren plant, the spring sandwort. In fact, so close is the likeness that it took some time for Cilian to assure me that I was scrutinising the correct plant.

'Look at the leaves. They are lobed – not pointed – as in *Minuartia* and the calyx is smaller with more distinct bracts than in *verna*.'

This, of course, was 'botany-speak': I tend to rely on visuals rather than verbals when it comes to new species. However, after my period of knee-grinding discomfort, paying homage to this minuscule item of Burren greenery, I felt I had at last become familiar enough with it to be able to identify it again. I had found (or been shown) something special, an insignificant growing thing with an illustrious pedigree, a returnee from a bygone time, a new sentence to be included in the story of the Burren.

There is something about rediscovery in nature that registers deeply, whether on a dramatic, international scale, like the sensational re-sighting of the Eskimo curlew, long declared gone from its transcontinental migration route, or the re-finding of a demure plant like the Arctic sandwort.

Despite the oft-reported decline of species and disintegration of our fragile environment due to man's lack of concern, nature's resilience does sometimes win out.

'Nor Earth Enough to Bury Them ...'

'Not water enough to drown a man, wood enough to hang one, nor earth enough to bury them ...'

Whatever about the sinister connotations of this seventeenth-century observation (attributed to Cromwell's Lieutenant Ludlow), the Burren's scarce soil has been the subject of scientific debate for as long as it has been connected with its riotous plant life. Since the majority of the plants are 'lime-loving' (calcicoles) and the parent rock is Carboniferous limestone, it would follow that the soils – exotically named rendzinas – derive mainly from the breakdown of the weathered rock and associated glacial drift. The principal soils of south Galway and north Clare are, according to the world soil map, 'dry, mineral, shallow brown earths' – in scientific parlance, 'Calcio-eutric Cambisols' – including but not entirely composed of rendzinas. Modern field investigation, however, has shown that the Burren's soils are not as uniform as was formerly thought.

Soil Core Sample

The fact that many acid-tolerant plants (calcifuges) also comprise a substantial element of the flora has been put down to the existence of eroded silicon from layers of chert and sandstone within the limestone. For many years botanists and other scientists seemed happy with this explanation. Stephen Mills, for instance, in his excellent *Nature in its Place* (1987), alludes to this scenario in describing the mix. Revisionist probing in the mid 1990s, however, pointed to a more complex explanation. Microscopic examination of soil particles accumulated in the wider Burren region indicated the prevalence of an aeolian (wind-deposited) soil, known as loess, deposited during

the tundra conditions towards the end of the Ice Age perhaps 13,000 years ago. Loess particles are immediately recognisable by their micro-fractured surfaces, the consequence of erosion due to frost shattering and incessant collision with others in airborne transportation. Parent rock suspects are Connemara granite and Old Red Sandstone from east Galway. No doubt surface outcrops of Namurian shale within the Burren, eroded by severe late glacial freezing and thawing, also contributed low-pH soils to the overall soil cover.

While the presence of loess was detected by a number of investigators, it was the aptly named Moles brothers whose field 'burrowings' and detailed laboratory investigations brought it to widespread notice. Their findings revealed finely textured, quartz-dominated soil of base-poor particles – in essence, a silt loam. Further field study revealed the widespread existence of this recognisable tan or red-brown material in pockets or wedged in the angles of escarpments throughout the Burren.

Professor David Jeffrey (one of my Environmental Science lecturers at Trinity in the early 1980s) put the Burren's loess in a wider context, using it to explain the paradoxical plant associations of calcicole and calcifuge plants outside Ireland. He described comparative situations in the south of England and around Teesdale where associative plant distributions on loess soils, resembling those of the Burren, are also known. The strange juxtaposition of, for instance, squinancywort and quaking grass (lime-lovers) with ling heather and tormentil (generally lime-shunners) makes sense in the context of scattered pockets of loess soil. His consideration is that the aeolian deposits of the Burren can be sourced to the Connemara granites north of Galway Bay.

Studies carried out under the Burren Life agri-conservation project on the region's uplands indicated a range of acidity in the sampled soils. Thin heathland soils with low pH values indicated long-term leaching of the uplands. Besides the usual heathland suite of 'woody' species, blue moor grass, squinancywort and wild thyme typified

these areas. Thicker pockets of acidic soils on the Burren's lowlands, also with distinctive flora, may have a mixed pedogenesis due to the original deposition and subsequent accumulation of hillwash material.

Dr Peter Vincent, lecturer in geography at the University of Lancaster, brought a biogeographical perspective, setting Ireland's soils and its flora and fauna in the wider context of Europe's north-western archipelago, the British Isles. At the end of his 1995 tour sampling soils in the greater Burren region, he confirmed the widespread presence of loess, finding the karst of the eastern Burren extensively covered with a thin layer of soil derived from the windborne material. He retained the belief that most of the mineral soil was limestone-derived rendzina, in contrast to Jeffrey's belief that rendzina or limestone-derived soil was in fact 'rare' in the Burren. Further work carried out by the Moles brothers since the turn of the millennium has shown that the soils in the National Park of the south-east Burren are varied and irregularly located. Here, discrete pockets of granitic till and weathered shale (perhaps from erratics), the consequence of apparently separate glacial episodes, occur on the Lower Carboniferous karst. Loess soils were located in scattered deposits in the upland karst. It is becoming clear that the scouring and depositional characteristics of successive glacial advances have left us with a puzzling soil mosaic that even the experts find difficult to interpret. The 'soil question' is ongoing.

When secondary school teacher and scientist Michael O'Connell pointed out a strange soil layer below the glacial layer but above the bedrock on Inis Oírr, another quandary emerged. Its location above the weather rock but below glacial deposits placed it firmly in the Tertiary, the period before the Ice Age, and dated it to perhaps two million years ago. A band of this red mineral soil close to Loch Mór provided a clear view of the profile. What was the nature of this deposit? Was it (as seemed unlikely) an accumulation of waterborne Old Red Sandstone particles or a pre-glacial loess? Was its redness

a consequence of the searing desert-like conditions known to have existed in the Tertiary, conditions that can be imagined in present-day Death Valley? Was it, as its fine, even-textured grains suggest, a product of the convulsive volcanic activity also known to have marked the Tertiary? Further analysis will undoubtedly be required to clarify this mystery.

A geological anomaly located in Aillwee Cave added another layer to the soils enigma. On the side of the cave wall, a thin seam of brown clay is detectable. It runs roughly parallel (horizontal) to the floor of the natural, water-created, phreatic tunnel along which one walks in penetrating the cave. How can such a layer exist within the body of solid rock? Is this deposition the consequence of clay seeping into a bedding plane in the rock from the surface? Could it be connected to volcanic activity in the Tertiary period? Or is there some other explanation? The layer, we learned, is a 'wayboard' (a Yorkshire quarrying term familiar to Dr Vincent), manifest as a geological anomaly formed by volcanic activity in the Carboniferous period at the time of the formation of the rock itself. This 2-cm (0.8-inch) layer is comprised of volcanic dust, accumulating uninterrupted over thousands, perhaps millions, of years. Subsequent geological quiescence, permitting the accumulation of more calcareous sediment (later to become new layers of limestone) sealed the wayboard in situ. At least seven of these clay layers have been detected in the body of the limestone, testament to successive episodes of volcanic activity over the long history of the Carboniferous.

The story of the disappearance of the Burren's surface soils coincides with more recent history in the region. We know from the augered core samples in various locations that soil was generally thicker and supported many tree species in the early postglacial Holocene. Some of the many glacial erratics, perched now on rock pedestals, testify to the disappearance of both soil and rock – eroded by thousands of years of exposure to the elements. A benchmark

of change is evident as a discrete soil layer beneath the Neolithic mound walls excavated by the archaeologist Carleton Jones in the 1990s. Here is unambiguous evidence of a higher, less fretted limestone landscape covered perhaps completely by a thin veneer of soil. Further evidence for the former existence of a thin surface soil layer came in a series of clever investigations by Emma Plunkett-Dillon. A change in cross-section from a U to a V shape with depth of a fretted limestone (Karren) surface was seen to be the result of variation in the rate of solution, initially due to the existence and later to the disappearance of soil cover. Interestingly, she also concluded that the original soil had been predominantly acid and therefore probably more loess or shale derived rather than a product of the limestone itself.

Centuries of woodland clearance and concentrated livestock grazing, probably mostly by herds of goats, have denuded the region of vegetation and subsequently of soil. The numerous overgrown outlines of booley huts and enclosures on the upper plateau point to organised winter herding of cattle in prehistoric times. While this practice continues today, it does so on the basis of the careful conservation of the upland grazing, a less critical factor, no doubt, in Neolithic times. Archaeological investigation points to the over-exploitation of the upland grasslands, leading to widespread soil loss in the Bronze Age. Most allusions to the upland landscape from earliest historic references speak of the Burren's barrenness. Indeed, its Gaelic name, *An Boireann*, presumably a thousand or more years old, confirms this. Was it due to the inability to 'put manners' on the region's uncooperative inhabitants and modernise their methods that gave rise to Ludlow's chilling seventeenth-century comment?

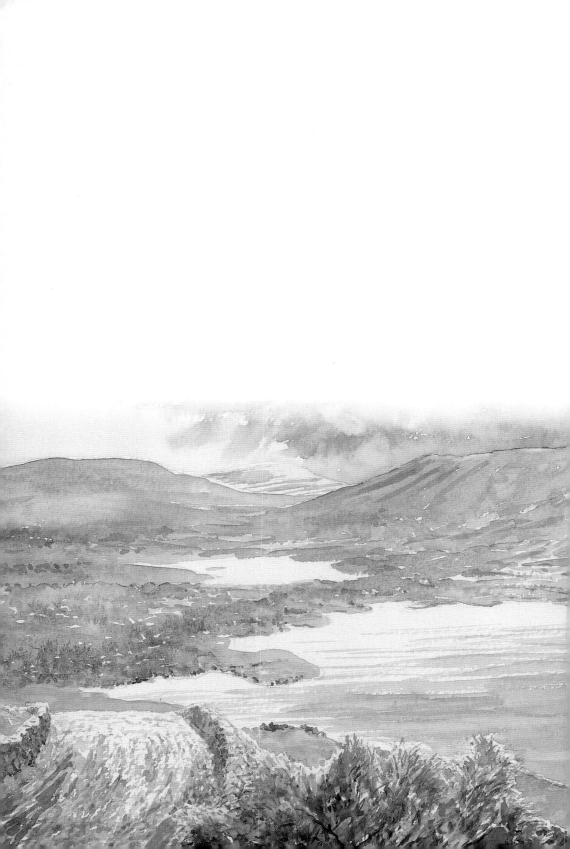

3

Walking and Stalking

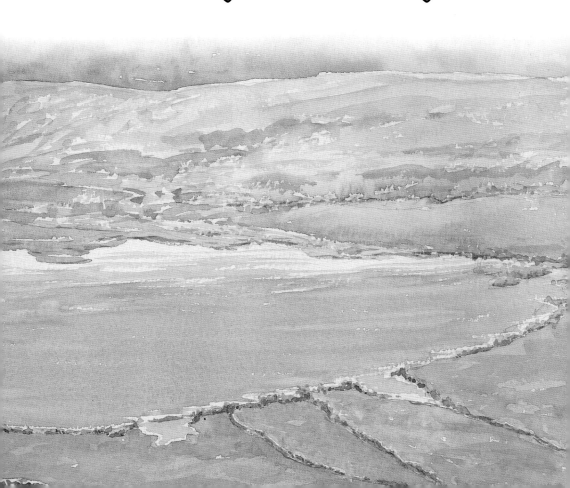

The Caher River

A Burren river? Impossible. Everyone knows that the water flows *into* the Burren's super-soluble limestone, not *across* it. The turloughs, those ephemeral lakes on the Burren's surface, lose their waters underground, transporting them patiently through cave systems and water-worn channels to the sea. Low tide at Kinvara reveals rivers of fresh water, some from 5 or 6 km (3 or 4 miles) inland, issuing out beneath the main road at Dunguaire Castle and near the quay. There are small overland stretches, like the braided channel of the turlough in the Carron basin (also known as the Castletown River) and short-lived 'issuings' on hillsides after heavy rain, but in general flowing surface water is a rarity.

So how do we explain the Caher, which *rises* from a 'swallet' within the shadow of Slieve Elva, close to a series of water-formed caves and underground channels, and flows overland north and north-west for 7 km (4 miles) before discharging into the sea at Fanore beach?

Should it not also disappear shyly from view or perhaps show itself only as a series of intermittent upwellings in times of heavy rainfall? Clearly the Caher is prevented from going underground by a non-porous layer. But what could it be, given that the Burren's limestone is geologically remarkably consistent and prone to solubility under the slight acidity of rain?

The occasional layers of compressed clay, within the limestone, from volcanic episodes during the Carboniferous era, are impervious. Seepage along the upper edge of one of these layers can be seen underground in Aillwee Cave. The horizontally bedded limestone is also regularly interrupted by layers of chert. Where this hard black material, much sought-after by Stone Age man for weapons, lies in thin slabs, water is prevented from penetrating deeper into the rock. There are also occasional sandstone layers in the rock which, like chert, being mainly siliceous (and therefore insoluble), tend to impede water penetration. Water issuing from cliffs and escarpments often does so due to penetration being blocked by one or other of these layers. After heavy rain, the north face of Gleninagh Mountain near Black Head streams with a series of mini-waterfalls from the edge of one such layer.

It is difficult to say which of these irregularities is responsible for the Caher's overland course: it may be a combination of all, or perhaps something else entirely.

The upper half of the river, where it trickles along, bisecting the broad valley, bubbling over its rocky bed beneath the road and meandering through wide soggy flatland, is typical of streams anywhere. The latter section, where it flexes its muscles and rollicks steeply downhill towards the sea, reveals something of the river's origins and a possible reason for its surface flow. The Caher flows down a deep V-shaped cut, which, over millennia, it has excavated itself. This notch-shaped outlet is described geologically as a 'spillway', having been created by the force of glacial meltwater from

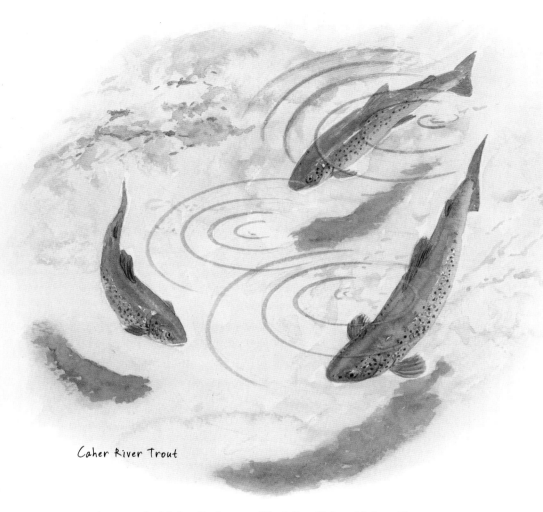

Caher River Trout

an impounded lake that once filled the Caher Valley. The pressure of the head of water, undermining and destabilising the interface between boulder clay and rock face, ultimately won out, triggering a dam burst. It is likely that the subsequent erosional gouging continued for hundreds of years for it to have rendered the defile as deeply cut as it is today. The relict stream, grandiosely referred to as the Caher River, is nowadays really no more than a rill. There are times, during periods of protracted winter storms, however, when it reverts to a dangerous, raging torrent, reminding us of its turbulent origins.

Great humps of tan-coloured water crash against the boulder clay banks, wrenching out new boulders, tipping up and barging others against one another, and seizing angrily at the roadside, threatening it with its surges. The Caher at these times offers the viewer one of the Burren's most exhilarating sights. One such event put paid to a rare station of the rather unassuming gromwell plant, on a tiny gravel island in the Caher river, shown to me by the late Hugh O'Donnell.

We gain something of a glimpse of the ancient vegetation of the Caher catchment thanks to the meticulous investigation of plant pollen found on the shale outlier at Lislarheenmore (*Lios Lairthín Mór*), at the head of the valley, by Professor Michael O'Connell and colleagues in the 1990s. Though the record goes back no further than the Bronze Age, it creates a picture of wild heathy uplands containing heathers, bog myrtle, bearberry, crowberry and hardy woody species such as juniper. Juniper in its prostrate form is still widespread in the valley today. Pollen from Scots pine posits a thinly wooded upland scenario, one that was easily cleared by early farmers in the establishment of their settlements. The pollen of plantain and ruderals associated with small-scale crop production on both sides of the prehistoric-historic divide testify to the community's capacity to eke out a living, keeping the wilderness at bay. Wolves, foxes, brown bears and wild cats, and perhaps lynx, would have been constant threats to such subsistence livelihood. One of the minor predators to have survived down to the present – the pine marten – is still an inhabitant of the valley. An abandoned cottage at the river's edge once hosted a family of pine martens, which entered and exited through the chimney. Their engaging exploits were famously recorded by wildlife film-maker Eamon de Buitlear. The garden of the same cottage (now occupied) has been dedicatedly transformed, by way of a clever minor diversion of the water flow, into a miniature Botanic Gardens (without the glasshouses). Green spraint mounds, adjacent to the nearby bridge, show that the river's otters are not put out by the attractive creation.

A stop at the bridge for an admiring look is *de rigeur* for Caher Valley walkers.

That the river supports otters, dippers and an abundant trout population indicates rich biodiversity and largely unpolluted conditions. There are nevertheless one or two spots, where cattle are watered, or where minor nutrient run-off occurs, where the water quality is undoubtedly compromised. This is especially acute and unfortunate in summer low-flow, but an examination of the invertebrate life, with its abundant caddis fly larvae, freshwater shrimps and water beetles, shows that, despite this, the river is holding up well.

A stroll along the Caher's length on a sunny morning in spring is a joy. The river valley, so ecologically dense, is a distillation of the region's natural richness. One moves from the orchid-rich grassland and dunes by the outfall steadily up and into the narrow water-cut defile, with its natural rock garden of gentian and avens and cliff-nesting ravens, and eventually out into the wide scrubby river holm. Here a dozen songbirds can be heard at one time, their melodies concentrated by surrounding higher ground. This is one of the best, most reliable locations to hear a cuckoo in the whole Burren. Shafts of sunlight pick out primrose, wild garlic, violets and other spots of colour amid the mossy ground below the hazel scrub. The arboreal community includes most of the Burren native trees, including several stands of aspen, their quivering leaves audible in the slight breeze.

The late John MacNamara (John Mac, as he was affectionately known) established the Caher Valley Nature Reserve in the early 1990s. His wish was for the valley to remain essentially undeveloped – to be given over to its wildlife. Unfortunately, he did not live to see his vision through to fruition, though the designated reserve area remains undeveloped and unspoiled today. It supports a rich representative array of the Burren's flora and fauna. Perhaps the most famous of the valley inhabitants was the inimitable John O'Donohue. Brought up in a small farmhouse in the heart of the valley, overlooking

the stream, John achieved much in his short life. A Catholic priest, philosopher, poet, writer of international bestselling books – most notably *Anam Cara* – John was also a lover of nature. Much of his poetry derived from the Burren's elemental components and natural inhabitants. His 'From Darkness to Light' Easter morning ecumenical Mass in the ruins of Corcomroe Abbey, which ran throughout the 1990s, is a cherished memory for those who were lucky enough to have attended. One wonders how much John's brave, nonconformist attitudes were shaped by voices echoing down the ages from the ruins of Penal chapels and deserted villages, and the resilient nature of the Caher Valley.

Though the Caher (as the word suggests) has been a human habitat at least since early historic times, it retains a serene integrity, a product of its topography, its wildlife and its thinly scattered farming population. It stands as one of the best examples of balanced heritage in the Burren. Were holiday homes or the infrastructure of recreation-orientated facilities to invade the valley, there is little doubt that the delicate balance of the riparian ecology would suffer. The overground flow of the Caher carries a plea for the otherwise hidden waters of the entire Burren – an imperative to be treated with sensitivity.

Turlough Traipsing

Unless they arrive particularly late in the year or during an unseasonally wet summer, visitors are invariably unaware of the existence of one of the Burren's famous landscape features – the turlough. This is entirely understandable, given the dry, settled look of the low valleys and hollows, grazed peacefully by cattle and horses throughout the summer. The clue to the turlough in its watery form, however, is in the clear demarcation between the grassy sward and the surrounding scrub, with the interface – the winter floodline – marked by a blackish moss horizon on stone walls and trees. From above, the turlough hollow resembles a comfortable green basin, the blackish rim like a dirty stain, left behind after the water has gone. The turlough moss *Cinclidotus* marks the normal flood limit, though in many years it is exceeded, sometimes dramatically. A drive around the region in summer, identifying the *Cinclidotus* horizon, conveys just what a watery place it is in winter. Nor are these ephemeral lakes, created

originally by the scouring action of glaciers towards the end of the last Ice Age, confined to north Clare: the lowlands of south Galway (part of the greater Burren) are pock-marked with them. They are, in fact, a feature of the limestone wherever it exists on or near the surface throughout a considerable part of the west of Ireland: they are found, for instance, throughout central Galway, in Mayo, Roscommon, Limerick and Sligo. There is even a vanishing lake in the exposed chalk of County Antrim (though it is not referred to as a turlough). The dozen or so in the Burren are among the best examples in the country due to their relatively pristine state, having been, to a large extent, unaltered by drainage. Crucial to natural functioning of a turlough is its vertical hydrology, its water table rising and falling through swallow holes connecting the basin with the fluctuating groundwater table.

Unfortunately, most of the turloughs were lost as functioning entities following two periods of wetland drainage, under the 1842 and 1945 Arterial Drainage Acts. My own Trinity College thesis concerned the disappearance of more than a thousand hectares of connected turloughs, known to have existed to the south of Tuam. Out of a complex of seven, including Turlough Mór, once the largest in the country, only one remains relatively unaltered. Today, Rahasane, near Craughwell, Ireland's largest, continues doggedly to function despite repeated attempts to drain it. All in all, hardly a hundred of these once ubiquitous water bodies remain.

An outing with Micheline Sheehy-Skeffington (turlough expert and plant ecologist) to a cluster of small turloughs, including Ballinastaig and Caherglassaun near the Burren's eastern fringe, in April 1997, was a memorable excursion. The trip, with three other enthusiasts, was well timed; the day was fine and thanks to a dry early part of the year, we were able to wander among the turlough basins without fear of getting our feet wet. Entering Ballinastaig from the west, we made our way across the sward-covered hollow, growing thick and luxuriant now due to the beneficence of lengthening bright days and a winter endowment

of naturally deposited calcium-rich fertiliser, by way of the swallow hole. Our leader explained that the sward is actually rather species-poor; the flora comprises only about two dozen species, mostly grasses, sedges, mosses and the like. Well-known open-ground plants like silverweed and creeping buttercup abound. A few, however – mudwort, a type of cress, a species of dandelion and one or two others – are rare and could be described as turlough specialities. Though we came across several species of viola, including the tiny heath dog violet, which was growing in thousands amid the sward, we missed out on one of the turlough's iconic plants, the fen or turlough violet. We were too early for this delightful pale violet 'mini-flower', immediately recognisable by its narrow leaves, which grows at the lowest level within the turlough, often near a swallow hole. Other flowers on show included the pink spikes of amphibious bistort, a kind of pondweed able to adapt to the fluctuating water table. As we approached a swallow hole, we were able to see that it was draped around its edge with what appeared to be white linen. This we were told was algal 'felt', *Oedogonium*, which grows spontaneously in the basin and is a consistent feature of turloughs. It starts life green but, on being bleached by the sun, dries out to look like cloth.

Since the discovery of the fairy shrimp *Tanymastix* in Irish turloughs in the 1970s, much research has been concentrated on turlough invertebrates. A suite of unusual beetles, adapted to the unpredictable water level, has been identified. These habitually follow the retreating water table towards the swallow holes, scavenging on detritus as they go. We noticed myriad ground beetles, various tiny bugs and extraordinary numbers of wolf spiders, all cashing in on the fecundity of the drying terrain. One of Ireland's scarcest butterflies, the brown hairstreak (a Burren speciality) is associated with the blackthorn fringe around turloughs. We would be required to return in autumn, however, if we were to encounter this distinctive brown and orange beauty on the wing.

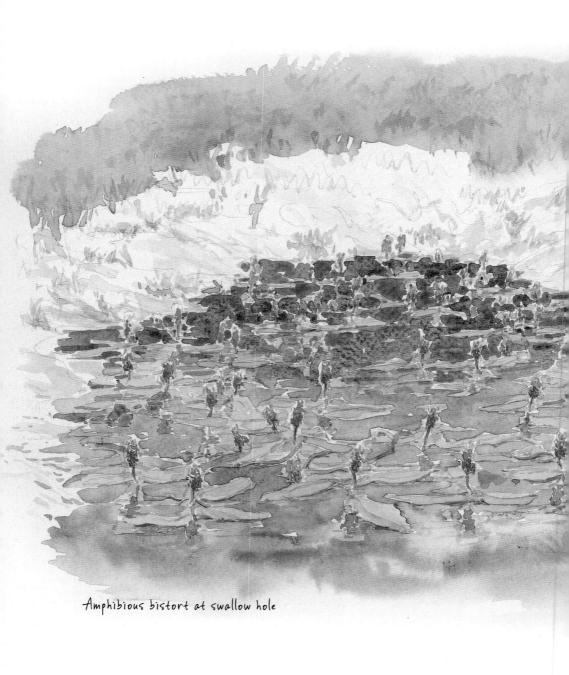

Amphibious bistort at swallow hole

A muddy area next to the swallow hole was replete with *Lymnaea* (pond) snails. These creatures, distinctive with their pointed-ended translucent shells, are by no means confined to turloughs; they are a feature also of limestone lakes such as Lough Bunny. They provide an important service to the hydraulic functioning of these water bodies by grazing algae and moss from the bed, thus helping water flow and the release of nutrients into the system.

As we retreated from Ballinastaig turlough basin, Mich pointed out the zoned change from the heavy dark-green *Fontinalis* moss to the blacker *Cinclidotus* higher up. This change reflected a primary characteristic of turloughs, the zoning of its flora and fauna. It is the freshwater counterpart of intertidal zoning, where seaweeds (algae), lichens, winkles and other shellfish occupy different shore levels, depending on their capacity to cope with twice-daily exposure to the air.

Turloughs are understandably devoid of most fish. With the absence of inflowing and outflowing surface streams, which would otherwise act as conduits for coarse fish and salmonids, fish life is normally confined to sticklebacks and eels. These can travel virtually anywhere there is water, including along underground streams and up through flooded swallow holes.

Unable to attain the middle of Caherglassaun, we had to make do with walking around its periphery towards the imposing O'Shaughnessy tower house. There are no less than ten swallow holes in Caherglassaun. Their individual Irish names, collected by local man Eugene Keane, hint at what life was like in Gaelic times and what the turlough was used for. *Poilín na nÉisc*, the little hole of the fish (presumably eels); *Poll an Níocháin* was where women washed clothes; *Poll na gCaorach*, where sheep were washed prior to shearing; *Poll Lair*, a spring well, presumably the local water supply; *Poll Luibhean*, where healing herbs were found; *Poll na Dealga*, around which bushes and thorns were found; *Poll an Mhadra*, where dogs were apparently drowned; *Poll Laoi*, where lays or narrative poems were recited; *Poll an Chailligh*, hag hole; and *Poll na bPéist*, the home of a huge worm or a snake. This last may have been the mythical home of a large eel and may have been named thus to keep children away from it. The pre-Famine Ordnance Survey map shows the location of several eel weirs close to the turlough's swallow holes, used to trap them for food. I have seen the metal tridents that were once used to catch them in the swallow holes in Ballinderreen turlough; at one time eel was a much sought-after food supplement to the monotonous fare of potatoes.

It is for birds – waterfowl and waders – that turloughs are most important, especially in winter. Rahasane, when shallowly flooded in winter, may host up to 10,000 wetland birds. Even 60-hectare (148-acre) Belclare turlough near Tuam regularly supports a thousand. While wigeon (often in thousands) comprise the majority of the waterfowl, mallard, teal and shoveler may occur in hundreds. The dominant wading birds (also in thousands) are golden plover and lapwing, with lesser numbers of curlew, redshank, snipe and dunlins. The great bulk of these birds come as winter visitors from Iceland, though many come also from northern Britain and Scandinavia. The spectacle of such enormous flocks is one of the greatest bird

sights to be had in Ireland. They winter here, of course, not to delight men's eyes, but for food. The saturated grass of the turlough fringe is relished by wild swans and white-fronted geese, while the 'soup' of freshwater shrimps, other invertebrates and abundant weed seeds is eagerly sought by ducks and waders. Sadly, with the drainage of many turloughs, the rare white-fronted goose has all but abandoned its former traditional winter habitats of bog and turlough for the safe man-made haven of the Wexford slobland. The last flock in the Burren (now gone, probably due to shooting) used to frequent Carron turlough – the largest in the Burren – and feed in a hidden meadow in the uplands alongside the winterage cattle.

Caherglassaun turlough has a remarkable hydrology: though almost 5 km (3 miles) from the sea in Galway Bay, its surface, in winter, rises and falls with the tide. It does this due to the pulsing of tidal pressure against the underground outflow at Kinvara. The turlough water remains fresh, however, due to the force of its outfall, preventing mixing. Caherglassaun's capacity to flood alarmingly is well documented. Though merely 4 m (13 feet) above mean sea level at its swallow holes, its water level has, during episodes of protracted winter rainfall, risen by up to 10 m (33 feet), cutting off roads, isolating livestock on islands of pasture and even flooding houses. This occurred in late winter 1991, 1995, 2009 and 2015. Nor is the flooding local. The entire region of *Hy Fiachra Aidhne*, particularly around Gort, is often the worst hit. In the Burren proper, the turloughs regularly overflow, resulting in long periods of hardship, particularly for those tending valley herds. The well-named village of Turlough, south of Bell Harbour, is among those to have been regularly affected, and the Ballyvaughan Valley, hemmed in as it is by surrounding hills, has often been temporarily cut off.

As we returned towards the cars, the discussion turned towards the disparate attitudes towards turloughs; how they are valued for their heritage and natural history, but often despised for their unpredictability.

In a region of low-intensity farming, it is well-nigh impossible to win landowners over to the virtues of these capricious but most interesting and precious wetlands, though botanists, ecologists and hydrologists continue to try. In the long term, they need to be seen not, as the mid seventeenth-century Down Survey describes one, 'a quarter profitable' – only partially useful, for summer grazing – but as unique landscape features confined to the limestone land in the west of Ireland.

A Great Hike

The prospect of a couple of months camping in wild Africa demanded an appropriate challenge in the limestone wilderness on our doorstep. Esther-Mary and I would, we agreed, undertake a trans-Burren hike, to check that we were up to it and to enjoy the experience of getting into exploring mode.

The autumn continued fine, so setting off in mid-October 2002 had the usual seasonal advantages: cool enough for walking but not so cool as to require winter weatherproofs, the autumnal dieback of vegetation enabling more confident footing on the precarious terrain, and a favourable absence of tourists. The only disadvantages we could envisage were the post-equinoctial decline in daylight and the imperative to be finished before dark.

Where to go? What route to take? The Burren is replete with hiking options (many more now, since the opening up and designation of marked routes for footloose enthusiasts). On the basis that we

needed isolation and challenge in the most inaccessible quarter, we elected to walk along the eastern escarpment, northwards, from the National Park to the sea. This required the placement of one car at the starting point, at Rinn na Móna, a kilometre or so south of Mullaghmore on the edge of the National Park, and the other at our proposed destination, Linnane's pub at New Quay. The rationale in the choice of this destination for the comforts it offers requires no explanation.

Consulting Tim Robinson's Burren map, our route measured a mere 25 km (16 miles) – a cakewalk on paper. Our backpacks did contain food, but not of the Marie Antoinette variety; plebeian food of sandwiches and water would be quite adequate in this instance.

Car number two safely deposited at the finish, we arrived at our starting point at 8 a.m. A moderate 3 miles (5 km) per hour, plus occasional rest stops, suggested arrival at the pub in mid-afternoon, giving us plenty of time to relax, eat, drink and recap on our achievement.

Departing across the fissured limestone flats surrounding the turlough towards the sagging hulk of Mullaghmore, illuminated now along its eastern side, we shared that special silent elation unique to embarkation on an adventure. As it is almost impossible to ascend the mountain directly, due to the steep cliffs fronting each of the natural terraces, we were drawn to the brightening slope of the eastern shoulder and thenceforth to the summit. Soon after beginning the climb, we found ourselves surrounded by clumps of coral fossils and outcrops of reef chert, testament to the ancient marine origins of the limestone. Beginning as layered ooze in a tropical sea, then solidified to rock and over eons transported to where we stood by the dual phenomena of continental drift and plate tectonics, the limestone's history is indeed a fascinating distraction.

An hour later, we sat on the summit cairn soaking in a scene defying description. The panorama, a study in grey, gives a lie to the

colour's usual mediocre connotations, creating a landscape familiar, yet somehow un-Irish. The impression is utterly dramatic. A recent prolonged spell of dry weather had reduced the turloughs to puddles amid the vast expanse of limestone pavement. The two-tone blueness of *Loch Gealáin* – light cerulean on the shallow fringes, Prussian blue in the centre – told a story of ancient geological collapse, the dark core now a chasm leading to the watery underworld of the aquifer. With my back resting on the stone pile, I mused about an intriguing archaeological mystery concerning the visible cluster of burial cairns on Glasgeivnagh ridge, overlooking Mullaghmore, and the actual dearth of megalithic tombs near the mountain itself. How do we account for this dichotomy, given that Mullaghmore's prominence (like that of Knockma, near Tuam, which has several prehistoric tombs) would be entirely suitable for some of its own? Did the ancients see the mountain not, as with other Burren heights, as a potential burial site, but rather as an otherworld monument, its weird swirling form, buckled and contorted by the power of mighty gods, feared and respected by those with no knowledge of science – an Ayers Rock to Irish aborigines?

The trek north from Mullaghmore takes the hiker into a geological wonderworld. Ahead, the vista of bare limestone, manifest now as a series of enormous semicircular swirls, is simply breathtaking. Beyond, a phalanx of isolated or partially overlapping silvery knolls lead off to the north like Balor's warriors. Despite the extraordinary view to the east, with the broad expanse of Cooloorta's glacially scoured flatland, its moraine of rounded boulders (or projectiles hurled at Balor's men?) and its mosaic of turloughs – azure on grey – the eye is fixed on the spectacle ahead. The visual impact is as disorienting as it is dramatic. Where are we? Are we in the strange Mesa country of Arizona or New Mexico? Is this really somewhere in Ireland?

Rested now, our route from summit to summit, north along the east Burren, guided us along the ridge of Slieve Rua and on towards

Knockanes. Though less outlandish, this hill rises some 50 m (164 feet) higher than Mullaghmore. The trackless route requires serious concentration. Periodic stumbling, due the instability of otherwise trusty-looking slabs or as a result of finding one's foot trapped in a fissure hidden from view by a mossy plug, reminds one constantly of the hazards. We could not expect prompt rescue from accident since, at the time of our hike, mobile phones were not the essential backpacking equipment they are now.

As before, the cherished compensation for the moderate hardship and the necessary concentration was the uncanny quiet, broken only by the occasional reassuring grunts and metallic-sounding clinks of the stone slabs as we proceeded. In the stillness, the far-off croaks of a pair of ravens cavorting in the sky and the squeak of a flushed meadow pipit gave agreeable vocal expression to the trek. I missed the plaintive whistles of the Icelandic golden plovers that inhabit these uplands in winter; we were just too early. I recalled on many occasions watching a flock, usually fewer than a hundred together, spiral and form up into a chevron above my head, calling quietly before settling again a kilometre or so away. In their preference for wild places, they speak of their summer home in the northern tundra. Upland plants announced their presence in flecks and hints of colour. Late flowers – harebell, devil's bit scabious, bloody cranesbill, tormentil – in blue, violet, magenta and yellow, enhanced the otherwise nondescript ground cover. The withered winter heads of carline thistle, a quintessential limestone plant, stood out in warm Naples yellow, in contrast to its paradoxical frosty summer greenness. The dieback of now flowerless mountain avens, with their strange twisted seed tufts, patterned the coarse vegetation of hardy grasses, sedges and ling heather. Evergreen ferns – hart's tongue, spleenwort, rusty-back – normally second fiddlers to the showy flowers, stood out against the ochre and olive background. Here and there, the 'penny bun' shapes of *Boletus* toadstools grew in clusters in the short scraw. These

fungi, along with certain scarce plants (wintergreen, for instance), are thought to be indicators of the now absent woodland cover of prehistoric times. Associated with birches or pines, they suggest a radically different landscape to that of today. Having picked up a *Boletus* and broken off a piece of the cap, we watched as the yellowish underside transformed magically to indigo on exposure to the air, a sinister performance that would deter even the bravest of fungal gourmets. Miniature parasols of champignon fungi, sprouting from cowpats and recognisable by their pointed brown caps – 'magic mushrooms' – seemed most appropriate in this spellbinding place.

On the summit of Knockanes, we came across an opened cairn, revealing the box-shaped cist of a prehistoric burial. Though now devoid of its skeletal host, reconstructed versions of cists in museums tell us that this kind of burial, containing a body in horizontal crouched mode, was a customary funerary arrangement for notables during a period of the Bronze Age. We were to encounter seven more intact iterations, still covered by their cairn of stones, before arriving at the sudden directional change of the escarpment at Cappaghmore knoll.

Our descent from Knockanes across the minor road linking Carron to Boston took us unexpectedly to the remains of an uncompleted Famine relief road. There are three of these 'roads to nowhere' in the Burren, poignant reminders of the alleviation schemes aimed at a starving population five or six times the size of the present day's. These monuments of despair are powerful reminders not only of the tragedy itself but also of the crude efforts to provide work for the stricken droves otherwise destined for the workhouses or the emigration ships. It's extraordinary how an encounter of this kind re-energises the body in the sobering realisation of the relativity of the term 'hardship'.

Mounting another series of grand semicircular rock terraces leading to the summit of Turloughmore Mountain, we joined the north-pointing drystone wall at *Cloch na gCoinnle*, an isolated and prominent rock

pillar. This ancient wall would be our guide from now on. Though ostensibly no more substantial than most other upland walls in the region, its ancient lineage points to a greater significance. Its line (and possibly some of its actual structure) corresponds to the boundary between Galway and Clare. County delineations, consolidated to barony boundaries in the seventeenth century, are apparently coincidental with the much older Gaelic *Tuatha* territorial interfaces, in this case that between the Burren's Corcomrua and the O'Hynes of south Galway.

Scanning to the west, we could see the upright ruins of a pair of O'Lochlainn castles in the lushly wooded Glencolmcille Valley. These and more than a dozen of the O'Lochlainn castles of the Burren were strategically located to control the ancient routeways used by winterage herders – access to the uplands. The O'Lochlainns, 'kings' of the Burren (according to the ancient gravestone

Feral Goat

Boletus Fungi

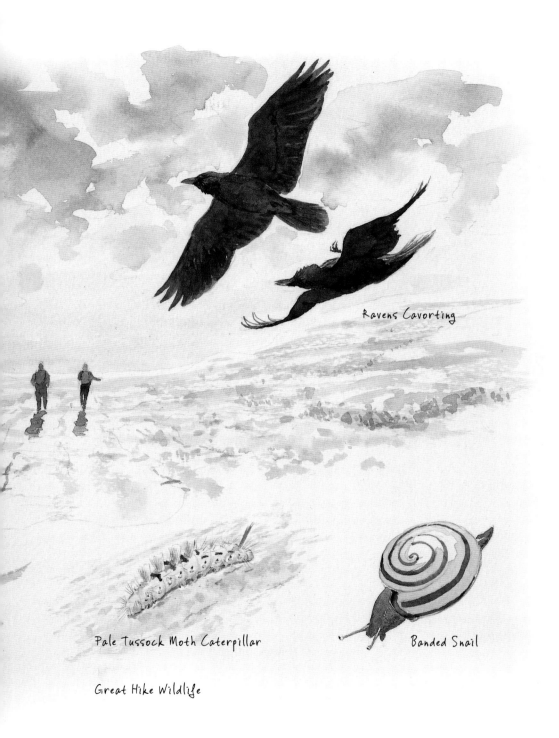

Ravens Cavorting

Pale Tussock Moth Caterpillar

Banded Snail

Great Hike Wildlife

in the chancel of Corcomroe Abbey) continue as prominent Burren inhabitants today, though now more as respected business people and farmers than royalty. Not long ago, this valley was open and treeless. Depopulation and abandonment over recent decades (as with much of the Burren) has rendered it agriculturally underutilised but, with the encroachment of hazel and ash, visually delightful.

Our route now took us along an arduous rollercoaster ridgeback trek beyond Turloughmore. Whether it was due to a drop in the wind or our increasing tiredness, the quietness seemed to amplify even the smallest sounds, adding decibels to our audible breathing. A hare exploded from behind a rock and a pair of ravens (possibly the same pair as before) barracked us overhead. A snipe, disturbed from its siesta, zigzagged into the air, rasping irascibly. In the quiet hollows, bees and hoverflies, making the most of their final days, added a pleasantly soothing hum to the atmosphere and a bullfinch whistled quietly from a patch of hazel scrub. I was reminded of how, on an earlier occasion, the silence had been broken by the report of a shotgun. I had watched from the height as two hunters and their dogs made their way through the valley scrub below after their elusive quarry, woodcock. This game bird comes to the Burren's hazel scrub in winter in response to harsher conditions in its northern European homelands. Though never common, some cold winters send more than others. It would take another month and a drop in Scandinavia's winter temperature before they would be back.

A sudden dart in the grass revealed a tiny frog, then another, and another. One is immediately curious as to how these water-dependent amphibians survive and thrive in such waterless uplands. It soon became apparent, however, that the remnant puddles of rainwater, still wet despite the drought, were sufficient for their purposes, for frogs are ubiquitous in the Burren, from its upper plateau to sea level. Judging from the abundance of their bones found in old accumulations of stalagmite in the caves, they have been so for a long time. A

botanic discovery in the short vegetation brought another unexpected 'froggy' dimension. Insignificant green spikes of tiny orchids revealed themselves at my feet, inviting me to kneel and inspect. These were frog orchids, so called due to the superficial resemblance of the flower to the amphibian's head. Like other orchids, they are pollinated by insects (in this case beetles), which abound in the uplands. One of the Burren's last emerging orchids (out of its suite of more than twenty species), the frog orchid has, unlike others of its genus, a northern distribution. It is, for instance, one of only four orchids found in Iceland. Its presence elicited a smile from both of us: a tiny flower for a tiny frog.

The northern end of the Turloughmore ridge is marked by two remarkable geomorphological irregularities. These twin rocky outcrops, which stand out against the sky when viewed from the west, also caught the imagination of our predecessors, for they are named *Léim an Phuca Mór* and *Beag* – 'great and little leap of the fairies'. Though conscious of the charming connotations, and those of other 'fairy places' in the Burren, we were now more intent on destination than on dalliance and saw the little hills less as poetic features and more as natural obstacles demanding extra effort to surmount. Somewhat further on, at a (nameless) point where the ridge reaches its highest, it was time once again to stop and admire the scene beyond the shadow of the escarpment, thrown now into relief by the lowering sun. The promontory provided us with a panorama of the vast eastern plain of south Galway. With the exception of the hill of Knockma, some 50 km (30 miles) to the north, the landscape is entirely flat and topographically featureless. Not so to the east. Our view in that direction was framed by the high ridge of Slieve Carran, topped by its giant cairn of stones, the burial place of some obscure (but clearly important) Bronze Age chief and fronted by the high cliff of Cinn Aille. Tradition has it that a pair of golden eagles nested here, probably until the early nineteenth century, at a time when over-

zealous landowners instructed gamekeepers to eradicate all game-threatening predators, feathered or furred. Nowadays the cliff is occupied by a scattering of sure-footed feral goats. These impressive long-horned beasts, clad in coats of many colours and patterns, cut statuesque outlines on their precipitous habitat. At a lower level, my binoculars picked out the ruined gable of St Colmán's Church, close to the saint's sixth-century hermitage. The shadow cast by the great cliff emphasised the sunless austerity of the circumstances in which the saint lived for the duration of seven long, cold years.

I was reminded of W. B. Yeats, for whom such history and myth was bread and butter, and whose tower house, Thoor Ballylee, punctuates the flat terrain 13 km (8 miles) to the east, just beyond Gort. I could imagine him (a century ago now) atop his tower, gazing towards the Burren's eastern escarpment, seeking inspiration from its mysterious profile. He was to realise local inspiration in much of his later poetry and in the airy performance of his play 'The Dreaming of the Bones', set in Corcomroe Abbey.

It was now five o'clock. Despite our doggedness and relatively good spirits, it was obvious that we had wildly overestimated our rate of progress. The constant effort to follow the line of least resistance but being forced to climb up and clamber down the unending outcrops had taken its toll. We were now confronted with the long haul to the 300-m (1,000-foot) summit of Slieve Carran, following the barony boundary along the flank of Turlough Hill, to the heights of *Greim Chailli* and thenceforth to Abbey Hill, before descending finally to New Quay and our destination. We had completed more than half of our planned upland hike. In the realisation that we still had perhaps 11 km (7 miles) of the mountainy variety left, we decided to let discretion be the better part of valour and take to the road for the remainder. Though undoubtedly a cop out, our change of plan would have the benefit of putting us into the hazel scrub and the habitat of wildlife not seen as yet. A drystone wall traversing open fields near the road,

composed of remarkably rounded limestones, spoke of late Ice Age erosion and outwash from a former glacial spillway, occupied now by the exit road. I find it interesting to consider the circumstances that gave rise to the availability of these stones, which once littered the ground in this place, and were then collected, unaware, by the landowner and formed skilfully into a Burren wall of a most unique and distinctive character.

Joining the New Line (in fact an early nineteenth-century military road), we tramped onward to the north. A kestrel, eyeing the ground for prey, hovered overhead as we approached Cappaghmore. Local placenames – Gortnaclogh ('rocky field'), Shanclogh ('old rocky place'), Leagh ('rocky flatland') – reminded us of the surrounding landscape (as if we needed a reminder). Funchin Mor and Funchin Beg (corruptions of 'large ashwood' and 'small ashwood') evoked the main tree species of the area, still evident in the hedgerows alongside the road.

In the calmer, warmer conditions of the lower ground, butterflies were still on the wing. Notable was the dowdy speckled wood, but there were also flashes of colour in one or two peacocks and small tortoiseshells, not yet gone into hibernation or butterfly graves. A painted lady, a colourful migrant from Southern Europe, came as a surprise, lifting our flagging spirits. However, the extraordinarily exotic caterpillar of a pale tussock moth, crossing the road, stole the lepidopteran show. This inch-long, hirsute larva, with abundant yellow 'fur' and red hairy tail, could be a model for a street carnival. It was a visual tonic. Feeling that it was vulnerable to being run over by passing traffic, I felt obliged to hurry it on its way to safety on the other side of the road.

Two hours later, and eight hours after setting out, we arrived heavy-footed at our hostelry haven. Despite opting out of perhaps the most interesting part of our pre-planned journey, we satisfied ourselves that we had in fact completed it, albeit in a modified version. All that was left now was to refresh the body and recover the other car.

While driving home, I was reminded of a previous African adventure and my attempted scaling of another iconic upland – Kilimanjaro. Thwarted by altitude sickness within an hour of the summit, I recalled the elation of the successful returnees and their generous commiserations. While recuperating, however, and unseen by the others, I had been treated to amazing views of one of Africa's most spectacular and elusive birds – a lammergeyer – as it soared in the updrafts. Failure, I mused, can have its compensations.

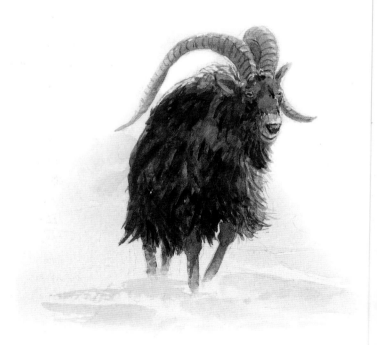

A Night in a Doline

The Glen of Clab and nearby Poulavallan (*Poll an Bhalláin*) indent the Burren landscape like a gigantic exclamation mark. Unlike other glens, formed over millennia by the erosional effect of a stream, it is totally dry, as is its crater appendage. It is nevertheless U-shaped in cross-section, as if bitten out of the limestone (*clab* means 'mouth' in Irish). The mode of its formation is just one of the many questions that challenge science's capacity to demystify this strange and wonderful place.

Geology asserts that prior to the last Ice Age the Burren was overlain by another type of Carboniferous rock, Namurian shale. In the process of being worn away, first by the heat of the end of Tertiary era, then by the initial freeze of the Ice Age, the shale contributed vast quantities of acidic water to the upper surface of the limestone, gouging out deep canyons and pits. As the glaciers subsequently overran the Burren, tearing away what was left of the fractured shale overlay, smoothly rounded valleys such as the Glen of Clab remained. The glen is a

smallscale version of a polje (a valley depression, closed off by higher ground at both ends), but linked to the Carron Valley, the Burren's finest example of one. Poulavallan, on the other hand, is a doline, a beautifully symmetrical steep-sided hollow – like an enormous bomb crater – created, it is thought, by localised collapse in the limestone.

Entering the Glen of Clab from the east in the summer is an enchanting experience. The trail leading downhill through dense scrub opens out startlingly into the glen's maw. Off to the left, a naturally regenerating ash wood, clinging high up to the valley side, surmounts a cliff face, the occasional site of a peregrine's eyrie. Above to the right, the bare escarpment supports a natural wall hanging of a spreading and decidedly ancient yew. In front, an enormous limestone boulder, fretted and cracked as if by hand, like a crazy art installation, flanks the trail.

The epitome of seclusion, the glen harbours wildlife galore. In daytime, fleeting glimpses of butterflies, lizards, birds and mammals are normally all that are available, but abundant spoor signs – opened hazelnuts, a sloughed reptile skin, strange feathers, animal-nail scratches on wayside rocks – indicate an extraordinary biodiversity. Birdsong, amplified and echoing back from the valley walls, is a consistent treat. On sunny spring days, blackcaps, willow warblers, chiffchaffs, blackbirds, mistle thrushes, woodpigeons and occasional cuckoos vie with one another for notice. Of all the bird-rich places in the Burren, the glen seems specially designed for avian glorification.

Ancient field boundaries criss-cross the valley floor, the legacy of some now forgotten clan, who, centuries ago, also found seclusion here. Nowadays, apart from a farmhouse near the entrance and a sensitively designed wooden shack at the trail end, the valley remains uninhabited. The shack was built by landowner, landscape architect and nature-lover Fergus Kinmonth, who, 'discovering' the glen in the 1980s and falling for its charms, purchased it, conscious of its vulnerability to development. Having been granted open-ended permission to explore and bring groups of enthusiasts here, I have

availed of this privilege on many occasions. On one occasion alone did I camp here, in early May 1999, in the crater of Poulavallan.

Our little overnighting group comprised my wife Esther-Mary and our niece and nephew, Niamh and Michael, both young children at the time. There was some disgruntlement about the uphill trek through the glen, but when we tentatively entered the great pit of Poulavallan through the copse of quivering aspens, the children responded open-mouthed. Arriving in this natural amphitheatre as light was failing in one of the remotest places in the Burren was quite unlike anything they had experienced before and observing the place through their eyes was a novel privilege. Tent assembled and cooking underway,

Torch lit badgers

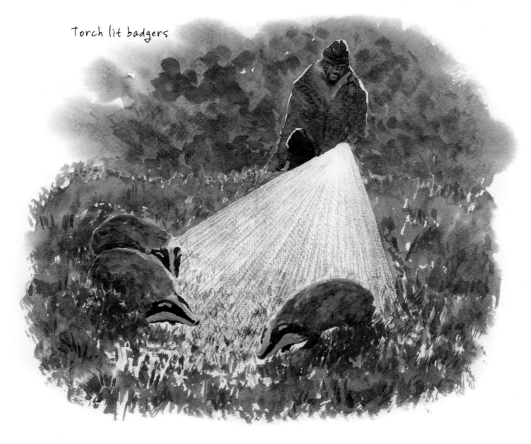

it was time to explore. Light from the declining sun brightened the grassy base, throwing the corrugations of Famine-era lazy beds into stark relief. What was the story of the people who lived here then? Cold statistics state that the Burren's valleys were populated with poverty-stricken tenant cottiers and labourers – densely in places. Most lived in what have been euphemistically described as 'class four habitations', one-roomed hovels of stone, wattle and mud with a hole in the scraw roof to let fire smoke out. Understandably, no traces remain today. Evocations of the former unfortunates nevertheless endure, in the myriad crumbling stone walls and overgrown tracks.

Walking around the top of the escarpment, we stumbled upon the remains of a Bronze Age tomb, a stone cairn (most of its stones removed for recycling into walls) that overlooked the crater. Did the great hole hold special significance in respect to the tomb's location, now lost to us? We discussed this as, towards sundown and with careful footfalls, we made good our return.

As light faded, I had just enough time to show the children a hole beneath a large rock where, on an earlier visit, I had watched a fox disappear from view. The entrance, characteristically untidy and reeking of musk, was obviously still occupied.

Meal consumed, fire quelled and everyone installed in sleeping bags, we lay in the darkness listening to the quiet whisperings of nature and focused on our place of repose at the node of *Poll an Bhalláin*.

Hours later, responding to the call of nature, I arose, careful not to wake the others, and stepped out, torch in hand. Almost immediately, the sounds of snuffling and grunting met my ears. In the torchlight, a few metres away, I beheld an adult badger intent on its private enterprise of 'worming'. It exhibited great concentration, scrabbling at a particular spot, and forcing its snout, pig-like, into the excavation to withdraw a few inches of pink prey. On looking directly at me, its pied head pattern stood out starkly, but not like its eyes, which, caught in the torch beam, reflected red from the retina, giving it a distinctly devilish

look. Snuffling nearby marked the presence of another badger, then, in the sweep of the light, another. Further off in the darkness, there were other snuffles, other *brocs*. Though I walked slowly among them, taking occasional flash photos, there was no sense of threat; they simply continued to go about their business as if I wasn't there. How unfair, I thought, the scorn heaped on this harmless mustelid. The myth that you should have a stick in your boot to inform a biting badger that it has indeed snapped your ankle bone, and could thus let go, is still purveyed in the Burren, as elsewhere in badger country. Much of the vilification emanates from the unresolved scourge of bovine TB, with which the badger is associated. Enormous sums have been spent both in Ireland and the UK, involving such radical (and draconian) measures as eliminating badgers from entire regions, in the hope of eliminating the disease. It is easy to imagine the badger, with its gregarious lifestyle and occasional association with grazing bovines, acting as a TB vector. However, it is not responsible for initiating the disease and there is a strong body of opinion claiming that herd mixing and unhygienic cattle transportation methods have more to do with the spread. In the Burren, where badgers are widespread and TB endemic, a policy of 'zero tolerance' is unfortunately commonplace.

When I returned to the tent, I decided not to waken the others, preferring to withhold the details of my experience for breakfast. In the morning sunshine, we went looking for the sett and found it not far away in the midst of the hazel scrub. There were the several entrances, complete with discarded bedding like stuffing from a cushion, and a nearby latrine: I explained that badgers are fastidiously clean, communal animals. The sett (I have examined it since) is extensive, covering the area of a small garden and may be twenty or thirty years in existence. I regretted not having awoken the children when I listened to their imaginative questions, more so in the knowledge that family commitments would soon draw us away. Memorable wildlife encounters tend to be like that; they are one-

A Night in a Doline **125**

offs, occurring unexpectedly, in accordance with nature's agenda.

Having camped in many places in the world, from the tundra of Iceland and forests of Canada to the grasslands of the Serengeti, I have a fervent belief in the magic of overnighting in the wild. Camping provides one with a unique and intimate perspective on nature, removed from the hubbub and protection of the human world. One also experiences more – much more. I recall on one occasion crawling out of my sleeping bag in Arctic Norway to witness the spectacular swirling lights of the Aurora Borealis filling the sky. The colourful kaleidoscopic display took me completely by surprise. By morning, when the others emerged, of course, it was gone. To be awakened by the contented grazing noises of zebra around the tent or kept awake by the distant roar of a lion extends human sensual responses to extremes – well beyond those with which we are normally familiar. When I was a teenager, camping was a given; it could be undertaken almost anywhere in the country. Nowadays it is much more difficult; permission needs to be sought and may be denied, understandably. In the Burren, where a common-sense, laissez-faire attitude still prevails, camping can still be enjoyed, but permission should be sought and the simple rules of consideration – leaving no gates open, no walls damaged, indeed no traces of one's having been there – still apply.

In these times of constraint and litigious consciousness, children enjoy formative experiences, like camping, much less than was commonplace in my youth. There are understandable (though sometimes overstated) reasons for this. The environmental writer Richard Louv, author of the bestselling *Last Child in the Woods*, regards this trend as disturbing. In his view, it can presage unfortunate outcomes such as detachment from and disrespect for nature, loss of coping skills, and even obesity; he warns of a condition he terms 'Nature Deficit Disorder'. Perhaps it is time to look more closely at opportunities offered by places like the Burren – opportunities that might help to counter such undesirable social outcomes.

'Like an Attenborough Documentary'

It was 25 May, a beautiful spring morning, and I was leading a group of student teachers from the Marino Institute, Dublin, with their tutor, Paddy Madden, on a tour of the Burren.

Response to the Burren's natural riches – its glittering flowers, ubiquitous birdsong and remarkable scenery – had been muted, at best. Whether it was as a result of the previous night's revelry in Cassidy's pub or the failure of the sun to show, the mood in the bus was decidedly subdued – until the big grey building came into view. As though primed by a choirmaster, the students broke spontaneously into the theme tune and Father Ted's house became the focus of attention. Spirits soared as the students re-enacted memorable snippets from the TV series. Banter reigned as they poured out on the roadside to take selfies with the building in the background. There was no ambiguity: this was the Burren upstaged by a farmhouse.

Where did this leave me, their guide? I didn't fancy my chances of engaging them for the rest of the day.

My challenge continued even after lunch, as we meandered through the region, stopping off at mysterious turloughs still flooded from winter excess, delightful hazel bowers and green roads flanked by walls of stacked limestone blocks. Finally, late on in the day, we arrived at the Flaggy Shore on the Burren's north coast. Here, with the breath of the Atlantic tingling city faces, things began to change. The stroll across an ancient seabed, with its patterned surface of coral fossils, was the beginning. Questions about how a tropical barrier reef had come to be situated at the edge of the cold Atlantic stimulated lively discussion and some uninhibited awe. Close-up images of the delicate filigree cross-sections were captured on phones and iPads, their owners kneeling or lying prostrate on the limestone terrace. As we strolled along the tidal splash zone amid shiny green saltwort and sea blite, white campion and sea pink, I suggested that we sample some of the edibles growing there. Here, Paddy came into his own. Having for decades promoted the growing of vegetables and other food plants in schools – to encourage children and teachers to be more aware of wild food and its associated wildlife – he led by example, nibbling leaves from scurvy grass, sea beet and, most tasty of all, rock samphire. Nowadays, we agreed, it's difficult to get either adults or children to sample the abundant foods of the countryside, some of which are presented as gourmet specials in expensive restaurants. 'Great nourishment on an outing like this,' he proclaimed, munching as he walked. Students, clearly captivated by the novelty, agreed, though one or two 'townies' held back, reluctant to consume anything that didn't have a sell-by date on it.

Next, it was into the 'Flaggy Field', just inland from the shore. As we walked across the fissured limestone flats – a pavement of clints and grikes – I invited the group to look for the land winkle, found here and nowhere else in the country. 'It looks like a tiny grey

turban with a perfectly round entrance.' Before long, discarded snail shells of several varieties were proffered on outstretched palms. A few were indeed those of *Pomatias elegans*. Despite our best efforts, however, we could not locate any live specimens, so recognisable by the shield-like operculum closing off their round entrance to prevent desiccation. The teachers nevertheless persevered, aware that this kind of investigation, perhaps with a class of child 'nature detectives', has intrinsic educational value, combining SESE (Social, Environmental and Scientific Education), one of the basic modules of primary education, with serious fun. As Paddy remarked, this kind of experience is priceless and can only be gained in the field.

An enormous erratic boulder, the focus of our little sojourn, sat incongruously on the limestone like a freight container fallen from an aircraft. It is one of many great blocks of granite dumped by retreating ice sheets, perhaps 10,000 years ago, on the Burren's north coast. Its irregular crystalline surface, dominated by pink and grey felspar, white quartz and glittering mica, invites close inspection. Hands dragged across the leeward surface responded uncomfortably to rough-textured *Ramalina* lichen, its absence from the windward side due to the inhibiting effect of exposure to salt spray. Scores of different calcifuge lichens, a significant fraction of the 350 or so calcicole species found on the limestone, grow on the acid surfaces of the Burren's erratics. Our boulder, a handy elevated perch for passing birds, was liberally sprinkled with bird droppings, an important source of nutrient for the prolific crusting of lichens. The glacial erratic thus represents an important microhabitat. 'How much do you think this one weighs?' came the obvious question. An emphatic '*Coupla* tons', based on its estimated volume and density, seemed to satisfy the mathematicians in the group.

It was while we admired the erratic that things began to happen. A cuckoo, which must have been watching us unseen, belted out its beckoning call from a nearby bush. 'Wow, it's just like the clock,'

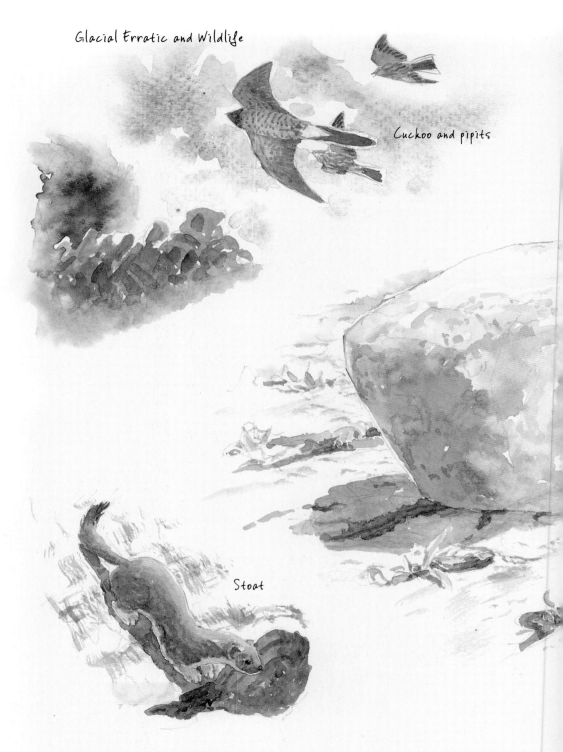

Glacial Erratic and Wildlife

Cuckoo and pipits

Stoat

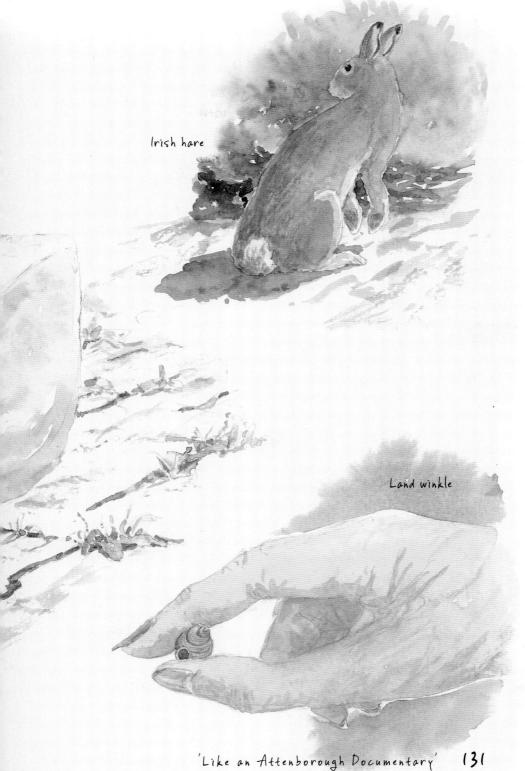

Irish hare

Land winkle

'Like an Attenborough Documentary'

exclaimed one of the girls, who clearly had never heard one 'live'. Eyes followed its hawk-like profile as it departed its song perch and joined up with another – apparently its mate – on a stone wall. In typical fashion, it was followed by another bird. These followers are known as *banaltra na gcuach* (cuckoo's nursemaid) – in this case, a distressed meadow pipit. The pipit swooped determinedly and repeatedly, making no secret of its disdain for the larger bird. Has any bird elicited more anthropomorphic comment than the cuckoo? Has it not always been presented as the epitome of sly wickedness? In fulfilling its evolutionary role, parasitising vulnerable unsuspecting hosts such as pipits, in demonstrating ruthless indifference to its victims and their offspring, it fascinates human onlookers from generation to generation. The cuckoo is of course just another of nature's extravagant regulators of species that might otherwise burgeon uncontrollably. Our pair seemed to be positively chuckling as they winged off out of sight, close to the ground, doubtless continuing on their nefarious business.

The bird profiles were immediately replaced by a larger brown shape, moving furtively beyond the erratic. It materialised into a hare, which, upright on the bare limestone, looked as big as a kangaroo. Eventually it loped off, stage right, casting timid glances over its shoulder. Simultaneously, a few yards away, a stoat jumped up from a grike like a jack-in-the-box and proceeded to engage us, hopping and bobbing amid the prostrate shrubbery and scattered stones. Binoculars were useless, given the speed and proximity of our little entertainer. Its tawny coat, creamy on the underside, and black-tipped tail were evident to all. Captivating and endearing as this little mustelid was, I explained that it was also a highly efficient predator, capable of catching and killing prey several times its weight.

'It's got something,' came the cry.

'Looks like a wren,' I replied, aware of the brown shuttlecock in its mouth. After a couple of minutes of disporting itself with its quarry, the

little hyperactive creature disappeared down a fissure as suddenly as it had emerged. We stood waiting for it to reappear, but in vain. It had caught its lunch and now was off down one of the rock-cleft corridors to privacy and an undisturbed repast.

We were already running over time as we traipsed back towards the bus. Paddy, conscious of the need to wind things up in order to ensure the students' return to Dublin at a reasonable hour, had gone ahead and regrettably missed most of the action. A couple of students, reluctant to give up the search for a live land winkle, came across a large 'hairy Molly' – a drinker-moth caterpillar. One girl, touching its rear end, jumped up with a start, alarmed at its sudden squirm-and-thrash defensive response.

'It does this to fend off a predator,' I explained, 'the cuckoo, for instance – caterpillar gourmet.'

As the bus came into view, one of the lads, obviously excited by the Flaggy Shore experience declared, 'That was like an Attenborough documentary!'

I agreed and was confident that others had felt the same.

Paddy and I share a hope that these young teachers will, from their Burren experience, go on to convey to their pupils something of the magic to be found in this 'outdoor classroom'. It might be too much to hope, however, that the reality of the Flaggy Shore will ever supersede the make-believe of Craggy Island.

Paddy Madden has been bringing his trainee teachers from the Marino Institute in Dublin for Burren weekends for a decade now. It used to be that the Burren was brought to the teachers via visiting experts to the institute, attempting to extol the region's wonders in the course of a single lecture. This is, of course, a weak alternative; there is no substitute for an actual Burren visit. While the facilities of the Burren, such as Aillwee Cave, are well known (even to Dubliners) for school outings, the famous landscape features – the limestone pavements, the turloughs, etc. – often are not. These spring weekends

are therefore beneficial in familiarising trainees with the variety of the region's attributes, with a view to future class outings. While the Burren is well used for educational purposes by the dozen or so primary schools in the immediate vicinity, it is undoubtedly greatly underused nationally. Nowadays, with facilities for overnighting an entire class in a hostel in several of its villages, an exciting outing and tour of the Burren could be on the agenda of many schools throughout Ireland. The realisation of this depends on teacher enthusiasm and on the steering of scarce school resources in this direction.

Finding Fossils

The rocky landscape of the Burren is at once revealing and concealing. It is patently an enormous stack of bedded sediments – formerly soft oozes laid down in ancient times and compressed over eons into rock. It has also obviously been shaped by ice, and continues to be shaped by the elements, particularly rain. But how did it come to be where it is? What forces brought it to us and from where?

A fair guess is that it was originally formed in water: most sediments form in water. But what water?

Did it arise in some vast freshwater lake, or in the sea? The regularity of its bedding would suggest calm, freshwater conditions, but this interpretation would be incorrect; the fossils contained within the rock speak only of the sea.

The grey limestone, comprised mainly of its undifferentiated microfossils, is an impenetrable medium: it could be concrete. It is the frequent visible irregularities – the macrofossils – that reveal its history.

Corals

Lamp Shells

Crinoids

Carboniferous Fossils

These show up in the many drystone walls and in the cut limestone blocks of buildings, where one can run one's hand around their distinctive protuberances. But the most assured way of realising the rock's origin is by walking on it. A walk along the Flaggy Shore in the north Burren is not only a walk across an ancient seabed replete with fossils; it is also a walk back in time to the Burren's very beginnings.

The fossils are comprised of corals – branched and solitary corals – which, in the main, sit upright in the flat rocky terraces exactly as they did when they were alive under the sea. Having been encased in limy sediments, transformed into rock, transported by enormous geological forces, then revealed by the scouring action of Ice Age glaciers, they show as discrete patches of white patterning in the grey surface. When examined at close quarters, on hands and knees and with a hand lens, the patterns reveal themselves as myriad composite cross-sections. Each cross-section is a filigree compartment, delicate as a spider's web, the former living quarters of a colony of microscopic inhabitants. Continuing for hundreds of metres on the same level,

the Flaggy Shore terrace constitutes a 330-million-year-old reef, similar to those in the process of formation today in the equatorial zones of the Atlantic or Pacific. Students of all ages, exposed to this remarkable time capsule, respond enthusiastically. Questions invariably come thick and fast.

'How did a reef formed in the tropics end up in temperate Ireland?'

'Could this reef have formed here, in Galway Bay …?'

The answer to the first question was explained brilliantly by the German geographer Alfred Wegener, who formalised the theory of Continental drift more than a hundred years ago: Ireland, including the proto-Burren, was once part of a greater land mass, Laurasia, in turn part of a composite supercontinent, Pangaea, in the southern hemisphere, which, on dividing into plates like the pieces of a planetary jigsaw, migrated northwards across the globe. The existence of fossils that once coexisted but are now found in countries thousands of miles apart is proof positive of Wegener's theory. Devoid of such fossils due to its newness as a geological entity, Iceland, with its volatile rift sundering the island in two, dramatically demonstrates the ongoing process today.

The answer to the second question lies in the current temperature range of the sea in Galway Bay. Normally no warmer than 17 °C (though in 2014 as high as 19 °C as a consequence of global warming), it is considerably too cold for coral colonies to thrive: corals (apart from unusual cold-water communities) require a minimum of 23 °C for viable growth.

A fossil exposure similar to that of the Flaggy Shore can be seen on the shore at Gleninagh in front of the fine O'Lochlainn tower house. Here, a storm beach of cast-up rounded stones holds many fine fossils, particularly those of solitary corals. These carrot-shaped species once sat upright in the seabed, drawing in plankton by way of a tousled head of tentacles. Their fossils look like outsize thumbprints in cross-section. Here, too, are abundant lamp-shell fossils. These ancient bivalves

(double-shelled filter-feeders) originally sat on the seabed, secured there by a stalk or foot from between the shells. Some had spines on the outer shell; some were as big as coconuts. Their fossil traces, where they are exposed in cross-section, resemble crescent moons.

As you ascend Mullaghmore Mountain, in the Burren National Park, you traverse an unexpected array of marine fossils in the limestone. First, an extensive blackish outcrop level with the ground surface reveals itself as a chert reef, the geological expression of sponges and countless millions of microscopic marine fossils (such as *Radiolaria*), with siliceous rather than calcareous shells. Then, at about 100 m (330 feet) above sea level, you pass through a zone of the branched coral *Lithostrotion* extensively blackened to chert. These fossil hummocks lie on either side of the trail like so many worn and discarded garden ornaments. Higher again and the oyster-shaped traces of lamp shells decorate the limestone before all visible fossil traces disappear. This elevated succession represents younger Carboniferous life than that evident at the Flaggy Shore.

My favourite place in the Burren to go on a fossil foray is to the flat limestone pavements at Fanore. The best exposures are in openings within the dunes and at the edge of the strand. Here, the clear white calcite outlines of an amazing variety of marine creatures can be found. There are corals and lamp shells, but it is the multitude of winkle-shaped creatures that stand out against the dark grey of the weathered rock. Some of these appear identical to their modern-day counterparts – periwinkles, whelks and tower shells – though the majority are of species either not found here today or completely extinct. The large spiral shapes of goniatites – like Catherine wheel fireworks – occur here, as do the fragmented remains of crinoids, which, despite their moniker of 'stone lily', were colonial animals, not plants. Others, such as echinoids (starfish and urchin types) are also found, but are often difficult to identify and show little resemblance to contemporary relatives. Another colonial fossil that I have frequently encountered

is the well-named sea mat. This has the extraordinary appearance of a man-made fabric — like coarsely woven canvas. A prized, rare fossil is that of a trilobite. This varied-sized Carboniferous crustacean has a distinctive armoured appearance. It bears a superficial resemblance to the sea louse (sea slater), a common shore creature.

To find examples of Carboniferous plants, one must go to the younger shales and flagstones, which overlie the limestones and are exposed at the Cliffs of Moher. Here, careful examination of the dark friable sediments may reveal the traces of plants like clubmosses, tree ferns, gigantic horsetails and primitive conifer trees. This suite reflects the deltaic conditions that, 300 million years ago, succeeded the laying down of the limestone. The sediments accumulating above the calm surface of the Carboniferous sea not only permitted the growth of primitive plants but created the circumstances for crawling invertebrates to wriggle across the muddy surface, leaving behind the iconic patterns on the surface of Liscannor flagstones. Extraordinary as it may seem, despite the clarity of these traces, we have none of the actual creatures themselves, their soft bodies having oxidised and disappeared with the passing of time.

The value of the fossil in education cannot be overstated. As a vehicle for learning about the earth — particularly geology, the story of the evolution of flora, fauna and ultimately humanity — there is no equal. The real power is in the fossil's capacity to appeal both to the imagination and the intellect. In musing over a piece of rock containing a fossil, a student can, with some supportive educational interpretation, reconstruct in his or her mind a long-lost world — not that of some far-fetched sci-fi movie, but of reality. Experience in the field, seeing the fossil in context, is the best way to do this, but 'hands-on' experience in the class is also effective. In these times of expensive 'techno trappings', a humble tray of fossils — whether those of the Burren or elsewhere — distributed to primary schools, at low cost, surely represents a most worthwhile educational option.

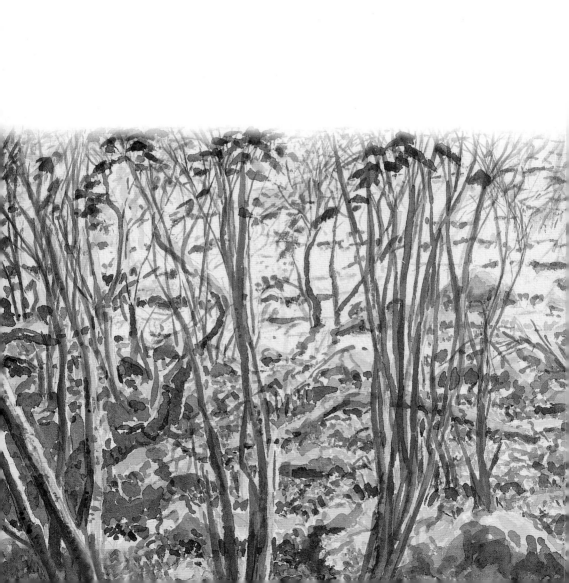

4

Burren Specials

Land Winkle

Snails do not normally figure highly in most people's bucket lists – not even those of naturalists. *Pomatias elegans,* however, is so remarkable that it leapfrogs most other creatures to occupy honorary Burren status. Its common name, 'round-mouthed snail', conveys no inkling of its singularity, since most snails seem to have a round or rounded mouth. Its other, more revealing name, 'land winkle', however, suggests an altogether more intriguing characteristic.

Winkles, as every shellfish enthusiast knows, are sea creatures. In their most familiar snail-like spiral form, they inhabit the littoral zone from mean tide level down to the (periodically exposed) level of low spring tides; in this respect, they echo other zoned species, including the wrack seaweeds (on which they feed). As to their form, they are highly recognisable, ranging from the squat blackish periwinkle of the upper shore to the exquisitely marked top shell of the lower shore; in between, a cohort of other distinguishable species is to be found.

Exposure to the elements, away from the sheltering influence of the tides, dictates the habitation zones of the various species. All are capable of taking oxygen directly from the sea, unlike land snails, which have rudimentary lungs.

A winkle living on land, therefore, would appear to be ridiculously out of place. *Pomatias elegans*, which has evolved to retain its marine respiratory system, defies that logic.

Winkle

As its Latin name suggests, this little creature (barely a centimetre in height) is a particularly beautiful mollusc. Elegantly spiralled in the manner of an old-fashioned spinning top, it has the graceful contours of a miniature Byzantine collectable, with a finely lined lilac-grey shell. Its most striking external feature is its operculum (a hard shield, carried normally on its tail), pulled neatly into place across the opening, protecting it from predation and preventing it from drying out. It shares this singular facility with its marine relatives, the periwinkles.

Another extraordinary fact is that, other than a kilometre-long strip of limestone pavement in the north Burren, *Pomatias elegans* is found nowhere else in Ireland. Methodical searching of other suitable parts of the Burren has so far failed to reveal others. Found initially near Bundoran in County Sligo by G. C. Hancock, as long ago as 1840, it is apparently entirely gone from there, and its shells have been found in archaeological sites elsewhere, indicating that it was once more widespread. The situation in the limestone districts of Britain and Europe also points to a retreating range. Molluscan specialist Helena Ross's brief reference to it states: 'Strongly calcicole [lime-loving], with a requirement for deep, friable soils in which to burrow. It prefers shaded places in the northern part of its European range though the

Irish locus is on open limestone … A south European species at the limit of its natural range in Ireland.'

Another reference states, 'The existence of numerous fossils shows that it was once much more widely distributed. Some people believe that this is because the climate was warmer thousands of years ago, while others suggest that the quality of the soil has changed during this time.'

It is hard to imagine this latter suggestion being a significant factor, in the Burren at any rate.

The most compelling question of all, of course, is why did a marine winkle evolve (and over what immensity of time) into a land winkle? What could have prompted a creature so utterly adapted to marine existence to depart its comfort zone for a more precarious habitat?

Perhaps we should not be so surprised, given that there are terrestrial crustaceans, for example land crabs, that have done the same. Also, familiar land invertebrates such as woodlice and even spiders have marine equivalents, though sea spiders, at any rate, are now taxonomically distant from their land counterparts.

But for a winkle to adapt to life above the tidemark, it had to find advantage away from the protection of the sea, learn to utilise abundant calcium carbonate as distinct from sodium chloride, and adapt to feed on completely different plant food. Carrying with it its operculum disc certainly provided the creature with a significant start in its new life, but radical adaptations were necessary, which can be traced to the living mollusc. It has, for instance, only one pair of antennae and its eyes are located at their bases – not on the ends – as with most members of the snail tribe.

Land Winkle

The retreating distribution of *Pomatias elegans* all over Europe suggests that,

despite its initial adventurousness, it has not, in the long term, been an expansionist success. During the present century, it has disappeared from many former sites. In addition, attempts to introduce it to potentially suitable habitats have been resounding failures. In Britain, it is still found in many southern localities, in some places abundantly. It is not therefore in imminent danger of dying out completely.

Ram's Horn Snail

What are we to make of the distribution in this country? The subfossil evidence shows clearly that, though it may not have been widespread at any time, it has retreated dramatically, perhaps as far back as the end of the Ice Age. Was it once common along the entire limestone coastline? Was it once found inland as well as along the coast, as in the UK and parts of Europe? Is there a case for it to be considered, along with the Kerry slug, for instance, as a representative of the postglacial Lusitanian fauna (a category under review in recent times)?

Is there a possibility that it is not native to Ireland, that perhaps it was recently washed up or even introduced to the Burren – like the slow-worm? Though this proposition seems improbable, it is a well-established ecological fact that islands such as Ireland are especially prone to invasive alien species. However, since it can be traced back to its subfossil beginnings, this seems highly unlikely. When *Pomatias elegans* is considered along with other ecological 'remarkables' – the Burren green moth, pearl-bordered fritillary butterfly, certain beetles and other invertebrates that are more or less confined (in Ireland) to the region – it is tempting to view the Burren as an outlying sanctuary for rare, declining or relict minibeast.

Pomatias elegans certainly raises more questions than answers.

While we ponder its background and character, it is imperative that we also consider its fate. An access road bulldozed more or less along the length of the site in the 1980s might have put paid to its sedate wanderings but for scientific intervention and sympathetic response from the landowner (unaware of the creature's existence), which ensured the survival of the habitat and, hopefully, the snail.

Remarkable as it may seem, this is not the first time a tiny snail has figured in road development. In a famous pre-millennium case in County Kildare, development of a motorway was put on hold while expensive measures were put in train to protect the wetland habitat of another tiny mollusc, *Vertigo geyeri*. Yet another member of the genus *Vertigo*, recognised by the shape of its shell – like a tiny beehive – it is found in a couple of places along the Burren's shore. An inhabitant of dunes, it is also found elsewhere along Ireland's west coast in suitable habitats. With the increased use of dune systems and increased tourist pressure, its future as a rare postglacial survivor is by no means assured.

Thankfully, *Pomatias elegans* and its little strip of habitat are now afforded protection under the Habitats Directive, and its security is being regularly monitored. Ultimately, the question of its survival may be more to do with extraneous pressures, such as man-induced climate change, than with local conservation measures.

Beloved Bully

Kinvara's spring music festival, *Fleadh na gCuach*, unlike many economically inspired though well intentioned community events, is no contrivance; it is based on a sound (pun intended) premise – the joyous arrival of one of our most iconic birds. Coinciding with the ancient Celtic spring festival of *Bealtaine*, this wild, western get-together, attracting nonconformists of all kinds, is just the event for the most radically liberal member of all the avian tribe. Such a celebration is nowhere more appropriate than on the edge of the Burren, where the bird's far-carrying call is as reliable a feature in early summer as is the famous floral display.

> *The cuckoo comes in April,*
> *It sings its song in May,*
> *In June you'll hear it change its tune,*
> *And in July it flies away.*

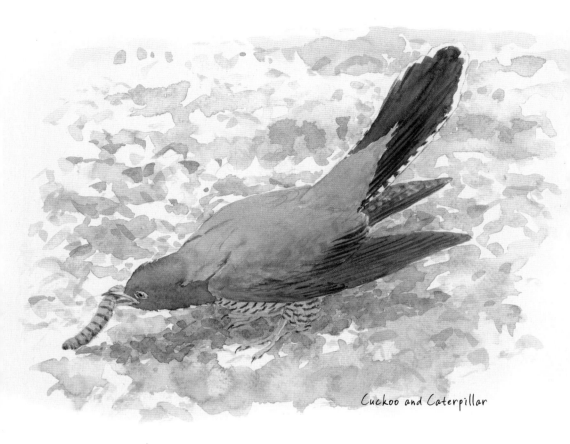

Cuckoo and Caterpillar

The cuckoo's antisocial lifestyle has intrigued people for as long as it's been possible to differentiate fact from fiction. Its wayward behaviour – laying its eggs in other birds' nests and having the hapless foster parents rear them – touches a chord with those weighed down by parental responsibility. Who has not wondered at the callousness of the cuckoo chick, resolutely evicting other eggs and chicks from the nest, and the pathetic commitment of the host parents in bringing up their surrogate? The female cuckoo's slick act – laying its similarly marked egg and removing one of the host's so that the replacement goes unnoticed – undoubtedly hatched the term 'cuckolded', a favourite Elizabethan expression of female deceit. It is understandable,

therefore, that many cuckoo sayings relate to human family circumstances. In Irish, an only child, *éan na cuaiche*, is 'the cuckoo's chick'. The vagaries of male-female relationships, including optimistic predictions of marriage, cast the cuckoo in the role of mysterious matchmaker. Other traditions emphasise negativity, marked by expressions of badness, even a curse: 'May you not live to see the cuckoo or the corncrake again!' One of the stone carvings high on the side of the medieval St Nicholas' Cathedral in Galway is a cuckoo with an egg in its beak. The bird is clearly displayed on the building's exterior as a symbol of evil, alongside sundry gargoyles.

The cuckoo's sudden appearance in early spring has given rise to many folk expressions and alternative names. So, another name for the lady's smock is 'cuckooflower'; the sheath-like early growth of lords and ladies is called 'cuckoo pint'; 'cuckoo spit' is the frothy secretion of the froghopper bug. There are many proverbs connecting the arrival of the cuckoo to inclement weather, such as a late spring. One is a warning to 'sell your cow and buy corn', if the cuckoo settles on a leafless tree.

The Irish language provides interesting insights into the Gaelic mindset and its affectionate, even spiritual connectedness with the natural world. There is a fundamental

Emperor

Garden Tiger

Convolvulus Hawkmoth

Elephant Hawkmoth

Oak Eggar

Drinker

difference, for instance, in the manner in which country folk refer to *the* as distinct from *a* cuckoo: the non-specific and intangible as distinct from the specific and quantifiable is clearly a hangover from Gaelic-speaking times.

The little bird that characteristically follows the cuckoo around (there are various theories about this, ranging from offended hosts to a warning to other birds) has spawned a variety of descriptive names in the Irish: *banaltra na cuaiche* (cuckoo's nursemaid) and *giolla na cuaiche* (servant of the cuckoo) are two of the most descriptive. One phrase, '*Titfidh an spéar nuair a rachfaidh an gobadán i mbéal na cuaiche*,' colourfully suggests that the sky will fall if the little bird pursuing the cuckoo falls into its mouth!

Given its unambiguous shout, one would think that the cuckoo would be universally named just that. But, as the Irish name *cuach* points out, this is patently not the case. The onomatopoeic epithet apparently came to us with the Normans, being derived from Old French *cucu*. The older Viking name (from Old Norse) is *gowk*, and this is the name by which it is still known in much of Scotland. The audible resemblance to the Gaelic name is striking. It is something of a paradox, then, that *gowk* is also the name for the cuckoo in Ulster Scots, a dialectical offshoot language not often associated with Gaelic (or Q-Celtic). In contrast, the cuckoo in Welsh is *cog* and in Breton, its P-Celtic near relation, *goukoug*, perhaps more onomatopoeically acceptable than its Gaelic counterpart.

P. W. Joyce, author of *Irish Placenames* (1900), points out the ubiquity of Irish localities named after the cuckoo. Numerous topographical features throughout the country are named after the bird – for example, Derrycoogh (oakgrove of the cuckoo), Cloncough (cuckoo meadow), Drumnacooha (cuckoo ridge) and Knocknagoogh (cuckoo hill). A townland in the eastern Burren, Killeenmacoog, appears to have been named after the cuckoo, the Anglicised version of the Irish *cuach* being 'coog'. One of the most evocative placenames,

from Galway, is Boleynagoagh, the dairy place of the cuckoo. One can easily imagine, in times gone by, the bird's muffled calls setting a rhythm to the squirting milk.

P. W. Joyce wrote at a time when the cuckoo was truly widespread. Nowadays, this is sadly not the case: for the past century, this irreplaceable bird has been declining throughout its European range and also in Ireland. It is particularly scarce in the eastern side of the country.

Surveys carried out in the 2000s, in the Burren, the Aran Islands and throughout Clare, revealed that, despite the decline, the cuckoo remained remarkably common in our region. In each survey, more than a hundred calling sites were recorded, including many on the Aran Islands. Indeed, it is not unusual, in the course of a day's tour through the Burren in May, to hear nine or more calling cuckoos. Though this does not imply that hundreds of baby cuckoos are being reared annually in the region, it does suggest that the species is in a healthy position here.

Why the Burren?

The surveys suggest that the variety of open, uncultivated habitats (scrub, cut-away fen, turlough and other wetland) and the number of potential hosts (meadow pipits, dunnocks, stonechats) are significant factors. The availability of food – particularly a wide range of caterpillars – could well be another. The Burren abounds with lepidopteran larvae. While most birds avoid 'hairy Mollys', the caterpillars of large nocturnal moths, due to their inability to deal with their hairiness, cuckoos thrive on these protein packages. Cuckoos also watch patiently for lackey moth caterpillars, feeding on blackthorn leaves, to emerge from their protective 'tent' (a common summer feature in the Burren), or pick off fallen unfortunates from the ground beneath.

It may well be that there are other as yet unseen factors at play in the cuckoo's decline, such as difficulties in migration, or climate change. Time will surely clarify this.

My notebooks record an amazing consistency in the arrival date of

the first calling cuckoo. In the thirty years of my living on the Burren's fringe, I have consistently recorded its arrival in the last week in April or the first in May. Its appearance on 9 April 2010, outside my house, was therefore as unbelievable as it was unprecedented. An extremely cold and protracted winter and early spring had suddenly given way to a mild Continental airstream, inviting in avian arrivals returning from their African winter quarters. After hearing the cuckoo, I went looking for, and found, the first swallow, willow warbler, blackcap and wheatear, all summer migrants, on the same day.

By the time of *Fleadh na gCuach* at the end of April 2010, the cuckoo, to the wonderment and approval of Kinvara revellers, was well installed and once again up to its bullying tricks.

Hooked Beaks
and Talons

St Colmán would have been familiar with the piercing cry of the eagle when he retired to his hermitage beneath Keelhilla Cliff more than 1,500 years ago. Keelhilla, derived from the Irish (and typically ambivalent), may refer to the cliff and the hermit's church beneath it or to 'the wood of the eagle'. The location, a nature reserve, is wooded and remote, much as it would have been then. A rock face where the eagles may have nested is still referred to as Eagle's Rock. The eagles could well have been golden eagles, though today we can only speculate: the ancients, as far as we know, did not differentiate between our two species, the golden and the white-tailed. Until the beginning of the Early Modern period, an eagle was an eagle and nothing more.

Archaeozoological material from the 1934 Harvard excavations at *Cathair Chomáin* has revealed the remains of the white-tailed eagle, differentiated from the golden species by its larger size and more massively hooked beak. Unlike its shy mountain-dwelling relative,

the white-tailed eagle would have lived in close proximity to humans, scavenging like a vulture on discarded rubbish and dead animals, and nesting in an inaccessible spot, though often within sight of human habitation. It might even have been kept as a status symbol by a chief or buried with one, as in the Bronze Age Tomb of the Eagles in the Orkney Isles. Coexistence with the Burren's inhabitants may well have been tolerated, until it was regarded as a threat to poultry and game, and eradicated by zealous gamekeepers in the nineteenth century. The white-tailed eagle, living up to its full name of white-tailed sea eagle, where it preys primarily on sea birds, is known to have nested at the Cliffs of Moher as late as the 1840s.

Another raptor that may well have shared the skies with the soaring eagles in medieval times is the buzzard. Smaller, but nevertheless eagle-like, the buzzard was also seen as surplus to requirements by gamekeepers and wiped out in the nineteenth century. It did, however, manage to hold on in the far north of Ireland, whence, since the 1950s, it has staged a spectacular recovery. The decline of gamekeepers, the spread of forestry and protective legislation have all helped the buzzard to spread back into former occupied territory. Adept at catching rabbits and other small mammals, its propensity for also preying on larger 'pest' birds such as wood pigeons, magpies and hooded crows has endowed the buzzard with the tolerance of farmers. Though apparently not yet nesting in the Burren, its forays into the region (to Garryland and Coole Park) have become annually more frequent and nesting here in the near future looks likely. Unfortunately, one of a pair frequenting Coole was found dead (possibly poisoned) in 2013.

One of our most beautiful but elusive large birds of prey, the hen harrier, is a regular visitor to the Burren. Rare now throughout Ireland (though strictly protected), the hen harrier visits wetlands, such as those along the east Burren, after the breeding season; it hunts mainly for water birds. The grey male, with black wingtips (like a large

seagull from a distance), is eye-catching, but the brownish female is easily overlooked due to the natural camouflage of its plumage. The hen harrier has nested on the south-western edge of the region in young forestry plantation and, with the continuing absence of wind turbines, may do so again.

The swift-flying falcons are represented by three species in the Burren. The most widespread and familiar is the kestrel, often to be seen hovering as though suspended in the sky. This beautifully marked raptor – grey on the head and tail, red-brown on the back – feeds mainly on small prey like lizards, mice and large beetles. It often nests on a cliff or in a ruined castle. In a ruined castle near Ennis, a pair of kestrels took up residency in a raven's nest a few weeks after it had been abandoned by its former occupiers.

The diminutive merlin has been found nesting in the Burren on a couple of occasions and may continue to do so in undisturbed upland on the edge of forestry plantations. It is, however, a rare breeder throughout Ireland, and is particularly unobtrusive near its nesting locations. Migrating merlins (probably from Iceland) occur regularly in the autumn along the north Clare coast, where they hunt small birds such as pipits and larks. On several occasions I have seen one – clearly a migrant – flying in off the sea at Black Head. The merlin's aerial dexterity in pursuit of prey has to be seen to be believed.

An age-old symbol of power and grace, the peregrine is the finest of the Burren's falcons. A favourite bird among kings and nobles, it was once sought after for the gauntlet. Nowadays, it is strictly protected and may only be taken and used in falconry under licence. Up to six pairs nest regularly on precipitous cliff faces in the Burren, but with so many such sites available, no one eyrie is guaranteed to be occupied in a particular year. I have vivid memories of being mobbed aggressively by an anxious tiercel with a female on the nest at one remote site, and watching the adults 'training' a fully grown young falcon at another. Preying mainly on pigeons, they are widely

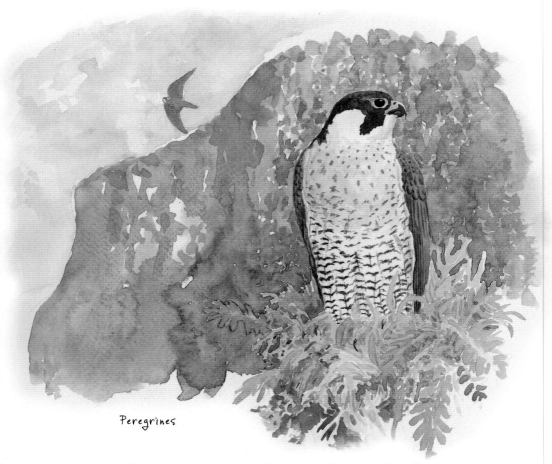

Peregrines

accepted as important agents of control at the top of the food chain. In winter, peregrines disperse to the coast where they may be seen panicking flocks of waders and even ducks. Their breathtaking 'stoop' on potential prey is one of the wonders of the natural world.

The commonest of the Burren's birds of prey is the sparrowhawk. Though sometimes seen in the open, avoiding harassment by crows or soaring in the sky, its predatory modus operandi is as a stealth hunter. It may often be seen dashing effortlessly through the hazel scrub, intent on ambushing an unsuspecting finch or thrush. When seen perched, it reveals long spindly legs and staring yellow eyes. The nest, usually high

in a tree, is often the reused nest of another bird such as a hooded crow.

The Burren has only two resident owls: the long-eared owl and the barn owl. Since both are nocturnal, hunting mainly for night-active rodents, they are rarely seen. Their presence may be detected, however, by pellets (regurgitated undigested material) left at regular perches. Long-eared owls often nest in isolated trees and in the unoccupied nests of other species. Some years ago, I had the pleasure of rearing and returning to the wild a young long-eared owl that had fallen out of a nest. My abiding memory is of its glaring yellow-orange eyes, which, comically, it could blink individually at will. Barn owls favour ruined buildings, such as abandoned tower houses or farm outbuildings. Though the long-eared owl seems to be holding its own, due perhaps to its tendency to shun humans and their habitations, the barn owl, as is the case throughout Ireland, is sadly declining. This has been put down to the use of rodenticides that particularly affect birds at the top of the food chain, the destruction or renovation of suitable nest sites, and other lesser factors. The barn owl is probably more common than suggested by the single nesting location found by Liam Lysaght and recorded in his 2002 *Atlas of Breeding Birds of The Burren and the Aran Islands*. Occasional night-time sightings in various parts of the Burren in recent years (particularly near Ballyvaughan) give grounds for some optimism that this beautiful and mysterious predator is still around and will continue to be an important part of the Burren's avifauna.

The appearance of a snowy owl near Black Head in 2014 was at first treated with disbelief but subsequent sightings by a number of observers verified that this spectacular bird, no doubt a straggler from northern regions, had indeed spent the winter on the Burren's north-facing hills. It was still being seen (and photographed) on Cappanawalla in April 2015.

Since the turn of the millennium, three of our grandest birds of prey – the golden and white-tailed eagles, and the red kite (not presently known to have been a Burren bird) – have been successfully

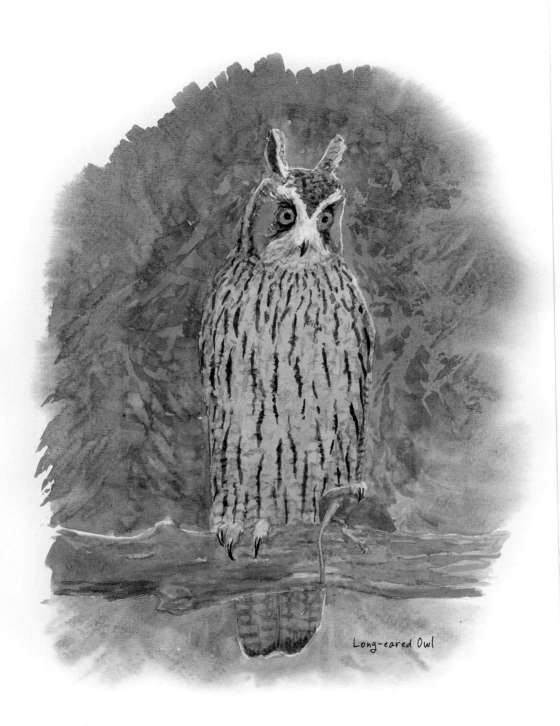

Long-eared Owl

reintroduced into Ireland. The white-tailed eagle's successful nesting on Lough Derg, near the eastern edge of County Clare, augurs well for its eventual return to the Burren. It would certainly add significantly to the attractions for tourists at the Cliffs of Moher were it to return there. Since 2008, the Birds of Prey Centre at Aillwee Cave has been thrilling visitors with displays of raptors on the wing and with hawk walks into the hinterland. Birds of prey (falcons, hawks, vultures, eagles and owls) from all over the world are on show in the extensive raptor aviary. While the majority of the birds are native to other countries, some – the peregrine, merlin, barn own and long-eared owl – are native Irish species. One, a young female white-tailed sea eagle, caused consternation on an occasion in July 2010 when, during an open-air display, a wild eagle appeared high above the centre and made vocal contact with the captive bird. The wild eagle – probably a stray from the eagle introduction programme in Kerry – entertained the gathering by swooping down dramatically to cavort with its captive counterpart. The captive eagle, to the great relief of the staff, eventually returned to its handler, leaving the other bird to continue on its way, under harassment by a pair of ravens. Was the wild eagle in transit – to Connemara perhaps – or was it prospecting in the Burren, where suitable eagle habitat undoubtedly exists? While the incident was a one-off, it demonstrated the capacity of these huge raptors to wander effortlessly hundreds of kilometres away from their homes. Though golden eagles have shown similar peregrinations, their preference for uninhabited highlands renders them unlikely returnees, at least in the short term. We will have to wait a lot longer, I suspect, to welcome their return to Eagle's Rock.

Old Goats

As with the pine marten or the gentian, the wild goat is emblematic of the Burren's wildlife. It is, in fact, feral – a human introduction that has gone wild. On approach, a herd of Burren goats will head off in a shy straggle or, when their kids are young, take up a defensive phalanx with impressive scimitar-horned billies at the front, as would wild ungulates in their native mountains. They look so much a part of the landscape, with its rocky terraces and crumbling stone structures, that it is hard to imagine the place without them.

From my experience, the herds tend to be of a size between fifty and a hundred animals, though in good breeding years they may amount to several hundred. The males, sporting wide, sweeping horns (sometimes a metre wide) are spectacular beasts. They disport themselves at their most dramatic during autumn rutting, when they bash their heads together to establish seniority and gain access to the females – which, unlike deer, are also horned and bearded. At

this time, the musky smell of mating, issued from a gland at the base of the horns, pervades the limestone uplands. The most venerable specimens are so theatrical looking they could be candidates for King Puck at the annual Puck Fair in Killorglin, County Kerry. Their colour and pattern is extremely variable – beige, chocolate brown, grey or a patterned combination of these being common. The occasional big black males convey a sense of the diabolical when viewed head-on, an illusion at odds with their potential to do harm. Goat numbers fluctuate according to augmentation by escapes from the many goat farms in north Clare and natural attrition due to the effects of the elements and occasional culling. A programme of unauthorised culling in the early years of the new millennium is thought to have reduced the population by more than a half. One (probably exaggerated) report claimed that thousands of goats had been removed from the region in a series of 'secret round-ups' over a period of ten years. Though feral animals are not protected under the 1976 Wildlife Act, the same report justifiably highlighted the illegality of such unilateral action, which contravened the European Transport of Animals Act. Many Burren farmers have an ambivalent attitude to the goats: on the one hand, they may support them for their capacity to keep back the spread of the scrub by browsing; on the other, they may despise them for competing with winterage cattle for upland grazing and for their propensity to knock down drystone walls in seeking it out.

Goats have been a part of the Burren for a very long time. Their bones have been found in numerous archaeological sites, even the earliest, along with those of cattle. Doubtless they have done their bit in rendering the Burren the bare landscape it is today. Goats have been kept for meat, milk and cheese, and especially for the renowned succulence of kid flesh. The milk is highly regarded for its efficacious qualities due to the wide range of herbage consumed; it has long been regarded as a standard remedy for people with respiratory problems and weak children. The cheese being made from it today

is of renowned high quality and much marketed throughout Ireland and abroad. The Burren uplands are littered with small collapsed stone structures known locally as *crós*. These simple structures were used for holding kid goats in early spring, away from grass and the attentions of the mother. The kid, suckled only in the morning and evening, would eventually be killed for the Easter celebration. Though more or less discontinued today, this practice, in its pre-Christian manifestation, might well be as old as goat husbandry.

Up until the turn of the last millennium, the Burren goat was considered (along with other surviving pockets of wild goats elsewhere in the country) of no particular heritage value. However,

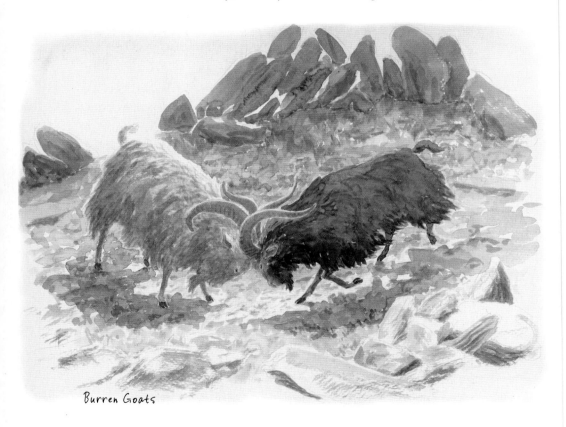

Burren Goats

a study in 2004 revealed that perhaps 10 to 15 per cent of the thousand or so animals then in the region showed characteristics of an ancient phenotype – the Old Irish goat. This beast, thought to be genetically connected to the original domestic animal brought to Ireland by Neolithic and Bronze Age farmers, is recognisably distinct from the recently introduced Swiss goat, commonly kept in modern goat farms. The physical differences include a concave shape to the front of the face, small pricked (upright) ears and stocky stature. Goats with these characteristics are known in a number of other upland regions in Ireland and correspond to other wild herds found in parts of the UK, particularly Scotland. The Irish animal is apparently a representative of the Northern Breed Group, formerly the only breed that ranged over Ireland, the UK, Iceland, Scandinavia and perhaps one or two other European countries. In the decline throughout most of this former range, the population remaining in the UK and Ireland represents the largest surviving fraction. The Irish Goat Society, having for many years promoted the vulnerability of the Old Irish goat, has, with the support of a number of national bodies including the Parks and Wildlife Service and Burren Life, succeeded in having it granted protection status in the Burren.

A Burren farmer, Patrick McCormack, working in conjunction with Burren Life, has managed to isolate a herd comprised of both male and female Old Irish goats. These are being kept away from the wild herds with a view to protecting the genotype. DNA analysis has shown that despite the inevitable cross-breeding and dilution of genetic integrity, goats with the dominant characteristics of the ancient breed still roam the Burren uplands.

In recent years, Burren farmers have expressed a greater tolerance for goats based on their scrub-containment capability. Their method of browsing by chewing and twisting saplings of hazel, ash, holly, elm and even yew (which is well known for its toxicity to cattle) often kills off new growth before it gets established. They can also digest

fungal ergot in grasses that are harmful to bovines. Older farmers may recount other favourable characteristics, including their pacifying presence near other livestock and their habit of removing ivy and other escarpment species in advance of cattle, thus protecting stock by default. Their ability to seek out sweet-tasting tussocks halfway down the Cliffs of Moher or high on Eagle's Rock has even earned them a sneaking admiration.

This newly revealed heritage value, combined with an increased awareness of their practical importance, is swinging the pendulum of tolerance in favour of the remaining Old Irish goats. Though not wild in the normally accepted sense of the word, they nevertheless occupy an exalted status, deserving consideration as worthy members of the Burren's rich fauna.

Rock 'Cats'

The furry form of the pine marten against a background of Burren limestone is as familiar on postcards or in book illustrations as the blue gentian. Such distinction is entirely legitimate, given that, less than a century ago, this large member of the stoat family was heading for extinction in Ireland. The Burren at one time represented its final stronghold. We owe a debt to an unsung group of concerned enthusiasts, such as John MacNamara from Fanore, who saw to it that pine martens could continue to find a safe refuge in the Burren at a time when they were nothing more than a folk memory in other parts of the country. In a determined effort to ward off possible extinction and genetic decline due to inbreeding, between 1985 and 1992 Paddy O'Sullivan of the Wildlife Service transported some thirty pine martens from the Burren region to Killarney National Park, a former habitat. The translocation has been a great success and the animals are once again well represented in the Kerry woods. A captive

breeding programme was less successful, perhaps as a consequence of stress felt by the animals in the confines of the breeding compound. In general terms, the development of commercial forestry has enabled the pine marten to greatly expand its range. Nowadays, it is thinly distributed in plantations throughout the country and its future survival is no longer in question.

Admiring a photograph or a well-wrought illustration is one thing; seeing a pine marten in real life is quite another. There are, of course, regular 'sight spots' – road crossings, feeding stations and the like, where prearranged sightings are possible – but in

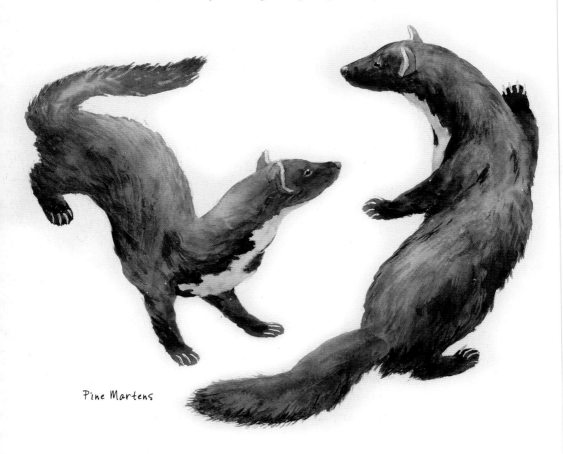

Pine Martens

general the pine marten is regarded as our most elusive mammal. There are, for instance, many Burren inhabitants who have never seen one. I have been lucky. But for someone who has recorded more than a thousand rambles in the region, my encounters with live pine martens (unfortunately they are most frequently seen dead on the road) amount to a mere fraction of those with others of the mustelid family. Gerrit van Gelderen, in his 1985 book *To the Waters and the Wild*, endorses the animal's elusiveness, mentioning the few occasions on which he encountered it in the Burren. He recounts an extraordinary nature ramble taken with John MacNamara into the wilds of Ballyryan where he came face to face with a pine marten and its kittens. Like so many naturalists and film-makers, he was clearly captivated by their beauty. I remember meeting an old lady in the 1980s who lived alone in Ballyryan (before its wildness was reduced by land reclamation), and who fed the pine martens with scraps from her back door.

I still bask in the memory of my own unique pine marten experience, in 1990. It was wildlife photographer John Hayward who found its home – high up on the face of a precipitous canyon in the north Burren. The den itself, a sheltered crevice in the limestone, was hidden from view behind a scrawny holly tree. Over the course of the spring and summer, we enjoyed many theatre-box views of the comings and goings from the other side of the canyon, some 20 m (65 feet) away.

The spring of 1990 was, as recorded in my notebook, particularly fine. Time spent at the vantage point opposite the nest was also time spent amid the natural Burren at its optimum. Gentians, mountain avens and a plethora of other Burren floral specialities adorned the open rock and a resplendent pink-blossomed crab apple tree decorated the bottom of the gorge. Spots of colour – yellow, blue, orange – came to life as butterflies – brimstones, holly blues, fritillaries – in the windless heat of the gorge below. Cuckoos echoed

their pleasing monotony, while small lizards basked on the warm rock nearby. All this and much more filled the waiting hours between views of the pine martens.

When the animals did appear, it was invariably unexpected. The adult, on return, would emit a quiet bark, eliciting mouse-like squeaking from the kittens. Food carried in the mouth – a dead bird or a young rabbit – could be identified through binoculars, as the animal deftly scaled down the cliff to the nest. Within a few minutes of disappearing behind the holly bush, the pine marten on domestic duty would be relieved by its partner. This happened daily, often in mid-afternoon. Such times of exchange offered opportunities to compare the physical differences between the adults. The female was a quarter smaller, a lot slimmer and (though this was probably no more than random variation) more tawny than the mahogany-coloured male. In his summer pelt, he was as substantial as a Persian cat, with an extravagantly furry tail. Unlike others of the mustelid tribe, his facial expression radiated intelligence, as distinct, for instance, from the rather menacing expression of a mink. Both adults had a clear yellow throat patch and prominent, cream-edged ears. The brevity of the views (less than a minute at a time) was nevertheless sufficient, time and again, to admire their singular beauty.

I have no doubt that the adult pine martens were aware of our presence but, whether realising that we could not easily approach them or simply that we were not a threat, they went about their business completely unperturbed. Even the activities of rock climbers, ignorant of the presence of the gorge's celebrated inhabitants, did not seem to much alarm them: they came and went unconcernedly, one at a time, when the coast was clear.

The arrival of a fox one day was received altogether differently – indeed, with dramatic repercussions. It was clear, owing to subsequent sightings, that the gorge was a regular run for the fox – perhaps the edge of its territory. Unfortunately, due to other commitments,

I was not around for the emergence of the kittens. But John had watched them, in June, playing in the base of the gorge, and had obtained fine photographs of the family. It was around this time, he thought, that the fox must have attacked, for when he next checked the den only one of the young pine martens remained, and there was no sign of the adults. The outcome would have been a total disaster had not John rescued the surviving kitten and raised it at his home in a specially constructed pen. By mid-July it was almost full-grown and in frisky good health. Not long afterwards, it was released back into the Burren.

As their name suggests, pine martens were originally arboreal; their capacity to spread with the expansion of forestry illustrates this. Their subfossil remains – from archaeological sites including Poulnabrone Dolmen and *Cathair Chomáin* cliff fort – point to their ancient pedigree as Burren inhabitants. Doubtless, they occupied the limestone country in prehistoric times when it was covered with pines, adapting later to life in the open. Elsewhere in Europe, they habitually nest in hollow trees, an option now denied them in the Burren due to lack of tree cover. They do, however, occupy the roof space of abandoned and ruined buildings. One pine marten family was raised in the attic of an unoccupied cottage, the adults entering and exiting through the chimney (see 'The Caher River', p. 95). In another instance, the access was through a hole in the thatch of a vacated farmhouse. In these circumstances, the animals are usually gone by late summer, but not (to the annoyance of the owners) before leaving a considerable mess behind.

Despite its detractors, many people are glad to know that this beautiful animal, an original inhabitant of our postglacial pine forests, can still find a home in the Burren today and bring excitement with its unexpected appearances.

Stoat Antics

This little carnivore, so suited to life in the rocky terrain and so often seen by visitors, is a frequent subject of conversation and amusement. I can't count the number of times I have been stopped in a Burren street, shop or hostelry with the words, 'Do you know what I saw the other day ... and it came right up to me!' And so begins an enthusiastic discourse on an encounter with a stoat. My own nature diaries are full of stoat encounters. There are of course plenty of stoats elsewhere in Ireland, in all sorts of habitats, but they seem so much at home in the karst, from mountaintop to sea level (and in the Aran Islands), both in the open and in the confines of man-made structures such as cashels, as to be synonymous with the region. The stoat is regularly seen dancing along the top of a drystone wall, using it as a vantage to look for prey. Physically disadvantaged by its stumpy legs, it often compensates by standing up on its hind legs like a meerkat. In Ireland it is often referred to as 'weasel', the closely related member of the

same family. However, the weasel is smaller, lacks the distinctive black tail tip and, although found commonly throughout Britain and Europe, does not occur at all in Ireland. The Irish stoat has a distinguished pedigree, being only one of two mammals to have come down to us from the Ice Age. The other is the Irish hare: a mammalian success story, also common in the Burren. In the ten thousand or so years of isolation here, *Mustela erminea hibernica* has evolved into a distinct subspecies of the European stoat. It is visibly different from its British counterpart, being generally darker and having its creamy underparts irregularly rather than linearly demarcated from its brown upper parts. In the north of Scotland, the stoat moults into its pure white winter coat, offset by its black-tipped tail. This, the ermine, was much sought after as decoration for regal garments. In Ireland, north or south, while it may moult partially white it does not turn ermine white. In a note in *Zoologist* in 1892, G. H. Kinahan remarked that he had seen 'piebald' stoats in the Burren and the crags of Galway and Mayo. While I have not seen a similarly patterned animal, my postman described having seen one in January 2014, not far from Kinvara, which he asserts was 'pure white with a black tail'.

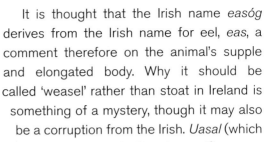

It is thought that the Irish name *easóg* derives from the Irish name for eel, *eas*, a comment therefore on the animal's supple and elongated body. Why it should be called 'weasel' rather than stoat in Ireland is something of a mystery, though it may also be a corruption from the Irish. *Uasal* (which sounds like 'weasel') means noble, or of noble birth, and may reflect the use to which its pelt was commonly put – as a decorative fur edging in a nobleman's garment. There is also the suggestion, given the rich folklore connected with the little animal throughout Ireland, that the stoat itself was seen as a noble animal.

The key to the stoat's success lies not only in its capacity to adapt to new and man-made habitats but also in being able to seek out and consume a wide variety of prey. Though classically thought of as a rabbit hunter or raider of birds' nests (both of which are readily available in the Burren), it is by no means diet specific. It catches rodents as small as pigmy shrews and as large as rats. Wood mice (found by zoologist James Fairley to be extraordinarily abundant in the Burren) must constitute a disproportionately large fraction of its prey. Though not widely known, stoats also catch small fish in coastal rock pools. How they manage to do this, given their physical limitations, is beyond comprehension. (I have never seen them actually do it.) The fact that they succeed must be down to their amazing agility. On 6 December 2002, while parked at the Flaggy Shore, I watched one return again and again to a rocky cleft from the

shore, each time with a small fish (a goby or blenny, I imagine) in its mouth. It may have been feeding young out of sight. At Black Head, they have been seen brazenly making off with fishermen's catch. On several occasions in August and again in November 1994, rod and line fishermen watched in amazement as a stoat dragged a mackerel as big and heavy as itself for several metres across the rocky ledge and down a grike for private consumption. They are well known for demonstrating such risk-taking for the sake of food.

Stoats are also fearless when with young. On one memorable occasion while lunching on the stony shore near Kinvara, I found myself suddenly and somewhat alarmingly surrounded by stoats. They, adults

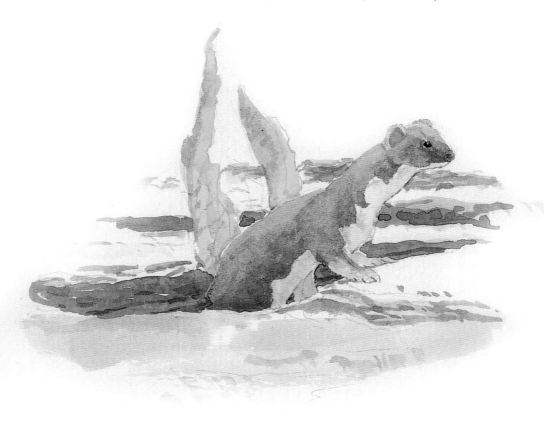

and an indeterminate number of young, appeared and disappeared like lightning into the fissured rock within a few metres of where I was sitting. As I sat there, they began to engage in a threatening display – running, stopping close by, retreating – constantly berating me with intermittent wren-like 'churring'. They kept this up, eventually generating such uneasiness to have me move away. This was not the well-known 'jump for joy' behaviour associated with training the young to mesmerise and catch prey; it was decidedly aggressive. I don't know why their behaviour was so resolute. I can only conclude that I had chosen the wrong place next to their den, perhaps, and that they perceived me as a threat to family security. Besides using their inherent aggression when deemed necessary, stoats are particularly good parents. On one occasion, close to Gleninagh Castle, I watched what I assumed to be a mother stoat dedicatedly carry each of its eight offspring from the stones of the storm beach to a new home beneath a large boulder. Like a leopard with an antelope, she dragged them one by one to the shadow beneath a boulder 20 m (65 feet) away. Each waited dutifully until all were assembled and the adult, uttering a reassuring squeak, finally joined them.

Michael Lynch and his team of fellow archaeologists, while working on the Mesolithic site near Fanore, stopped to watch a similarly engaging stoat event. An entire stoat family were on the move, perhaps as a result of the disturbance caused by the excavation. Unperturbed by the worksite, an adult stoat led a train of about ten young past and within a few metres of the archaeologists. They watched, intrigued, as the adult went back

again and again to retrieve and cajole reluctant offspring to join the others making their way to a more secluded location. Such an incident explains why this endearing yet ruthless predator is so admired by those who are fortunate enough to encounter it at close quarters.

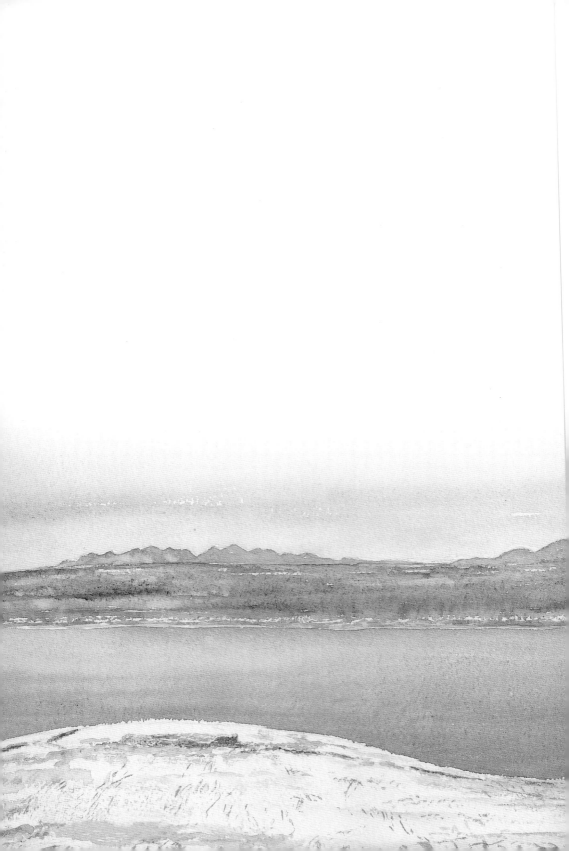

5

Along the Shore

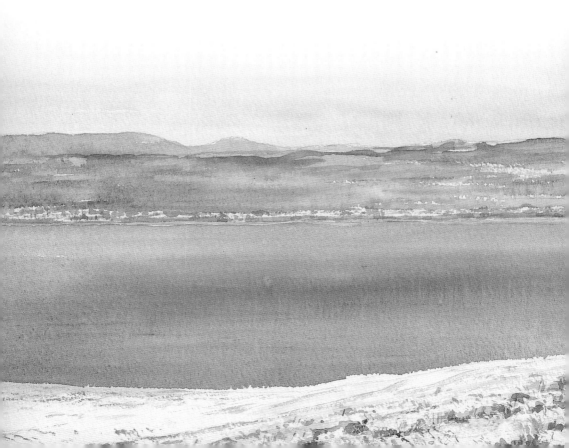

'Dusty'

When the singer Dusty Springfield was dying, she apparently requested her ashes to be distributed at the Cliffs of Moher. Though decidedly recent, this event is already a Burren legend and like most legends it has taken on a life of its own. When a bottle-nosed dolphin appeared close inshore on the County Clare coast some time later, it was assumed to be the singer reincarnate and was accordingly named 'Dusty'.

Spotted first by fishermen in 1998, Dusty had, by the summer of 2000, become a regular accompaniment to the ferry between Doolin and the Aran Islands, and the coastguard vessel on manoeuvres.

Having more or less taken up residence in a little cove, *Poll Mairéad Ní Thuathail*, a kilometre south of Fanore, in sympathy with the iconic status of her human namesake, she soon attracted sightseers and wellwishers galore. She (gender assumed) fast became the Burren's answer to Fungi, Dingle's perennial cetacean superstar.

Initially her relationship with people was benign – as it has remained with Fungi. Everyone, it seemed, was excited by the presence of the exotic newcomer. As parked cars, bikes, camper vans and slow-moving coaches began to clog up the coast road, seriously interfering with the flow of traffic, however, attitudes changed. Tensions boiled over when nearby property owners found their freedom seriously curtailed by the crowds of enthusiastic dolphin watchers, blind to the sensitivities of local residents. Protests followed and signs making it clear that cavalier behaviour of this kind would not be tolerated were erected. Obstacles were placed in front of roadside houses to insure that obstructive parking could not continue as before.

Still people came. They picnicked, partied, held night-time vigils by moonlight and torchlight. Enthusiasts of all ages took to the water to swim with the dolphin. Kayakers and boaters plied the waters at the entrance to the cove. Sub-aqua enthusiasts practised synchronised swimming and deep diving alongside the celebrity. One young woman, having developed an intimate relationship with Dusty, practised a graceful pas de deux resembling a sub-aquatic ballet.

Gradually, Dusty's behaviour became more and more unpredictable. She would disappear to destinations unknown for long periods and would suddenly, unexpectedly, return – to rousing response from fans. Her erratic behaviour was manifest in swift circuiting of the little cove, her swept-back dorsal fin knifing the waves, followed by tail-thrashing on the water surface. This often resulted in alarmed parents recalling their children even from the shallows. Older folk took to wearing life jackets as a matter of course and kayaks kept well away from the dynamic mammal for fear of capsize. When a few swimmers were vigorously butted by Dusty, it became clear that something was awry. Mouth-rattling and rapid opening and closing of the mandibles were seen as signals to vacate the water altogether. Conservationists from the Irish Whale and Dolphin Group issued a warning discouraging people from swimming near Dusty.

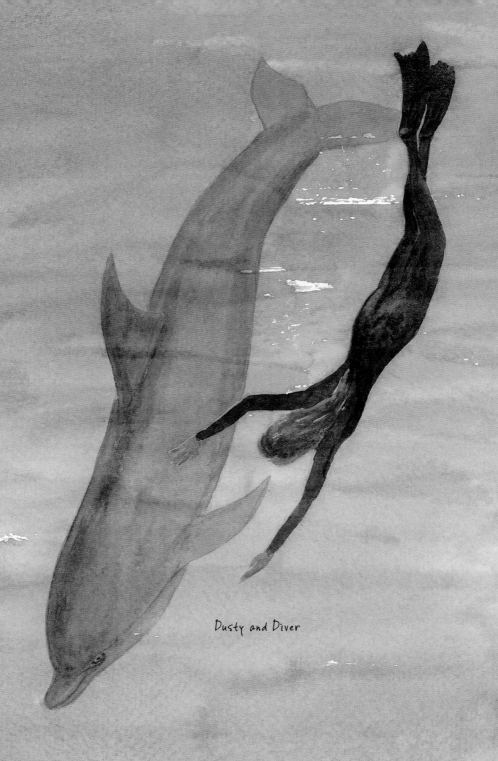

Dusty and Diver

Dusty 183

Unfortunately, this was not heeded by all. A near-death experience inflicted on her former human partner and confidant in 2011 resulted in the woman being evacuated to hospital in Germany, and a BBC News report of 3 August 2013 reported that two women had been badly hurt by the 'same dolphin' during a ten-day period: one was aggressively rammed in the stomach, the other sustained a broken rib, compressed vertebrae and lung damage. Both were taken to hospital.

The Irish Whale and Dolphin Group, the organisation committed to cetacean conservation, under the directorship of Simon Berrow, has an unsentimental view of these mammals and their relationship with humans. While emphasising their incredible communication skills, strong social bonds, intelligence and adaptability – traits that win universal admiration from humans – the group also publicises their capacity (like other wild animals, and humans) to be aggressive. As with other mammals, males can be particularly aggressive and may even kill pups to facilitate mating. Dusty (eventually confirmed as a young female) added another dimension to the spectrum of dolphin behaviour. Her aggression by all accounts cannot simply be put down to cetacean exuberance, to watery boisterousness; it was simply too violent for that. Of course, she may have been, or had developed into, a one-off, unpredictable wayward, perhaps affected anatomically by some unknown natural irritant, a parasite perhaps, but any human – no matter how aquatically competent – assumes a great deal in befriending a powerful half-ton animal in its natural medium. Dolphins are naturally gregarious. It has been established by modern research that contact within the pod occurs by way of a 'signature whistle' conveyed to each young member by their mother. Is the isolation of a particular dolphin therefore triggered by loss of contact with family members through some inexplicable failure of this unique communicatory initiation?

There is among conservationists the belief that interference in the marine environment is a factor in behavioural change in sea

creatures such as dolphins. Increasing fluctuations in ocean currents and temperatures, water quality, availability of fish stocks and other attendant ecological factors are frequently cited. Berrow points to change in ambient noise levels in the sea – particularly those initiated by humans – as a potential factor. The proliferation of modern, high-tech ocean-going vessels, such as inshore boats with loud motors and submarines, has undoubtedly been making our seas noisier. Are cetaceans – creatures that in everyday existence rely heavily on their sophisticated sonar system – suffering as a result of these disturbances? Is there in fact a connection between the frequent incidents of cetacean strandings around our coasts and disruptive ocean noise? Judging from the regularity of news media reportage, these distressing events do seem to be on the increase.

Dusty's underwater world is vast, but it is interpreted by a vocabulary of complex squeaks and clicks. Could her increased aggression be linked to the 'white noise' created by humans above and within her otherwise peaceful cove? Early reports suggest that she originally sought out human company; she may have been excited at encountering new playfellows. But just as a human might develop a headache, did the build-up of stress in the noisy environment cause her to react as an irritated adolescent might after a party?

In a broader context, could there be a connection between the excited visitor responses and the recent tragic events involving cetaceans in enclosed circumstances? Noise levels in confined show arenas are invariably elevated, high-pitched and, as in indoor swimming pools, amplified by echo. Could recent attacks by orcas on their often long-standing and trusted handlers be a consequence of the frustrations attendant on inescapable elevated noise levels?

Regardless of the undoubted entertainment provided by dolphins and their kin, whether captive or free, we can never forget that they are creatures of another world, one that we must enter on their terms.

At the time of writing, Dusty is still around. She has been seen

hanging out near Inis Oírr, the nearest of the Aran Islands, and seems to have lost interest in her former play area. However, another bottle-nosed dolphin named Clet (for reasons unknown to me) has been seen interacting exuberantly with surfers. To date, its occasional bouts of boisterousness have been put down to fun-seeking, though a swimmer was buffeted and bruised. Another (perhaps Clet?) has been reported as being a nuisance to swimmers at Blackrock near Salthill. Given Dusty's rapid drop from favour, it is likely that even one over-the-top incident could be enough to have this new animal ostracised as a threat to public safety. It would be a pity, in general, if it became necessary for lifeguards to warn bathers of the proximity of one of these much-loved, but sometimes unpredictable, mammals.

Dolphin Days

On 24 July 2014, a surfer at Fanore was joined by a pod of no fewer than twenty-five bottle-nosed dolphins, which cavorted and played in his company for the best part of an hour. This kind of event is by no means a rarity, though it is much more likely now than in the years prior to the new millennium. In fact, nowadays, incidents of cetacean appearances are much too frequent to be recorded. The sea temperature in 2014 reached 19 °C, the highest yet recorded for the Burren coast. This warming of inshore waters has been connected with increased piscine and cetacean activity. Basking sharks are occurring with greater frequency off the Kerry coast and have made a comeback to Achill, where in the 1950s they were hunted almost to extinction. Sunfish, those great, circular flat-bodied fish of warm waters, are being encountered regularly in west of Ireland fishing zones, their languidly waving dorsal fin announcing their presence in calm waters. Their main prey, jellyfish, also appear to be occurring

in greater quantity. On the day of the dolphins at Fanore, the beach was littered with washed-up (non-stinging) moon jellyfish. They were so numerous they formed an unpleasant gelatinous barrier to be negotiated by bathers heading into the water.

These are among well substantiated reports pointing to changes in our coastal ecology and the onset of climate change.

Cetaceans of many species are well known on the Burren coast. The middle-sized bottle-nosed dolphin is perhaps the most familiar. Smaller species include the white-beaked, white-sided and common dolphins. The porpoise, the smallest and probably the commonest, is found close in off Black Head, where it is often reported by artist and cetacean watcher Sabine Springer. Many other species, recorded by zoologist James Fairley, have been found either stranded or washed up dead in Galway Bay. I regularly encounter the carcasses of dolphins and porpoises in inner Galway Bay; once, I came across that of a minke whale. Other large members of the tribe, such as pilot whales and (on one or two occasions) orcas have been identified off Black Head. On a day in summer 1988, a male and two females were clearly seen: they were easily identified by their large size, high dorsal fins and pied pattern. For most of the others, however, there is often an element of doubt since views tend to be brief and distant, and confusion with similar species cannot be eliminated. Such a difficulty arose in May 1995, a time when many cetaceans were to be seen along the west coast, at the start of what was to be one of the best summers of the century. What I took at the time to be rare false killer whales, due to their size and fin structure, may in fact have been another, commoner species. Not so a young humpback whale, which with characteristic breeching (hurtling into the air and splashing down again into the water) entertained trippers to the Aran Islands on many occasions throughout that summer.

On a day in May 1995, a pod of Risso's dolphins came so close by Black Head that identification was without doubt. Having seen them

before off Cape Clear Island in Cork, I knew what to look for. Bigger than bottle-nosed dolphins at perhaps 4 m (13 feet) long, pale grey with very pale, almost white heads, and with high swept-back dorsal fins, they made a dramatic appearance as they rolled and heaved, audibly puffing their exhalation. Telltale scars and abrasions on their upper bodies (caused, apparently, by sharp lower-jaw teeth during bouts of sparring) were clearly visible. Again, on 22 October, a pod of the same species (perhaps the same one) appeared unexpectedly close inshore at Gleninagh, a kilometre or so from Black Head. Watching from near sea level allowed good views of their domed heads as they spouted and rolled forward into the waves. Their massive lumbering forms conveyed a ghostly image, like the entourage of Manannán Mac Lir or some other mythical figure returning from the depths.

A 20-m (65-foot) fin whale washed up on the rocky shore between Fanore and Black Head, showing that even the largest whales ply these waters on occasions. Its carcass became the object

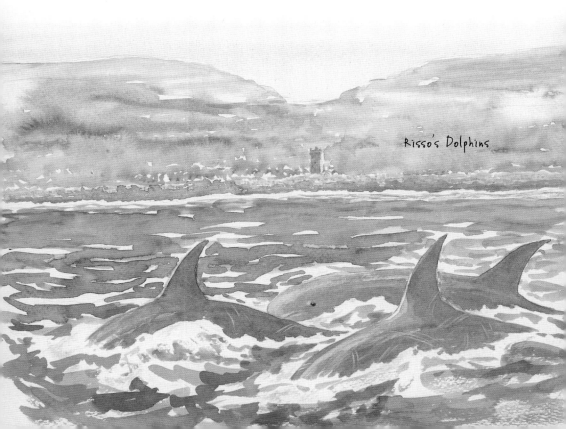

Risso's Dolphins

of considerable attention. Initially, it was shunned due to the stench from its rotting flesh. With the passing of time, however, and the scavenging efficiency of gull, crow and fox, its bare skeleton became the focus of attention for visitors. Ultimately, it was disassembled by sightseers, who made off with sundry bones for garden ornaments. The skeletal jawbone of a sperm whale, washed up on one of the Aran Islands, was incorporated into a drystone wall near the shore and provided a handy reinforcement spar. A most intriguing carcass was that of a pigmy sperm whale, washed up on the shore near Kinvara in 1999. This cetacean (in fact unrelated to the well-known sperm whale), though not much bigger than a large dolphin, shows a distinct profile resemblance to the blunt-headed 'Moby Dick'. A tropical-temperate water species, unknown in the waters around the British Isles until 1966, it initially became a celebrity corpse when one was identified washed up on the shore near Lahinch, just south of the Burren. It may therefore be a more regular visitor than its subsequent rare strandings suggest.

A study carried out by the Irish Whale and Dolphin Group in the period 2011–13 revealed the stranding of a total of fourteen species, the majority (64 per cent) of which were of common dolphins and harbour porpoises. In addition, the figures showed a general increase in the number of strandings over the study period, with a maximum of 193 in 2013. Unequivocal and disturbing as these findings are, it will probably take longer (a ten-year span perhaps?) to establish whether or not this upward trend is ongoing and what the cause or causes might be.

With the banning of whale hunting and the designation of Ireland's inshore waters as a cetacean protectorate, whales and dolphins are being seen with greater regularity than for many years. Fin, humpback and even occasional blue whales occur now within sight of Ireland's south-western coasts. Whale surveys carried out by members of the Irish Whale and Dolphin Group are now regular events not only

from boats or aircraft but also from headlands around our coast. Also, regular tourist dolphin-watching boat trips operate from several locations along the coast.

Black Head, on the Burren's Atlantic coast, may not be as prominent as some other regular viewing points but it is always worth a stop and a look when passing.

Storm Birds

Wednesday 22 October 1986 was no ordinary autumnal day in the Burren. Two days of westerly gales pushed in by a deepening Atlantic depression had created a storm of monumental proportions. People inland simply stayed indoors. Only the reckless or those on a mission ventured out along the coast road. The Burren Harvest Symposium, an annual gathering of wildlife enthusiasts held at Ballinalacken (near Ballyryan) on the west coast had the makings of a washout. Attendees, 'lectured out' by Saturday lunchtime, yearned for a *real* nature experience in the outdoors. Despite the horrendous conditions, it was clear that a few stalwarts were prepared to venture out – in cars. Thus, like Scott leading his intrepid band on the South Pole expedition, I found myself leading a convoy of cars towards Black Head to look for seabirds: there was no point in searching out other nature; there was no other living thing to be seen.

That late autumnal storm was an echo of an even more savage

event, Hurricane Charlie, which had hammered Ireland two months earlier. It had assaulted open country, knocking down long-standing drystone walls, uprooting trees and salt-scorching the seaward side of yew bushes at Lough Bunny, 30 km (18 miles) from the coast. Described as 'an extra-tropical cyclone' by the Met Office, its winds – well in excess of 100 km (60 miles) per hour – had created downright dangerous conditions for anyone foolhardy enough to venture out into it.

Forewarned of the risks, we struggled down the steps like a line of manacled prisoners towards the light station and the only shelter available. The leeward side of the structure would be both our sanctuary and our observation post. Huge waves pounding the low cliffs below sent seismic shudders through the rock and through us. Sheets of spray periodically engulfed our shelter, sending foam up as far as the road. In front, the sea roiled in a watery rage, its charcoal depths indistinguishable from the angry sky. Only the charging ranks of white horses gave definition to the scene. Looking at the ironic smiles on the faces of my accomplices, I realised that there had to be something perverse in all of us: who in their right mind would subject themselves to soaked discomfort, huddled against a wall, binoculars trained on a mountainous sea?

I thought back to my early birdwatching days in Northern Ireland and to weekends spent perched on a clifftop or marooned on an island to watch migrating seabirds. Many memorable (if uncomfortable) days were spent doing just that at isolated promontories like Benbane Head in County Antrim, or beneath the lighthouse at St John's Point in County Down. And despite the oft-cited impatience of youth, the activity continues to attract young, diehard enthusiasts. Loop Head in County Clare and Cape Clear Island in County Cork, two outstanding seabird-watching locations, retain a vibrant following.

What is the attraction? What would cause otherwise normal people to retire to remote perches to sit for hours in discomfort looking at

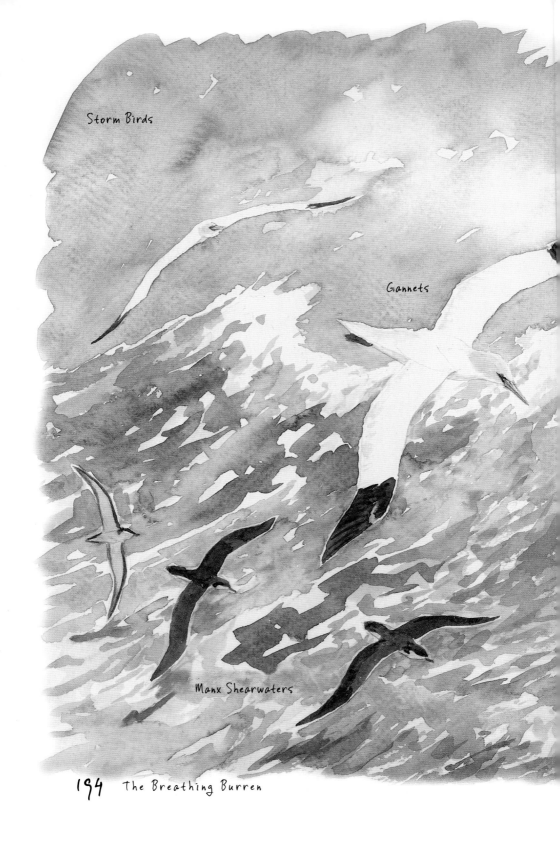

Storm Birds

Gannets

Manx Shearwaters

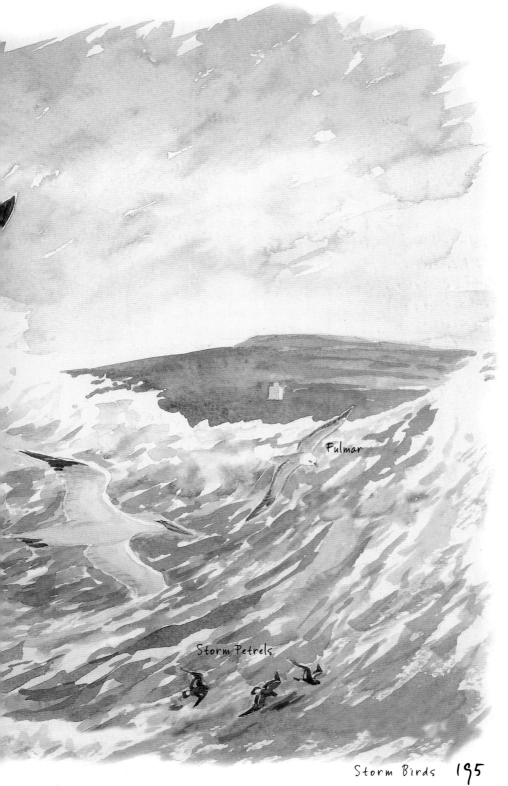

Fulmar

Storm Petrels

Storm Birds 195

the sea? I have contemplated this and have come to the conclusion that there are several factors involved. The seabird watcher is a pioneer of a kind, drawn by the possibility of witnessing some special ornithological event, something rare. It might be a spectacular mass movement of seabirds on migration or the chance observation of some alien pelagic species blown in from another part of the world. The idea of being a voyeur at some otherwise unwitnessed event has a cachet that is particularly appealing to the adventurous. Being in a position to observe while being safely detached from the elemental chaos of the circumstance is a bonus. There is a sense (often exaggerated by the more serious devotees) that one is engaged in scientific endeavour – adding fresh material to our store of knowledge of the natural world. Finally, and perhaps most significantly, there is a spiritual connection – the often unspoken (and perhaps unrealised) outcome of private communion with great elemental forces.

As it happened, we had timed our visit perfectly. It was 3 p.m. Seabirds were streaming past so closely we could see their features even without binoculars. They poured past us in long, undulating lines, all in the same direction – towards the south-west. As we watched, scores of dainty kittiwakes battled the gale. In an hour, more than 700 had made their way past our viewing point. They were accompanied at one point by two little gulls, waifs from other shores. Periodically, groups of skuas appeared. These oceanic bullies make their living harassing other seabirds for their food, often forcing them to regurgitate it in the process. The smaller gulls would have been easy pickings. It was evident, however, that discretion had taken precedence over indulgence and survival was the order of the day, even for the skuas. Most of the skuas were bonxies – heavy set, sinister-looking seabirds, sporting white warning flashes on their wings, but here appearing strangely incompetent as they beat hard into the storm. Others, more hawk-like pirates – Arctic skuas – joined in the laboured parade. A flock of nine pomarine skuas, distinguishable by their twisted central

tail feathers, scarce visitors to Irish coasts, provided field-guide type views, eliciting a stir among the observers.

Other birds – gannets, fulmars, guillemots and razorbills – battled against the wall of wind and surf in an effort to make progress past Black Head. A line of black-and-white shearwaters, veering close to the surface on scythe-like wings, managed more competently than the others. Some poor fliers, cormorants and shags, defeated by the storm and rendered immobile through exhaustion, were flung ruthlessly to the water, desperately seeking respite. Many would perish.

Occasional gaps in the wave crests allowed glimpses of deep in-between hollows. Here and there, tiny feathered forms – storm petrels – negotiated the ever-changing troughs, careful to avoid confrontation with the merciless gusts that would fling them like caps a kilometre or more back into the bay. It is astonishing how these tiniest of seabirds can nonchalantly patter the water surface in feeding while their much larger and powerful counterparts must battle relentlessly just to stay airborne. Even more unexpected was a cluster of grey phalaropes that, like tiny sea gulls, fluttered and settled briefly on the roiling sea, sharing the troughs with the petrels. There was no mistaking them as they entertained us, defiantly dancing and twirling on the water before taking off on the angled wings of sandpipers. They zigzagged their way competently through the heaving canyons of the waves that would ultimately convey them to quieter southern oceans, where they would spend the winter.

Shortly after 4 p.m. the storm lessened to a gale before gradually dying off. On cue, the seabirds disappeared, drawn away no doubt by the promise of more equable conditions further from shore. With fading light, we elected to retire to the cars and the comfort of the nearest hostelry.

There was lightness now in our step. People were clearly buoyed up by the exhilaration of the seabird experience and also by a sense

of privilege – of having had the good fortune to be present at the unfolding of a unique spectacle.

One tends to think terrestrially about the Burren's wildlife wealth. Seabird watching is another, largely unrecognised aspect. Over the years, I have enjoyed many Black Head experiences, though none quite as bird-filled as that of October 1986. Patient observation, allowing the drama to take precedence over discomfort, is a must in every case.

In these times of climate change, with forebodings of gales increasing in frequency and severity, where battening down the hatches is the normal human response, battling storms birds demonstrate that even in the most hostile circumstances, nature's rhythms proceed unabated.

A Dandy's Refrain

Every year, around the time of the spring equinox, a remarkable bird assembly takes place on the north Burren coast. It is remarkable, not for its large numbers, but for the fact that such a gathering takes place at all. The birds, great northern divers, are for the most part solitary winter visitors, though, like all birds, they pair off for the breeding season. Nor are they alone. Another assembly of black-throated divers, scarce relatives of the larger birds, usually accompanies them, though at a discrete distance. The gathering may remain till late April, the birds awaiting favourable weather conditions as a prelude to departure for Arctic and Northern European breeding grounds.

Ireland hosts three species of divers – the great northern, the black-throated and the red-throated (less common than the others in Galway Bay) – on its inshore waters during the winter months. Both of the 'throated' species belong to the Western Palaearctic – that is, the European Arctic. The great northern, on the other hand, is essentially

Nearctic, its range encompassing the remote wetlands of Canada, many of the northern states of the US and southern Greenland. It is known there as the 'loon', the name derived not from an association with the moon or lunacy, but from the Icelandic word for lame – a reference to its clumsiness on land, due to back-set feet. Its occupancy of Iceland (a few hundred pairs nest there) has a decidedly western bias on the island, suggesting colonisation by eastward expansion from Canada. Its recent discovery as a breeding bird in Scotland is probably an extension of this trend. The Irish wintering population of a thousand or more, found mainly along our western seaboard, is made up of birds from Iceland and further afield. The Burren's substantial diver assembly of a hundred or more individuals is of national and international importance.

Weighing in at between 4 kg (9 lb) and 6 kg (13 lb) and almost a metre (over 3 feet) long, the great northern diver is our largest coastal bird. A voracious fish-eater, it consumes a wide range of inshore species such as wrasse, rockfish, herring, small flatfish and crustaceans such as crabs. Completely at home on and below water (spending up to three minutes in a dive), it looks decidedly ungainly in the air. Flying with a laboured hunchbacked profile, it looks ill designed for the arduous two-way migratory flight it annually undertakes.

In its drab charcoal-and-white winter plumage, the great northern can be difficult to distinguish from its smaller relatives, which are similarly liveried. However, the dagger-like beak and large head are giveaways, if seen clearly. After the late winter moult, each species adopts strikingly different breeding finery. The 'throated' species may be highly regarded for their beautifully varied silky plumage, but the great northern is a wonder to behold. In its black-and-white patterning of stripes, spots and geometric checkering, it has the look of a fashion creation or a design for a fancy dress party. The angular head, fronted by its 'no-nonsense' beak and cold red eye, is bizarrely softened by a striped neckband and chinstrap. It is a pinstriped dandy of a bird. It is

easily seen why it was avidly sought after as a stuffed mantelpiece curio in Victorian times. William Thompson, the nineteenth-century naturalist, listed numerous divers 'obtained' by wildfowlers in different parts of Ireland, presumably for this purpose, and Payne-Gallwey mentioned how their feathers were used for making caps and waistcoats. Thankfully, under the 1976 Wildlife Act all divers are strictly protected. Unfortunately, they still sometimes are inadvertently caught and drowned in fishermen's nets.

Though the divers may be dispersed throughout Galway Bay for most of the winter, their late assembly is invariably in the lee of Black Head and along the coast as far as Gleninagh. Here the water is shallower – around 10 m (30 feet), and therefore manageable diving,

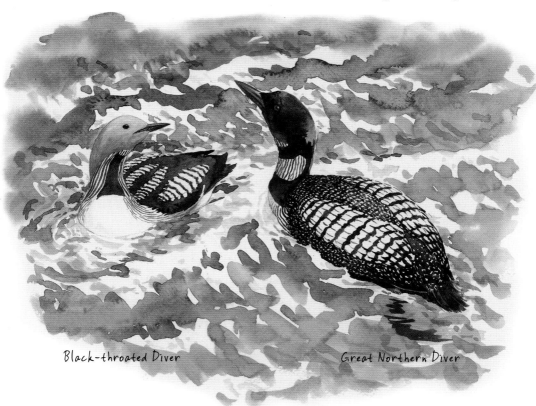

Black-throated Diver Great Northern Diver

compared with some 30 m (100 feet) off the head itself. They gather here also to enjoy the shelter from the south-westerlies provided by the headland and to take advantage of the ocean currents, which, entering the bay from the west, circulate around it anticlockwise before exiting again along the south Connemara coast. It seems likely that a zone of current mixing and therefore of fecundity is most accessible in this zone. It is no coincidence that a large colony of 200 pairs of cormorants – also fish-eaters – is situated on Deer Island, in the current's slipstream, a kilometre or so to the east. The fact that so many diving and fishing birds can be supported in this region is a testament to the productivity of the bay.

For about a month before the start of the tourist season, the diver assembly is highly visible from the coast road. The large birds can be watched courting on the surface or diving for food, their underwater alacrity visible on a calm day due to the elevation of the road. The spectacle is often missed by otherwise preoccupied drivers and due to the lack of suitable parking. By early May, only a handful of young birds or non-breeding adults remain, though still close in.

Of all the characteristics of this extraordinary bird, it is its call that has most captured the imagination. In the US and Canada, the loon is the epitome of wildness. Its haunting call and beautiful appearance has gained iconic status along with the bald eagle and the bison. A symbol of wild America, it decorates innumerable posters and postage stamps and is a motif on Canadian and North American coins. It is also the state bird of Minnesota and the provincial bird of Ontario – quite a CV.

The call (or song) has been variously described as a tremolo, a yodel, a howl, an ululation … Indeed, a vocabulary of specific communicatory and nuptial sounds has been identified by ornithologists at the breeding grounds. Its frequency of calling has been found to vary with time of day, weather and season. Cold, still days with little or no rain are apparently favoured. Doubtless, quantifiable elements of this

vocal sophistication may be discerned here too. However, for many charmed listeners such analysis detracts from its magic. Though not particularly long-winded, loud or forceful, the call is decidedly far-carrying, particularly on a calm day. I have often detected it when hiking in the high Burren on Cappanawalla or even further afield. I have never been able to identify with the call's purported eeriness. Anthony McGeehan's poetic description of it as 'a requiem for the turn of the season', in *Birds Through Irish Eyes* (2012), is both beautiful and sad. Sir Ralph Payne-Gallwey, in *The Fowler in Ireland* (1882), describes its call as a 'demoniacal laugh' and elaborates with 'the old anti-Jacobite ditty of "Lillibullero", [which] when quickly pronounced is no bad imitation ...'

For me, it is a primordial sound emanating from a past eon, from the Upper Cretaceous, perhaps; it is the call of the first aquatic bird, the *Hesperornis* – to all intents and purposes, the original great northern diver.

Carrickadda

Carrickadda, from the Irish *carraig fhada*, means 'a long, rocky place' or 'a reef', and that is precisely what it is. It extends for the most of a kilometre, protruding westwards into Galway Bay from the Flaggy Shore, that well-known north Burren attraction. Though normally barely discernible, even at low tide, it shows to its full at spring tides when moon and marine cycle are at one. At high tide it is invisible, its limit marked by a standing wave more than a metre high (as yet undiscovered by the surfing fraternity). Carrickadda's teeming intertidal life provides us with a window, albeit a contemporary one, into the Burren's extravagant origins. A close look at the encrusted surface shows it to be full of the Carboniferous fossils of shelled filter feeders, some of which bear more than a passing resemblance to those inhabiting the reef today.

On a day in February 1992, I had the good fortune to accompany Dr David McGrath, a marine biologist, into the world of Carrickadda, a world usually reserved for the likes of scuba divers, normally hidden

from landlubbing naturalists like me. Dave, a gifted communicator, does so in a style all his own. His method is both clever and bizarre: he *becomes* part of the intertidal ecosystem that he is interpreting. For him, limpets are not simply shellfish, they are fellow tide-dwellers. In explaining their lifestyle, he follows them on their twice-daily migration from resting place to feeding ground. Limpets are transformed into miniature cows, grazing on underwater algae at high tide and returning like the herd to the byre in the evening to their holdfast – oval-shaped homes in the rock – for the duration of exposure at low tide. It is marvellous to watch the faces of children as Dave weaves his magic, animating the creatures of the shore in this singular manner.

On our chosen day, a low spring tide had left the entire reef virtually high and dry, a high pressure situated over the west of Ireland helping by holding back the tide for a longer period than normal. We would have two hours, at least.

Dave and a student were looking for porcelain crabs – tiny, delicate creatures, as their name suggests – which they were studying. We found them, too, inhabiting the underside of rocks, in rock pools, in private little colonies. They were sensitively examined, measured, recorded, photographed and returned whence they came. Crabs, or decapods (as the biologists prefer to call ten-limbed crustaceans), of at least a dozen species were found. Some were particularly abundant. It was marvellous to see them in the hand, though some with 'attitude' had to be handled with care. The velvet swimming crab (*Necora puber*) belies its benign name in being one of the most aggressive creatures on the reef. When disturbed from its hidey-hole, it immediately adopts a pose like a kick-boxer in defence mode. It feints, parries and snaps its claws at everything strange – even a Wellington boot – and glares impassively through stalked crimson eyes. Its name derives from its flattened rear legs, which enable it to swim efficiently through the water for short distances. Though less than saucer-sized, it is a formidable creature, which, I have to admit,

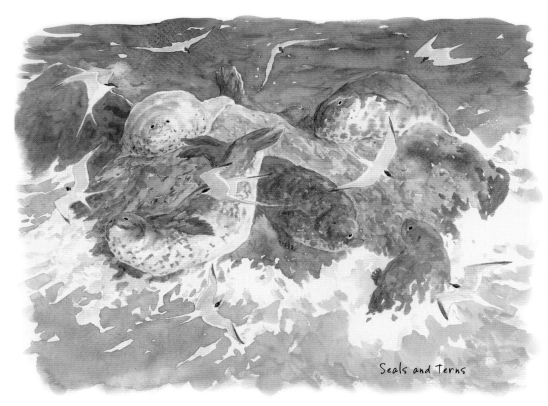

Seals and Terns

I was reluctant to pick up. Other, more benign decapods included the hairy crab, common shore crab, hermit crab and that well-known restaurant variety, the edible crab. One or two iron crabs, like small rust nuggets, were also caught, examined and returned.

There were unfamiliar creatures that weren't crabs, such as sea spiders, which, like their terrestrial counterparts, had eight legs. There the resemblance ended. Camouflaged like limp fragments of seaweed, they reacted sluggishly, making no attempt to escape on being picked up. Other 'limbed' creatures (though not strictly speaking) included starfish. Several different kinds were found, of different colours and patterns, most but not all with five points. They can apparently regrow or grow another limb on losing one to a predator — a bit like a lizard detached from its tail. Brittle stars, equipped with sinuous, feathery-looking arms, graced the pools, like exotic plants. They reminded me of dwarf forests of similar creatures I had watched in a reef in Tonga. Other, more colourful animals, red and marbled anemones, purple

sea urchins and sponges, illuminated the blackness of the rock pools, enhancing the tropical effect.

The variety of shelled creatures (particularly molluscs) in the pools had to be seen to be believed. Besides the commonplace cockles, mussels, limpets, winkles and whelks, other unexpected species were represented. Beautiful pink queen scallops shared the shallows with clams. Venus shells, top shells, otter shells and even large, thick-shelled Norway cockles littered the sandy basins between the rocks. Pink cowries – one of only two European varieties of this well-known tropical shellfish – skulked in crevices. Though tiny, their unmistakable shape (a fertility symbol in the tropics), with a split in their genital-shaped shell, reveals their species. Chitons, like armour-plated woodlice, adhered to the underside of a rock and a beautiful rayed limpet, its top marked with neon-blue stripes, stuck to a strap of kelp.

Not all the mobile creatures crept to safety on being disturbed; half a dozen different kinds of rock-pool fish flitted so fast that one was left wondering whether one was imagining things. Most were diminutive gobies. Blennies, one type recognisable by its bright orange eyebrows (really tiny fin-like protuberances on the head), were larger, almost the size of stream trout. Pipefish, like pointed-nosed elvers, wriggled discontentedly in the hand, while a butterfish and a rockling seemed to enjoy the experience. A little scorpion fish, mottled and ragged-looking – perfectly camouflaged in its weedy habitat and harmless despite its name – looked decidedly like an escapee from an aquarium.

Drapes of gently waving weeds formed a graceful backdrop to the rock pools. There were deep-brown wracks, khaki-coloured kelps and green algae such as *Enteromorpha*. One, chocolate brown in the shade, actually glowed petrol-blue for an instant as its fronds became illuminated by sunlight. Another, *Zostera* eelgrass (not a seaweed, but a flowering plant that remarkably can withstand total immersion in seawater), grew abundantly in one location, its green strap-like leaves trained by the tide on a muddy bank.

The rock pools were encrusted with coralline algae, pastel pink and grey, so-called due to a resemblance to 'real' coral. Alive, it comprises fine filamentous weed with a coating of calcium; dead, it resembles fragments of eroded fish bones. Vast quantities of this detritus accumulating on some west of Ireland beaches has given rise to the misnamed 'Coral Beaches' – as at Mannin Bay in Connemara.

My experience of the rock pools of Carrickadda had me reconsidering my decision in this book to represent the flora and fauna in watercolour illustration rather than photography. I was reminded of the kaleidoscopic portfolio of stunning images (the work of many photographers) of marine creatures from other marine sanctuaries, such as Lough Hyne in County Cork – images that could simply not be adequately reproduced in paintings.

As we made to return to the shore with the turn of the tide, a host of wading birds could be seen using the opportunity to exploit the abundant marine life they normally have to work hard for. Oystercatchers, 'pied pipers' of the shore, stalked the sides of the rock pools, levering off and digging into young mussels with their long, more-orange-than-orange beaks. Curlews were extracting their softer prey by probing worm casts in the muddy edges. Gangs of turnstones worked feverishly, flicking over small stones and weeds to capture sandhoppers. A few redshanks jabbed for small crustaceans in the shallows.

All the while, a scattering of avian scavengers 'worked' the flotsam and jetsam along the edge of the reef. Hooded crows, dropping winkles onto the exposed rock surface, swooped down regularly to check on their ingeniously won titbits. A few gulls, apparently satisfied with less fresh fare, hovered and settled, picking intermittently at washed-in morsels.

Carrickadda is unquestionably a marine treasure. Inaccessibility (except at low spring tides) may have saved it from the pillaging of urchin hunters before adequate protection rendered such exploitation illegal in the 1970s, but it remains vulnerable to other activities in Galway Bay. The development of Pacific oyster beds in the inner

Velvet Swimming Crab

bay and the possibility of other invasive shellfish represent ongoing threats to the pristine conditions on the reef. With studies of the flora and fauna already undertaken – famously by Professor Máirín de Valera – on the reef's seaweeds many years ago, it is well placed to monitor the effects of climate change in Galway Bay.

The NUIG field centre, built in 1972 to facilitate the ecological study of the reef and that of Lough Murree, the brackish lagoon nearby, is ideally situated at the side of Finavarra's peripheral road. Sadly, however, apart from the occasional short-term visit by a student or two, little is made of this valuable facility. While students cannot be expected to be protectors *per se*, regular academic presence in the field centre would act as a deterrent to those who might be tempted to take advantage of the abundant marketable resources found there. Hopefully, its designation as a marine nature reserve will assure more academic attention and help secure its otherwise vulnerable status.

6

Into the Past

Cave Insights

I had known about the amazing revelations from cave excavations in the Burren long before I was actually able to engage with them out in the field. Correspondence with archaeologist Marion Dowd and attendance at an elucidating lecture had heightened my curiosity and my resolve to find out first-hand. Her fresh discoveries of ancient animal remains and three discrete human periods of occupation in Glencurran Cave prompted me to go to and see for myself when the opportunity arose.

This occurred on 26 October 2012 when, as a treat for my students at the Burren College of Art, I arranged for archaeologist Michael Lynch (himself a discoverer of new insights into the occupation of the Burren by Mesolithic hunter-gatherers) and geologist Eamon Donoghue to meet us and act as our guides.

Wending our way on a fresh autumnal morning through the 'dingly dell' of hazel scrub and moss-covered boulders towards the cave

mouth in a low escarpment was an enchanting introduction to the experience. Despite the inaccessibility of the cave, the entrance had been fitted with a metal grill, a guard against the potential damage of unwanted visitors, animal or human. After a briefing about the geological history, we were issued with protective helmets and our group headed down the soft slope into the dark bowels of the cave. Within a few metres, our torches illuminated the floor matrix of calcareous stalagmite (downwash from the walls of the cave),

Brown Bear

The Breathing Burren

in-washed sediment from the mouth and incorporated animal bones. Excavated samples of these bones had proved revealing; they indicated the former existence of creatures not now found in the Burren. These included brown bear, red deer and (probable) wolf. Remains of other, more familiar contemporary species, such as Irish hare, hedgehog and bank vole, were also found. A brown bear bone, carbon-dated to about 10,000 years ago, proved to be the oldest known bear bone from County Clare. The remains of hedgehog and bank vole are most interesting in that they are both regarded as being introductions to Ireland; the hedgehog perhaps in late prehistoric times and the bank vole in the mid twentieth century. Interestingly, while the hedgehog is nowadays rare in the Burren, the bank vole has become fairly widespread in a substantial part of the mid-west of Ireland, including the Burren. The existence of their remains in the Glencurran Cave points to the difficulty in attempting to date animal remains from caves: the bones, though probably of more recent origin than others, have become so intermixed with ancient bones due to irregular inflow of water, that stalagmite stratigraphy is worse than useless as a guide; AMS carbon-dating, though expensive and thus limited, is the only reliable method. The bird-bone evidence (from about twenty species) was also illuminating, both in terms of expected and unexpected revelation. It included common scrubland passerines found in the Burren today – finch, thrush, blackbird, starling, pigeon, crow, tit, sparrow, cuckoo, kestrel, woodcock – and jay, which was also found in Newhall and Edenvale Caves near Ennis and, like the woodpecker bones, suggests an ancient wooded Burren hinterland. Evidence of the corncrake (which regrettably has not rasped its inimitable call in the Burren's meadows since the 1970s) was also uncovered. A number of bird species, including the water rail, moorhen, mallard, domestic goose and common gull, hint at procurement from a distance, there being no wetland of any consequence near the locality today. While many of these birds may have been captured

and brought to the cave for consumption by a predator such as a pine marten, badger or fox, one cannot rule out the involvement of man, who, as the finding of human bones testifies, frequented the cave at various times since the prehistoric.

As we assembled, crouching in the dank depths of the cavern, listening to the evocative dripping of water from the roof, our geologist guide explained the creation of the Burren's many caves: some are the result of run-off of acidic water in preglacial times (acid shale overlying the Burren limestone then); others were scoured by glacial meltwater during the last Ice Age; still others are the legacy of solution by rain water. Most of the caves had been formed by a combination of all these factors. The network of subterranean passages has created a complex underworld, a limestone labyrinth, dry in summer, waterlogged (and dangerous) in winter. Glencurran's situation, high in the Burren, is not subject to flooding from fluctuations of the ground water table – a feature that no doubt rendered it attractive to early human inhabitants.

We were informed of some of the intriguing human remains and artefacts uncovered by Marion Dowd in the course of several seasons of excavations: the skeleton of a Bronze Age man and other disarticulated bones; a cairn of stones, possibly a tomb; and, most fascinating of all, the ritual burial of an infant.

This child had been buried accompanied by selected bones from young animals including piglets and hares. The body was apparently placed on a grassy bed with a collection of amber beads and a couple of clay pots. A collection of perforated periwinkles and dozens of cowrie shells accompanied the corpse, adding a distinct air of poignancy. A late Bronze Age date (around 2,500 years before the present) was determined for the human remains. A large, 4–5 cm (1.5–2 inch), canine tooth, perforated for ornamental use, was found nearby. The collection of cremated neonatal animal remains – leverets, piglets and lambs – was thought to be 'sympathetic' sacrifice. Though the

deliberate placement of the body and its funerary accompaniments suggests (along with the cave itself) the concept of womb, fertility and rebirth, the burial remains enshrouded in mystery and we may never know its full significance. In a further remarkable revelation, a DNA sample from the infant skeleton was found to correlate with that of two infant children attending Carron National School today! Does this example of genetic continuity suggest what has been long been hinted at, that the Burren's population (or a part of it) has remained unchanged down the ages? The finding of a beautiful glass and gold Viking necklace, on the other hand, points to connections beyond the Burren, perhaps through trading. The archaeologist's excavations

Jay and Hazelnuts

showed that the cave had at least three periods of human usage or occupation: during the Bronze Age, the Early Medieval period and more recently, the Early Modern period. The cave's significance as a prehistoric burial site is more intriguing than the more practical uses to which it was later put.

Our retreat along the passageway and up the slope to the entrance was greeted with regret at leaving such a fascinating place and relief

Great Spotted
Woodpeckers

The Breathing Burren

at re-emerging into the light and the freshness of the day. Outside, we were treated to one more extraordinary circumstance. Excavation had revealed substantial Iron Age workings on the terrace to the cave entrance. Quantities of iron slag, the residue of iron manufacture, had been uncovered. An iron sickle, a tanged knife and an iron buckle suggested that the small platform had been used as a workshop by an Iron Age smith. I was immediately reminded of the comprehensive cache of iron items uncovered by the 1934 Harvard expedition to Cahercommaun (*Cathair Chomáin*), the famous cliff-fort only a kilometre to the east of Glencurran. The iron items included swords, daggers, spearheads, billhooks, a hostage manacle, various utensils, a bronze-covered iron bell and even a padlock. Was the cave entrance at Glencurran the location of the iron works, or some of them? In the absence of other potential sites in the vicinity, it must rank as a candidate. And what about Lon, the fantastical blacksmith, subject of an enduring Burren fable, who is still to be seen today (I am reliably informed) bounding from hill to hill across the region? His remarkable physique (he had only one leg but three arms, the middle one for holding secure the anvil while the others worked the iron) has been interpreted as the symbolic personification of the arrival of iron into the Burren. Lon's fort, *Mothar na Ceártan*, a kilometre to the east of Cahercommaun, is surely worthy of archaeological investigation in the context of the intriguing mix of fact and fiction still surrounding this part of the Burren.

In another cave, on Moneen Mountain in the north Burren, excavations carried out by Marion Dowd have revealed more human remains – those of a youth. Though more recent than the Glencurran burial, the Moneen death remains shrouded in mystery and poignancy. A beautiful hammer, fabricated from a red deer antler, found in the cave points to the inextricable link between the animals of the region and the people who depended on them for survival.

In an incredibly significant discovery, a Burren cave has recently

produced evidence of the earliest humans yet found in Ireland. A bear patella, clearly marked with parallel cut marks, has been carbon-dated to around 12,500 years ago. The marks on the bone are interpreted as incisions caused by a stone knife in the preparation of the bear's meat for cooking, and are considered to be contemporaneous with the bone's age. The discovery came to light in 2016, not from recent fresh excavation work, but as a consequence of meticulous scrutiny by Ruth Carden, animal osteologist, of formerly unexamined faunal remains in the National Museum. The bone was in fact one of a quantity uncovered around a century ago from Gwendoline Cave at the south-east of the Burren.

We look to scientists such as Marion Dowd and Ruth Carden, who, at the cutting edge of Burren exploration, continue to provide us with fascinating insights into the Burren's remarkable history.

Life Down Below

Souterrain, French for 'beneath the ground', is clearly an inappropriate name for the underground chamber found within the many ringforts, cashels, cahers and other Gaelic enclosures in the Burren. The Irish word, *oin* or *uaimh* (literally 'cave'), like *cromlech* (the Irish word for a dolmen), appears to have been banished to the underworld, along with the *Tuatha Dé Danann*. Though commonly located within the confines of medieval enclosures throughout the country, some, for reasons unknown, appear to be unconnected to former habitation sites. Many, in boulder clay country, in Kerry for instance, are tunnelled into the earth, but those of the Burren are understandably made from the ubiquitous limestone; they are solidly stone-lined and overlain with heavy flagstones. Though less awe-inspiring than the many prehistoric megaliths, souterrains are impressive for their clever design and layout. The best of them are monuments to ingenuity, construction technique and endurance. When inside and down

Lesser horseshoe Bats in Souterrain

below, one can easily picture the cooperative enterprise and dogged application of their Early Medieval builders.

Entering a souterrain usually requires a headfirst crawl and squirm through a small box-like structure, similar to a *pooreen* – the gap at the base of a drystone wall for sheep to pass through. There can be no doubt that their builders had limited access in mind – refuge was as important a consideration as the equable conditions for the storage of perishable foods or valuables. Entry successfully accomplished, the interloper may stand up and, with the use of a trusty torch, examine the layout of the dark, dry interior. Some souterrains are simple, stone-lined corridors, but others lead off to one or more side chambers, each accessed only by way of an even more sophisticated trap entrance.

Awkward as the process of entry is, it is invariably worth the effort. That wonderful imaginative delusion – that you are the first person to have ventured into the black stillness since medieval times – is to be savoured, but summarily abandoned if the torchlight settles on modern graffiti. Occasionally, the entrance chamber leads to a hidden exit, beyond the fort's rampart. One extraordinary souterrain, at *Cathair Chomáin* cliff-fort, leads out to the cliff, where escape to the bottom required the use of a rope. A human skull found in that passageway by the Harvard archaeologists may have been left as a warning for interlopers.

Despite their solidity, souterrains are vulnerable to modification and, unfortunately, also to destruction. Many disappeared or were filled in, along with their enclosing ring forts, during the grant-assisted land clearance phase of the last quarter of the twentieth century.

Farmers, understandably concerned about potential injury to livestock, habitually fill in entrances and exits with stones. However, unless destroyed in the process of land reclamation, souterrains tend to survive better than other vulnerable stone-built artefacts, being by definition largely hidden from view.

Down the years, they have been put to varied, often nefarious, secondary use. They have been hideaways for outlaws, refugees and priests during Penal times, shebeens for the distribution of illicit alcohol, storage chambers for weapons and explosives, rendezvous locations, and retreats during times of trouble. Some contain recycled ogham stones or centuries-old signatures and passionate declarations in their graffiti.

Though long abandoned by their builders and nowadays shunned by everyone other than the adventurous and the curious, souterrains have become welcome habitats for many opportunistic wild inhabitants, particularly in winter. Foxes and badgers frequently use them as underground retreats. Left-overs from meals – bones and feathers – are often to be found near the entrances. Badgers leave telltale

claw scratches on entrance kerbstones. Sometimes, recognising their potential as ready-made setts, they have even been known to make their homes in them. Indeed, entering head-first can be daunting, due to the prospect of coming face-to-face with a panicky badger, its exit blocked by a potentially threatening invader. Professor de Valera's warning, 'Beware the badger', in the dedication of Mark Clinton's book, *Irish Souterrains*, is surely tongue in cheek. Though I have been similarly cautioned, I have never once been confronted by a badger in my many souterrain visits. I am inclined to disregard the warning, along with the (often malevolent) country myths concerning our wild animals.

Our most celebrated souterrain occupant is the diminutive lesser horseshoe bat, a species with a distinctly western distribution in Europe and, due to its abundance in north Clare, one for which the Burren is especially important. It often uses the souterrain as a hibernaculum, usually in winter. A benchmark survey of underground bat sites carried out by the Parks and Wildlife Service in 1994 located more than 250 hibernating bats in the greater Burren region. The vast majority were lesser horseshoes but a few long-eared, Natterer's and Daubenton's were also found. Though the bats were found in small numbers in about a dozen souterrains, the majority were actually located in caves. With so many underground options (many subject to potentially lethal rising water tables), it is likely that the bats move from hibernaculum to hibernaculum as the circumstances demand. Souterrains may thus be more important than the results of the survey suggest.

To observe a cluster of these little creatures hanging upside down from the flagged roof, wrapped up in their wings, like miniature fruit parcels, is to witness one of the unique natural history sights of the Burren. How they manage to find their way in is a source of some mystery, since they can be encountered even in apparently closed-up souterrains. A bat will occasionally open the curtain of its wings in response to dipped torchlight, revealing its strange pig nose and gimlet eyes. Close and protracted disturbance however is to be

avoided, since it can result in a bat exiting its sanctuary and flying out into the winter countryside; this, as one can easily imagine, can have disastrous results for such an insect-dependent creature. As a true hibernator, it must not be disturbed from its state of torpor until its natural biological rhythm dictates, in early spring.

The consistent temperature within the souterrain – about 10 °C, despite fluctuations outside – provides ideal conditions for other hibernators too. Many butterflies, mainly small tortoiseshells and moths such as the well-named herald moth (its closed wings resembling a little shield), are to be found in the drier cracks and crevices between the stones of the structure. Here they may sleep out the winter, prolonging their lives by an extra six months, before emerging to mate and lay eggs in the spring. As with other invertebrates, however, souterrain hibernation for potential prey species like butterflies is no bed of roses. The large, spindly-legged *Meta* spider (sinister looking though harmless to humans) occupies the crevices, preying on any invertebrate that strays into its fine web. Impressive as the spider is, its flask-shaped cocoon, hanging like a tiny delicate lampshade from an overhead slab, is a thing to behold. Within, a score of tiny spiderlings share the silken comfort under the protective eyes of their mother.

The wren is the only bird bold enough to venture into a souterrain in search of pickings – all kinds of invertebrate food. An indignant 'churring', followed by hurried departure, signals its presence in the dark. Its taxonomic name, *Troglodytes troglodytes* – literally 'hole dweller' – is spot on.

Excavated souterrains in County Meath have revealed quantities of animal bones, the bulk of which have been identified as cattle, sheep and pigs, and domestic animals such as cats. Though largely undated, these animal ossuaries are consistent with the long post-occupation period. Do such repositories exist in the Burren's souterrains? If so, what tantalising information about post medieval fauna is yet to emerge?

Rockforest Relict

In Ireland, we are blessed with about twenty-eight native trees (though, in fact, most are shrubs), several fewer than the UK total and a mere fraction of the European complement. Of these, only three are conifers (as distinct from evergreens like holly) – yew, juniper and Scots pine. While yew and juniper are locally common in uncultivated rocky areas, mainly as shrubs, pine in the wild has long been considered extinct. The abundant root boles and other remains, often referred to as 'bog deal', excavated from our raised and blanket bogs, however, testify to its former abundance. Pollen evidence from various localities, such as Lislarheenmore (*Lios Lairthín Mór*) on the shoulder of Poulacapple Hill, points to its widespread abundance in the Burren throughout much of the prehistoric period. Both literary and palaeobotanical evidence suggest that pine more or less disappeared from Ireland some time during the Medieval period.

In fact, the story of its disappearance from Ireland echoes its

decline and disappearance from most of Scotland, where it was first described. It was (along with birch) the dominant tree of the Highlands until perhaps the seventeenth century and the story of its exploitation reads like the ruthless eradication of the passenger pigeon. It was simply too useful to survive in the face of pioneering zeal.

The abundant remains of Scots pine (*Pinus sylvestris*), sometimes charred and marked with cuts made by stone axes, indicate that prehistoric Irishmen were utilising this ready resource in *landnam* clearances of forested land. In some bogland and at various levels within the bog, the remains are so prolific as to suggest a completely contrasting (forested) landscape to that of today. Since pine (unlike broad-leaved trees) does not grow back from the stump, Neolithic farmers had little problem clearing large tracts for good. Pine is listed in the ogham alphabet, which was largely based on trees, as *Ailm*. In the Brehon laws, *Giuis* (the later Irish name for the pine) commands special significance; its use in building was reserved for the clan chief, who used it as the ridge timber (*Octach*) for his house. It had an important additional use, in its straight form, as ship masts. Also, the resin was collected for use in caulking boats, and preserving wood in general. Doubtless, however, its main use was for fuel. The turpentine-laden timber, needle leaves and small cones burn readily in the fire, giving out strong light. Also, dried out and pulverised, bog pine made vividly burning torches. One can imagine the gateways of ring forts and cashels illuminated with pine torches fixed to the sides of gates.

There are tantalising references to pine in medieval annals, most suggesting its rarity by the middle of the second millennium. It is hard to imagine the Normans, with their legendary exploitative energy, overlooking the tree's potential. One reference from the Middle Ages describes a search for pine in Connacht for use in the construction of a monastery. The fact that the monks had to invoke the assistance of a saint in finding the tree suggests that even then it was rare.

The most recent dendrochronological date for native Scots pine in Ireland appears to come from the early fifth century. However, as late as the 1500s, Philip O'Sullivan Beare, in his 'Zoilomastix', refers to 'tall waving pines in Conkeyney' (the forest of Glenconkeyne at the north-western corner of Lough Neagh). Could it have survived, in pockets perhaps, elsewhere at that time?

By the early eighteenth century, Scots pine introduced from Scotland was being planted in the new colonial estates. Later, an energetic replanting programme promoted by the Williamite administration, undertaken in both Scotland and Ireland, saw the eventual return of pine to deforested regions.

A more comprehensive reafforestation plan advocated by Sean MacBride in the early years of the Irish State saw Scots pine included in a suite of commercial non-native softwoods. This programme gained momentum in the 1950s with the establishment of the Forestry Service and later, in the 1980s, with Coillte.

The question of the survival of 'native', as distinct from introduced, *Pinus sylvestris* has in recent times exercised scientific imaginations stimulated by the prospect of conserving a unique and rare botanical gene pool. Dendrochronologists and botanists have for years been searching in out-of-the way habitats, taking samples

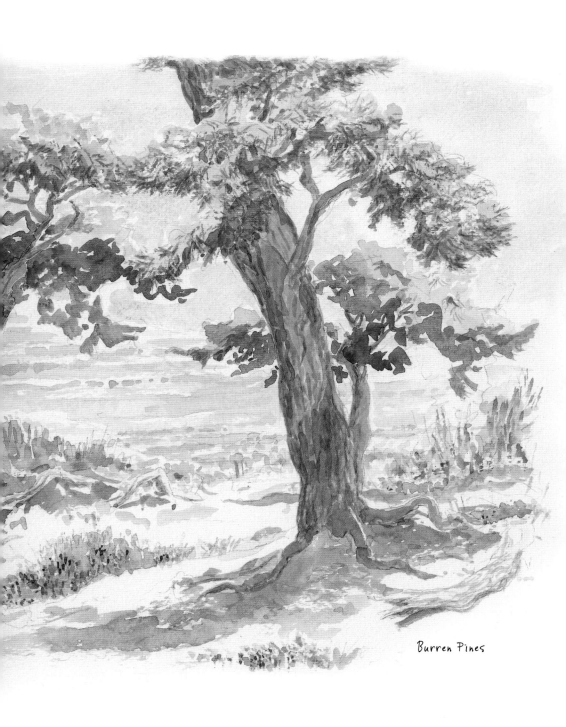

Burren Pines

Rockforest Relict

and checking DNA, in the knowledge that deviation from the post-seventeenth-century genome might indicate endemic characteristics.

A relatively remote 15-hectare (40-acre) limestone habitat in aptly named Rockforest (due not to its trees but to its morainic 'forest' of large glacial boulders) may have come up trumps. In this undisturbed pocket, separated from the open karst by a strong stone wall, grow a few dozen gnarled pines sporting small cones and short needles. In their stunted form, noticeably different from their tall Inverness counterparts, they convey an impression of ancientness. The apparently undisturbed habitat is otherwise replete with woody shrubs, including heather, bilberry, juniper and yew. Initial investigation suggests that the pines are of stock other than that of the modern plantations. The pollen record from core sampling close to the site points to the more or less continuous existence of pine for thousands of years, perhaps since before the arrival of man to the region. Two out of four core samples taken from lakebed sediment in the vicinity of the south-east Burren – at *Rinn na Móna* and *Loch Dá Éan* – indicate continuous pine growth since prehistoric times. At the *Dá Éan* site – less than 5 km (3 miles) from Rockforest – the core indicates an incongruous increase in pine pollen around 900 AD. This pollen 'rebound' is in stark contrast to the decline and disappearance of pine elsewhere in the country and will require further investigation and explanation. Sample results from elsewhere in Ireland are unequivocal: they show that pine disappeared from the botanical record during Gaelic times, perhaps around the time of the Rockforest rebound, and long before colonial reintroduction.

Similar-looking pines grow in rocky ground, where they may have been ignored, near Boston (*Móinín na gCloigeann*) and near Newtown Turlough (*Turlach an Bhaile Nua*) on the edge of Garryland Wood. However, given the wide range of source material and the capacity for pine pollen and seeds to be distributed widely by wind, the situation remains unclear. The signs are nevertheless positive.

Comparative DNA sampling and charcoal analysis should eventually provide the clarifying data.

Walking through Rockforest, stopping to admire the twisted trunks of its venerable pines, listening to the wind singing in the evergreen canopy, is an evocative experience. Though untypical of the present, it has the feel of an ancient ecological reality. The wolves and wildcats and woodpeckers may be gone, but amid the Rockforest pines one can still be transported to the Burren of long ago.

Winter's Gift

From the air, the Burren uplands are pimpled with prehistoric archaeological features. Some, casting crescent-shaped shadows on the bare rockscape, are identifiable as burial cairns of Bronze Age chieftains. Others, like the hundred or so tiny ring shapes encrusting the top of Turlough Hill, are enigmatic. Archaeologists believe them to be the foundations of temporary dwellings occupied by prehistoric cattle herders. They would have been used by people engaging in the practice of transhumance – the movement of livestock from lowland to upland pasture with the change in season. Remarkably, despite the widespread pressures on agriculture to modernise, this ancient practice of 'booleying' (from the Irish *buaile*) continues in the Burren today.

Transhumance is by no means confined to the Burren. It has a long history elsewhere in Ireland, Scotland and in many parts of Europe where both upland and lowland pasture is available and optimal

for grazing at different times of the year. Transhumance in high European mountains – the Alps and the Pyrenees – is well known and described, but it is also still practised in many nomadic livestock-dependent cultures throughout East Africa, Asia and the Americas.

The Burren style of transhumance is, however, unique, in that the movement reverses the norm: animals grazed on lowland pasture in summer are moved to the uplands for the winter. 'Winterage', though remarkable to the mind of the outsider, is part of the rural culture taken for granted by Burren farmers who, over millennia, have learned to harness the region's accommodating contrariness. The limestone lowland pastures, colder, wetter and subject to frequent flooding, have limited availability in winter, while the dry uplands retain the capacity for grazing throughout. In addition, the heat-retaining characteristics of the limestone hills, which are largely frost-free due to the influence of the North Atlantic Drift (an extension of the Gulf Stream), permit a more or less continuous growth of nutritious 'herbage'. Very little, if any, supplementary feed is required for out-wintering beasts. Hardier breeds, such as Aberdeen Angus and Herefords, were once the norm, though formerly – in Gaelic times – they were shorthorns of the small black Kerry breed. Nowadays some of the more robust Continental beasts accompany traditional breeds. Once predominantly bullocks, the herds nowadays are mainly composed of suckler cows; however, the mineral-rich grazing and outdoor conditions have proved beneficial to a range of stock types. While the number of beasts per herd is small – usually between a dozen and a score – the herds are many and scattered throughout. Many thousands of bovines avail of this unique facility. So successful and desirable is this regime that large tracts of Burren winterage are rented out to cattle farmers from far beyond north Clare. In spring, as the upland grazing diminishes, the animals are taken down for 'finishing' on the abundant pasture set aside for their return.

It can be difficult to convince an outsider viewing the region from

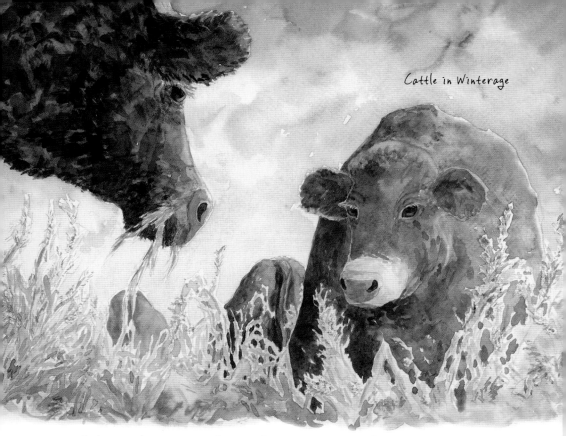

below or from across Galway Bay that the bare Burren uplands do indeed support droves of winterage cattle. The sceptic must actually walk the grassy terraces to get a sense of their productivity. The 'grass' (a diverse mix of grasses, sedges, herbs and mosses), now no longer green, rather a suffusion of ochres and umbers, is a surprise indeed. As one proceeds (cautiously, due to the frequent natural pitfalls), one becomes aware of the toughness and the tenacity of the vegetative mix – characteristics ultimately transferred to the livestock.

In ancient times, this productivity must have been even greater. Manual removal of the light tree cover and scrub with stone implements, exposing vigorous ground growth, rendered the uplands a grazing paradise. However, concentrated overstocking in the Bronze Age, followed by cooler, wetter conditions, causing removal of soil and exposure of the limestone rock, must have resulted in a drastic reduction in this natural bounty. Overgrazing throughout

much of the expansionist Early Medieval period would have caused further reduction. Favourable elemental conditions have nevertheless continued to provide valuable pasture, though in recent historic times in a more regulated manner. Some control would have been exercised by the O'Lochlainn clan, 'kings' of the Burren in Gaelic times. Their tower houses are strategically located alongside routeways to the uplands and livestock watering places to facilitate rental collections from winterage drovers. Radical agricultural changes, including the decline of the rundale system and the land enclosure acts of the seventeenth century, seem to have impinged little on transhumance. It also survived the devastating effects of the Famine, which affected the Burren particularly savagely.

The greatest threat to the unbroken continuity of the practice came with the initial directives in the 1970s and 1980s from the European Union. New recommendations attendant on intensification – sedentary herds, slatted sheds, continental breeds, etc. – urged change to what were perceived as outmoded practices. Also, a determined policy of converting formerly unproductive land such as the rocky Burren into fields of silage to feed sedentary herds struck at the core of the Burren's extensive agricultural traditions. Thankfully, the realisation that the agricultural value of the Burren was intrinsically connected to its natural and human heritage caused a rethink – just in time. The emergence of the EU Habitats Directive, supported by the environmentally friendly Rural Environmental Protection Scheme (REPS), emphasising the role of cattle grazing in sustaining the rich limestone grasslands, supported a new conservation-orientated perspective, incorporating the ancient practice of winterage. The REPS has been viewed in retrospect as a mixed blessing: while some of its conservation requirements made genuine advances, others were seen as largely 'cosmetic' and even occasionally counterproductive.

The field studies carried out under the Teagasc-supported Farming and the Burren project in the early 2000s incorporated the pioneering

work of Ivimey-Cook and Proctor's botanical surveys of the 1960s. A new agricultural framework recognised eight ecotypes, ranging from upland heath through normal winterage grassland to lightly summer-grazed areas and all-year-round grazing. The studies examined the detrimental effects of undergrazing, local artificial fertilising and feeding, and regularly utilised areas in drawing up a viable and sustainable management plan. Paramount in the studies was the identification of the most botanically rich ecotypes, with a view to their conservation in the ongoing agricultural context. A typical limestone grassland ecotype contained associated plants such as slender St John's wort, blue moor grass, lady's bedstraw, bloody cranesbill, bird's-foot trefoil and wild thyme. This suite contrasted with that of limestone heath, usually at higher altitude, where mountain avens and heather dominated. The winterages were found to be progressively more compromised in areas of summer and all-year-round grazing, with familiar 'agricultural' species such as ribwort plantain, clover, daisy, dandelion and thistle taking over. Though ryegrass for silage was prevalent in more intensively farmed lowland areas, its presence was also detected, along with indicator species self-heal and crested dogstail, in some sheep-grazed areas of the uplands.

In conservation terms, sheep are undesirables in the Burren uplands. 'Ruthless' grazers compared to cattle, they will eat orchids and other sensitive species declined by bovines. They do, however, have an effect (though less than that of goats and horses) in reducing the spread of some scrub species. Historical references from the latter eighteenth and early nineteenth centuries point to a Burren in that period dominated by sheep rather than cattle, a contributory factor, no doubt, in the barrenness of the pre-Famine years. Importantly, the Burren Life studies demonstrated that three factors – soil depth, altitude and management history – contributed to the quality (and the ecological richness) of the upland grazing in the Burren.

The new millennium has seen the 'Burren Farmers for Conservation'

programme (formerly Burren Life) under its director, Brendan Dunford, enthusiastically working with the farming community to promote the transhumance tradition. Under the banner of sustainable farming, this scheme, funded by the EU and the National Parks and Wildlife Service, went from a tentative pilot stage in 2010 to a mainstream activity involving some 160 farmers and approximately 300 in 2016. Indeed, it has been praised as an exercise in 'community-led farming' and has received nationwide acclaim. An annual winterage celebration (coinciding with the ancient pagan festival of Samhain) is held annually during the October bank holiday weekend. It includes a promotional event advertising the essential link between people, food and nature. Lectures, displays and participatory activities are aimed at all sections of the population and include school projects and games for the young. The festival culminates with the communal driving of cattle herds from around nine locations throughout the Burren to the upland winterages. The procession that accompanies each is both practical, in supporting the farmer, and ritualistic, in re-enacting the transhumance theme.

'Burren Farmers for Conservation' has brought a coordinated, empathetic approach to the notoriously diverse aspirations of people connected to the land. This has been no mean feat, considering the range of interests represented in the region – from agriculture to tourism, local business to recreation, development to conservation, archaeology to education … In demonstrating the viability and sustainability of the ancient practice of winterage, an imaginative blueprint has been devised for other related practices and communities elsewhere in Ireland.

Forward
from the Past

Now that we find ourselves in the unenviable role of managers of the planet, we have no choice but to embark upon the most ecologically sustainable path to the future. We must also try to rectify centuries of human-inflicted environmental damage. Most conservationists at least agree that things cannot simply be let go; we cannot abandon our precious environment to blind human ambition or the vicissitudes of human-distorted elemental forces. Nature nowadays needs a helping hand.

Enter restoration ecology. A central tenet of this optimistic new science is that restored environments should be guided by reference to the past. If we take this as a given, the time factor comes immediately to mind. But how far back must we look to guide us with a vision for the future?

Until relatively recently, a cut-off of around 1600 AD was seen as the chronological pivot when human advancement began to impinge

significantly (and permanently) on the planet's ecological well-being. Commencing with the Early Modern period, colonial expansion, fuelled by the needs of burgeoning populations, was beginning to exploit the world's resources on a massive scale. The evidence – timber clearances, wetland drainage, mining and fuel exploitation, rampant industrial and infrastructural development, and pollution, combined with the pushing aside or eradication of native peoples – marked the preliminaries to widespread habitat and species loss.

In reality, irreversible ecological destruction can be traced back to much earlier times. The disappearance of many vulnerable faunas on Pacific islands occurred in the Bronze Age as a consequence

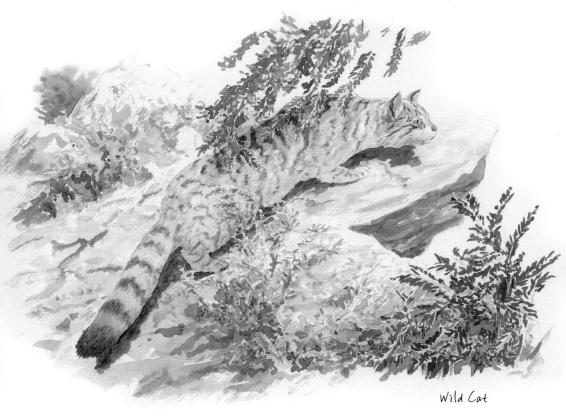

Wild Cat

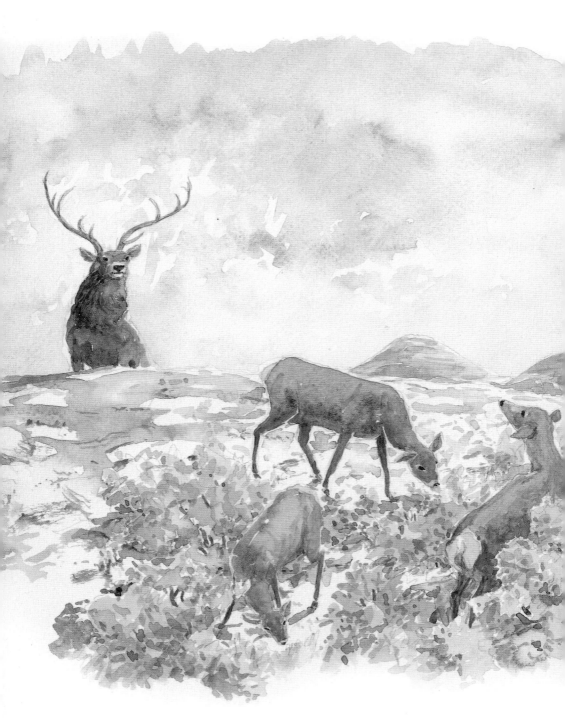

Red Deer

of invasive plundering by pigs and dogs brought by Polynesian boatmen. In some places, even Neolithic activities have been cited as permanent and irreversible. So where do we begin?

The Burren, in which thousands of years of man-induced environmental degradation is known to have occurred, is an obvious candidate for ecological restoration. But the starting point? Thanks to palaeobotanical investigation, we can now set the scene prior to the *landnam* transformation (clearance of forested land) wrought by prehistoric settlers. If we consider a period halfway between the end of the Ice Age and the present, just before the first farmers made their permanent mark on the landscape, we can envisage a largely wooded plateau and a climate slightly warmer than that of today. Early forest cover – pine and hazel, followed by oak, alder and birch (species insignificant in the Burren today and reflective of formerly thick soil cover) – was to become established. Ash and yew would constitute a later fraction. The existence of open ground, mainly in the north Burren, is strongly suggested in the presence of woody plants – juniper, ling, crowberry and bearberry. We have no coherent notion of the floral diversity, though core-extracted material of shrubby cinquefoil (one of

the 'cold' suite of the Burren's contemporary flora) indicates early Holocene links. Other Ice Age relics, though undetected in the core record, must have survived at least in pockets to be represented as they are today. Doubtless, further delving will cast light on our incomplete knowledge of these links. Of the invertebrates, one or two land molluscs are regarded as Ice Age relics and there are others that hint at this. We know something of the avifauna from the bones recovered from caves. Typical woodland inhabitants – pigeons, jays, blackbirds, thrushes, cuckoos, sparrowhawks, tits and finches – coexisted with (the now absent) great spotted woodpeckers and hawfinches. A date of 3,750 years before the present (Middle Bronze Age) has been established for a woodpecker leg bone found in Edenvale Cave. Other peripheral habitats (wetlands and coast) are indicated in the discovery of crane bones, also in Burren caves, and of great auk bones on the County Clare coast – remains of prehistoric hunter-gatherer meals. We can also assume the existence of large birds of prey such as eagles, buzzards, harriers and goshawks, which appear to have been widespread in prehistoric Ireland, and were doubtless so in the Burren.

A suite of formidable animals (mainly survivors from the Ice Age) also roamed the prehistoric Burren. The faunal bone evidence shows that brown bear, wolf, wildcat, Arctic hare and wild boar were present. There may also have been lynx, whose bones have been found in a County Waterford cave, dating from this period. Stoats and otters were undoubtedly also part of the mix. The issue of the red deer (whose bones have been found in many places in the Burren) is contentious. A gap in the subfossil record between the end of the Ice Age and the end of the Neolithic period has been interpreted as a dying-out followed by a reintroduction by early farmers. While Neolithic humans are known to have brought with them a range of domestic animals – mainly cattle and goats – the advantage of bringing skittish, non-milking animals like deer is hard to envisage. The absence of antler

tines, so important to Stone Age people for tools, is certainly a mystery, but is extinction and Stone Age reintroduction the explanation? It is difficult to imagine a heavily forested Stone Age Ireland replete with predators such as wolves and large felines without their primary prey, deer.

Other familiar, contemporary mammals – badger, fox, pine marten, red squirrel, pigmy shrew, wood mouse and at least two species of bats – have been shown through DNA sampling to have ancient lineage, though, according to theories put forward by Professor Peter Woodman and others, some appear to have entered Ireland shortly after the arrival of the trees, possibly from former 'refugia' (island habitats ultimately swamped by the postglacial rise in sea level), to the south of Ireland. We are also reminded of the possibility of intentional or inadvertent introduction of some of these animals, the fur-bearing ones for instance, by the earliest settlers.

Can we regard this pre-farming scenario as a legitimate blueprint for ecological restoration? Or do we need to look to a time when the Burren was already transformed to something resembling that of today? Fast forward to 1600 AD. Sufficient evidence exists in the form of literature and archaeozoology to enable us to reconstruct an overview of the Burren at this time. According to references from Irish and English sources, the landscape was already largely deforested (though pockets of woodland remained, much as today) at this time. The wolf/red deer interrelationship still existed, though, due to relentless hunting under the new colonial dispensation, it was about to come to an end. Fallow deer, originally contained in estates such as that at Leamaneh, may, with the collapse of the old system, have run wild in the Burren. The brown bear, wild boar and wildcat were probably long gone and, with the disappearance of the woods, many of the large birds were, too. Eagles would have remained as significant avian predators for another century or so. We know from early chroniclers (e.g. Welsh botanist Edward Lhuyd) that the open

limestone grassland held at least the basis of today's celebrated flora, and perhaps some species that have disappeared in the interim. Herbs used in homeopathic circumstances and in the many ecclesiastical sites probably added to the number. Certain 'useful' plants (vegetables, cereals and ruderals), invasives of a kind, were undoubtedly already naturalised.

Which of these past ecologies is the more appropriate as a guide for the future? Do we need to go back further, to the arrival of the first humans? Or do we look to the radical changes brought on with the decline of extensive agriculture and the arrival of subsidy-influenced agriculture in the 1970s? Or do we, as is generally happening, ignore the past, or at least sublimate the hope of an 'authentic' ecology to the economically driven forward march of agriculture? The concept of a 'novel ecology' based on such expediencies in various parts of the world has been documented by the environmental author Paddy Woodworth. This ecological 'reality check' declares that perhaps a glance to the past for guidance is the best option to be hoped for. A conservation argument that suggests the return of a former predator-prey relationship, one that poses major challenges to modern-day farming, is clearly out of the question. With the elimination of two of the main players, the red deer and its chief predator the wolf, probably in the seventeenth century, the broader ecological circumstance will remain a mystery. The deer, primarily woodland creatures and browsers of new growth (as in Killarney), could act as a natural vector of curtailment of hazel expansion in the Burren today. It would, however, be necessary, in the absence of their natural predator, to cull them as and when their numbers threatened to get out of hand, a measure that sometimes occurs in an unauthorised manner with the Burren's goat population.

The Burren today remains ecologically important by default. In another location, in other times, it might have been reduced to a shadow of its present state by reclamation. Indeed, in the 'developmental push' years of the 1970s and 1980s, when more than 1,000 hectares (2,400

acres) were bulldozed and reclaimed for silage, the ecological balance of the entire region was threatened. Nowadays, a new awareness of the fragility of the limestone environment and its water quality has resulted in a more sympathetic 'agri-conservation' relationship. The Burren Life model, with its focus on the sustainability of family farms, has demonstrated that environmentally orientated farming such as winterage is also conservation-friendly. Indeed, it has shown that there are viable tourism and educational ramifications. Given that

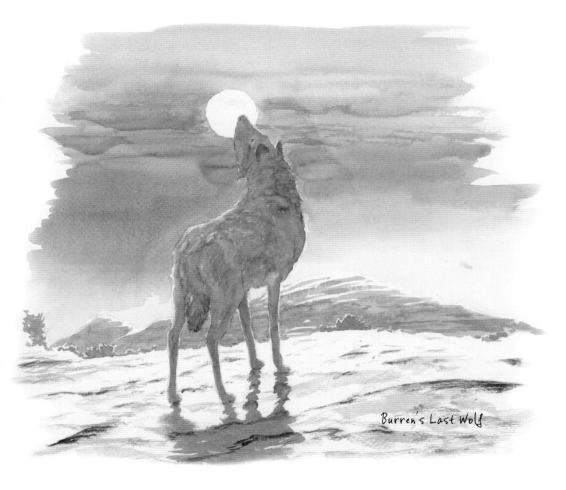

Burren's Last Wolf

the emergence of home-grown conservation in Ireland has been at best paltry and often non-existent, this new arrangement promises a bright future.

Admirable as the efforts for ecological restoration might be, they are likely to be overshadowed by the looming threat of climate change. One is inclined to question efforts at reinstating a more authentic regional ecology, one less affected by humankind's transgressions, if the circumstances on the ground are in the throes of long-term change by way of this enormous, seemingly uncontrollable phenomenon. It is hard to imagine, even with ongoing advances in mitigation, how a delicate and complex ecology like that of the Burren can escape.

So, if the impending phenomenon of climate change is to be the inexorable force of ecological transformation that it threatens to be, what is the best course of action? If we ignore the clamour of the unconvinced minority, there remains an inertia born of a sense of hopelessness. What can we do that would be of any use? Some, overwhelmed by the scale of the problem or fatalistically laissez-faire, fall back on the philosophy of allowing nature to take care of itself. In fact, as our fossil record adequately demonstrates, nature can well take care of itself and, in the context of James Lovelock's Gaia theory, will casually reject humankind if it so ordains. There is also a fear that restoration might, due to the present incapacity to impact on a force patently indifferent to human endeavour, rapidly become ineffectual or anachronistic, or that attempts to redress a 'broken' system might lead instead to multiple fractures.

A factor often overlooked by the pessimists is the amazing capacity for humans to analyse, plan and adapt to adversity. Humankind has and continues to show the capacity to deal with problems on a planetary scale, a minor example being the solving of the human-created hole in the ozone layer. There are good grounds to be optimistic that our collective application will bring about workable adaptations to climate change, here in Ireland at any rate.

It is this optimism that will spur efforts to maximise the ecological richness of our wild places. We may need to envisage a 'novel' Burren, derived from a combination of historical factors, practical management and the conviction of those who consider even a transformed Burren too precious to abandon to chaos.

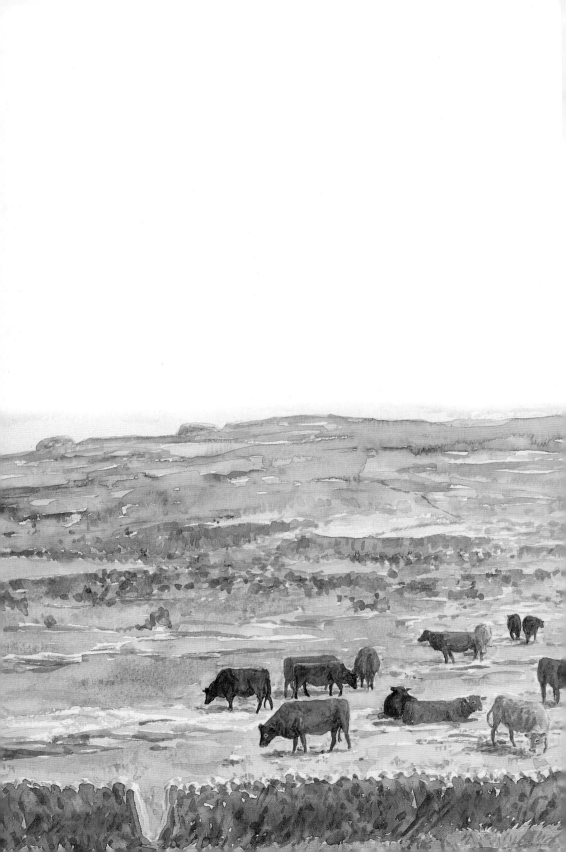

7

Musings

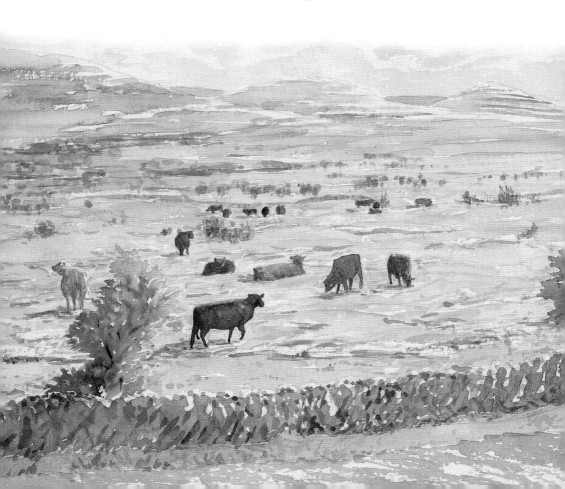

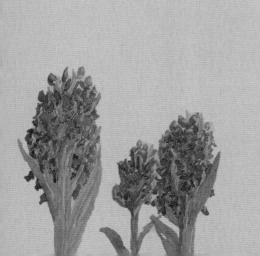

Aliens and Invasives

In the world of human rights, terms such as these resonate with inappropriateness, even discrimination. They are studiously avoided in the context of political correctness.

In consideration of the natural world, distinct from humanity, these terms are highly relevant: they are loaded with biogeographical significance since peripheral islands such as Ireland are more affected by alien and invasive flora and fauna than equivalent landlocked regions within the Continent proper; the Burren – a kind of island within our island – especially so.

We can be confident that the Burren has been subject to ecological turnover for as long as it has supported life. The fossil record in the Carboniferous limestone, with its many extinct species, speaks eloquently of this. However, due to unknown geological interventions and the scouring efficiency of recurring glaciations, we know virtually nothing of the fluctuating fortunes of life since then. Indeed, with the

exception of plant remains extracted from Late Tertiary deposits in limestone country outside the Burren, we know very little about the circumstance prior to the Ice Age. Palaeobotanical investigations carried out near Gort have provided us with an image of the forested landscape of a warm stage within the last Ice Age from about a quarter of a million years ago. Most of the species of woody plants identified are still around (with a few notable coniferous exceptions), but nowadays in quite different proportions. Frank Mitchell likened this forested landscape, with its spruces and pines, to that of the southern Caucasus. Postglacial (early Holocene) pollen presents a picture of habitat succession – from tundra to forest – attendant on climatic amelioration, uninfluenced by humans.

The circumstances of the first Irish people, the hunter-gatherers of the Mesolithic period, were largely insular and therefore unlikely to have contributed significantly to ecological change. However, we know that from the outset, the first farmers brought with them a suite of non-native crops, livestock, and hitchhiking wildlife. Thus, for the past 6,000 years, it is safe to assume that Ireland's (and the Burren's) native flora and fauna were not only regularly supplemented with new arrivals, but also diminished by extinctions.

Since the glaciers effectively 'swept the slate clean', facilitating first tundra, then forest, replete with Holocene fauna, it can be argued that the suite of plants and animals, even before human introductions, were 'invasives' of a kind. Ironically, one of the plants viewed as an undesirable invasive throughout wild Ireland – rhododendron – was (from the Gortian evidence) once abundantly native during the Ice Age. Its removal, in the context of ecological restoration, is more to do with its capacity to outcompete other, more sensitive plants and engulf woodland than with its right to remain. In the Burren, the issue is moot, however, since acid-favouring rhododendron will not grow in the thin, limy soils. Purple saxifrage, on the other hand, a lime-lover whose abundant pollen has been located in the Burren's Ice

Green Lizard

Age cores, is mysteriously
no longer found there.

The question of 'native' versus
'introduced' is one fraught with argument.
Despite the lack of hard evidence in the
pollen record to date, we can be sure that 'cold'
plants, such as mountain avens, pyramidal bugle, hoary
rock rose, Irish saxifrage and others, are survivors from the
Ice Age. How, though, do we account for the many southern or
'warm' plants – 'Lusitanians', for instance – also found in the Burren?
The consensus is that they moved north and west, seeding as they
went, in the ameliorating conditions following the end of the Ice
Age. But was man indirectly involved in this process? There can be

little doubt that the spread of, for instance, ruderal plants — those associated with cereal cultivation — was greatly aided by the Neolithic style of forest clearance and shifting agriculture. The appearance of the pollen of plantain in soil core samples is a reliable indicator of such activity. There also can be little doubt that many species came with human advancement and the extension of trading links and early infrastructure. Arrivals of new cultures, with commensurate advances in cereal production and livestock husbandry, certainly played a part. Throughout history, waves of newcomers, particularly coastal settlers, brought plants and animals new to the island, some of which became established as 'naturalised species'. Returning pilgrims and continental travellers, not subject to customs scrutiny, undoubtedly added to our growing bounty. Escapes from colonial gardens and estates have, over time, impacted to an even greater extent. Nowadays, with the popularity of gardening and horticulture and the largely unsupervised trading between countries, almost anything comes and goes. Railway embankments and road networks become convenient linear corridors, facilitating the inexorable spread of opportunistic escapees that have gained a foothold in the wild. The three-cornered leek, for example, which enhances the bohereens around Gleninagh, seems to have spread from the plots of a few long-abandoned habitations.

Professor David Webb went to considerable pains to try to distinguish between plants he considered native and those that were alien, or had become naturalised, in the Burren. Some of his findings remain controversial. Wall lettuce, a ubiquitous spindly yellow-flowered plant of the limestone pavements, originally recorded as a native, is now considered a 'naturalised alien'. Plant taxonomist Charles Nelson and his botanical associates have cast new light on the origins of many of the Burren's plants. Some, like babington's leek (a kind of wild onion), cotoneaster and columbine, having the appearance of wildness, growing sometimes in remote circumstances, have been

shown to be aliens, though perhaps not recent ones. He has also raised the issue of the famous plant carvings in Corcomroe Abbey, suggesting that they may have represented medicinal plants used in the infirmary and grown in the monastic gardens almost a thousand years ago. Rampant invasion can be seen near Finavarra, where valerian – a distinctive pink-blossomed garden flower – has taken over more than a hectare (2.5 acres) of the shattered limestone. On the other hand, the fairy foxglove, a 'naturalised alien' that has decorated the Pinnacle Well near Ballyvaughan for decades, shows no sign of such expansion. While certain plants have, and continue to find, a place for themselves in the 'most democratic of habitats' (an aposite term coined by ecologist Stephen Mills), the Burren, by virtue of its base richness, has been saved the tsunami spread of exotics such as gunnera ('giant rhubarb'), Japanese knotweed, Indian balsam and, of course, rhododendron, which have plagued other parts of the country.

When considering invertebrates and other smaller fauna, the picture is particularly obscure. Some snails may have arrived recently with road-construction material, while others, such as tiny vertigo and the land winkle, have probably been around since soon after the Ice Age. Some of the beetles are regarded as relicts from after the Ice Age, but many more must have arrived here in turf creels on boats or, latterly, in horticultural consignments. The period of arrival of honeybees into Ireland is undoubtedly ancient. The allocation to them of an entire section of the seventh-century Brehon Laws, *Bechbretha*, points to their importance and suggests that they have been kept for their golden produce since early Celtic times. Their fortunes have fluctuated due to mite affliction and other diseases and, over the past century, hybridisation with imported strains. However, according to beekeeping authorities, the 'native' Irish bee, *Apis mellifera mellifera* (Amm), is still present but drastically depleted, and its distribution is something of a mystery.

Having located what I considered to be Amms in several places

in the Burren (in grikes and in the walls of ruins) in the 1980s and 1990s, I have noticed a marked decline, and wonder if colonies of wild honeybees are still to be found here.

The freshwaters of the Burren remain relatively fish-free, though eels and sticklebacks are widespread inhabitants of the turloughs and trout survive in the Caher River, despite dramatic seasonal fluctuations. The limestone lakeland of the eastern Burren, however, supports not only salmonids but also many species of coarse fish. Perch, roach, bream and tench – thought mainly to be introduced species – are avidly sought there by anglers. Once also thought to be an introduced species, DNA study has revised the status of the ubiquitous pike from 'naturalised alien' to 'probable native'. The means of arrival of the frog in the Burren and Ireland is still open to discussion (it definitely predates the well-known account of the release of frogs into Trinity College Dublin in 1699), with the excavation of its bones in disturbed stalagmite in Burren caves leaving the issue unresolved. The marvel of DNA investigation, however, points to it having ancient lineage. Our only lizard is generally considered native, though, like the shrew or the mouse or indeed a variety of invertebrates, it could easily have arrived here anciently by boat, hidden in animal hides. Two reptiles, the green lizard and the slow worm, are definite alien introductions. Fifteen individuals (males and females) of the former were deliberately released into the Burren in the late 1950s. According to David Cabot (who saw one there in 1962), however, it appears to have died out. Having encountered many Burren lizards down the years – including one that, at about 20 cm (8 inches), was as big as a green lizard – I have never come across one in my rambles and I would speculate that they are indeed no longer extant. The slow worm (a legless lizard), on the other hand, has taken to the Burren as though it was always there. I have seen it and recorded its presence in many places – from Gleninagh to Corofin – since it was initially introduced near Kinvara in the early 1970s.

It is generally assumed that, excepting the wood (or field) mouse (apparently an early arrival here), all the Burren's rodents are alien introductions. With the exception of the bank vole, a modern denizen, they have all been present for a long time – perhaps millennia. Two bats, Leisler's and Daubenton's, have been shown by DNA to have an ancient lineage. The hedgehog, whose bones have been found in Glencurran Cave and noted (alive) in Ballykinvarga Cashel by T. J. Westropp over a hundred years ago, is an interesting case. It is clearly rare nowadays in the Burren; in thirty years, I have never seen a live one, and only once or twice seen one as roadkill in the region. Considering its ubiquity elsewhere in the country, its absence

Slow Worm

in the Burren requires some explanation. Is it that over much of the region the ground conditions are unsuitable, or has it been heavily predated, or been affected by some disease ...? The red squirrel (apparently reintroduced into Ireland after its disappearance in the Early Modern period) is undoubtedly making a comeback, probably due to the increasing spread of hazel. Its trademark of axis-opened hazelnuts is a feature of the scrub's quieter retreats. Though other, larger mammals such as wild boar, wildcat, wolf and red deer have been wiped out, probably by hunting, certain long-standing species such as pine marten, badger and fox continue to thrive. Deer, whose numbers are increasing rapidly throughout the country, will return to the Burren sooner or later. Should the red deer be pre-emptively reinstated as the Burren ungulate, a position it enjoyed for thousands of years before it was eradicated and before other alien introductions such as the fallow or sika move in?

The DNA analysis of samples from archaeological sites has revolutionised our understanding of the lineage of our flora and fauna. We now have a better sense of those species that have a claim to be 'native' and, by comparison with others of the species from other countries, of when and how they came to our island, and indeed the Burren.

Alien invasives, with their capacity to overwhelm not only species but also habitats, engender strong reaction from conservationists. Work gangs of conservation volunteers engage in heroic efforts to stem their advance. The curly-leaved waterweed, an invasive from South Africa with a propensity to block waterways and shade out indigenous and threatened stoneworts, has caused major problems on the limestone lake of Lough Corrib. This and a handful of other subaquatics pose an ongoing threat to the Burren's limestone lakes. Draconian measures such as the introduction of a (non-native) weevil, which feeds on the plants, have been suggested. Such measures, however, raise questions relating to the control of the controller,

and the potential for other undesirable knock-on effects. Aquatic invasives have become such an enormous economic problem in South Africa that control measures have been carried to a new level entirely, involving the complete eradication of all species – natives and invasives – in an affected waterway, followed by the controlled repopulation by the natives only.

The concepts of aliens and non-natives, once thought to be well defined, can no longer be considered so. As with racial mixing and migration of humans, they have become somewhat blurred notions. Drifting seeds may have once found a foothold on an alien shore at the whim of ocean or wind currents; nowadays, with the everyday toing and froing of peoples and products, alien seeds are just as likely to arrive by way of horticultural packages or transit vehicles.

Species that defy biogeographical imperatives by becoming established far from their normal range, due to direct or indirect human influence, will inevitably continue to do so at the expense of long-standing resident species with fragile footholds. Most, however, will simply die out. 'Permission' to remain will probably be assessed on a species by species basis, and factors other than hard science will come into play. Who, for instance, would advocate the removal of the beautiful (but non-native) fairy foxglove from the famous Pinnacle Well? Perhaps the best way of securing a future for vulnerable 'natives' is by protecting the conditions they require for survival, rather than by declaring war on those deemed to belong somewhere else.

What Use the Burren?

Nowadays, we are led to believe that land must be used. Land is there for us to employ, to gain from economically. Land that is not used – bog, wetland, dune, saltmarsh, mountaintop, rocky outcrop – is *wasteland*; not to use it is *wasteful*. After all, the earth is there for our utility, our exploitation, is it not?

This philosophy, endorsed by the 'dominion over the earth' biblical statement, has been a 'taken' for millennia. It received formal recognition and accelerated practical implementation, however, from the writings of Early Modern philosophers such as Francis Bacon and, subsequently, from Enlightenment advocates. Utilisation was a driving concept behind the colonial policies of the seventeenth century. One of the tenets legitimising the Plantation of Ulster was that if the locals (the Gaelic residents) were not using the land efficiently – which, by contemporary English standards, they clearly were not – then they had no right to it. In fact, although Early Modern advances in agriculture were

late in coming to rural Ireland, the Brehon Laws point to an 'inclusive sophistication' in Irish farming practices largely misunderstood and overlooked in the denigrating commentary of the time.

A traditional commitment to pastoralism, constant movement of livestock and the transhumance phenomenon nevertheless restricted agricultural development in 'wild' Ireland until the Early Modern period.

The Burren's primary use since prehistoric times has been for grazing livestock. Since the first farmers, favouring the easily cleared uplands over the heavily forested lowlands, came to the Burren, its all-year-round offer of pasture has been its unique attraction. The process of transhumance was then, as now, influenced by the natural cycle of equable summer conditions favouring lowland grazing, deferred at the onset of winter to the dry upland grasslands. The practice continues today, despite the promise of more economically viable husbandry involving sedentary herds of mainly Continental breeds, thanks in no small measure to the vision of the Burren Life project and a supportive cohort of conservation-minded farmers (see 'Winter's Gift', p. 232).

The Burren upland was certainly glacially scoured and consequently never well endowed with soil or luxuriant vegetation, but it owes its present-day threadbare appearance largely to overgrazing. As far as is known, there were three major episodes: in the Bronze Age, in the Early Medieval period and in the Early Modern period. In the last instance, historical references refer mainly to sheep. Nowadays, due to an ongoing significant decline in farming families (thus labour force) and reduction in the area of viable farmland due to the withdrawal of EU-backed agri-conservation initiatives, the Burren finds itself yet again in the throes of change. Encroachment of scrubland – particularly hazel – is changing the character of large tracts of the region. In short, and paradoxically, *underuse* threatens the Burren as we know it.

The north Clare that was 'discovered' by Welsh botanist Edward Lhuyd a few decades after Cromwell's officers had ravaged the

region would have been much more scrub-free than today. Constant coppicing of the precious hazel – for thatch scallops, wattlework, tools and myriad other functions – and the harvesting of the nuts would have ensured this. Photographs from the late nineteenth century reveal a Burren almost devoid of scrub at that time.

Lhuyd was the first to record the rare and wonderful beauty of the abundant flora. Subsequently, the Burren has been described as a floral paradise, harbouring three quarters of all the plants of Ireland, including many rarities. Remarkable? Undoubtedly. But of what *use*? What good is flora?

Such a question would not have been posited until relatively recently. Far back into the mists of time, plant diversity was respected and revered, here as elsewhere, for culinary and medicinal reasons.

The late Cyril Ó Céirin and wife Kit, long-time Burren inhabitants, spent many years investigating *usable* flora and left us a legacy of floral practicality and lore (*Wild and Free*) that nowadays would be difficult to assemble. In pre-pharmaceutical, pre-supermarket times, when ordinary folk had no other recourse to medicines and wild food than that available (often on a trial-and-error basis) from the hedgerows, field headlands and wild rock gardens, the region was combed for its natural produce. Blackberries, sloes, hazelnuts, garlic, sorrel, crab apples, cress and a plethora of other wild fruit and herbs were gathered seasonally as a matter of course, and knowledge of healing collectables would have been passed on unselfconsciously from generation to generation. Such arcane knowledge was also bread and butter to the likes of Biddy Early and the legion of folk healers who identified with wild, growing things. In the widespread circumstances of poverty, where orthodox medicine was beyond most pockets, such healers were constantly in demand for their skills. The arrival of foods and medicines from unseen sources and by methods unfamiliar heralded a loss of a centuries-old connectedness with and respect for the beneficence of wild nature.

Wild Rock Doves
at Martello Tower

Nowadays, the responsibility for the conservation of the Burren's flora and fauna falls to the Parks and Wildlife Service. Their area of influence includes a mosaic of protectorates – Special Areas of Conservation, Statutory Nature Reserves, etc. – admirably served by a small cohort of dedicated personnel. The centrepiece, the Burren National Park, though encompassing many of the region's special habitats, is, at 1,500 hectares (3,700 acres) the smallest of the six in the Republic. It will no doubt expand as more land becomes available for purchase. But what is its optimum size and should its extent be determined by availability of land rather than the acquisition (by some other means, perhaps) of the most conservation-valued habitats?

It has been argued that the conservation of the Burren's wildlife is

actually of *little use* since it does not appear to directly benefit local people in a quantifiable sense, and without a doubt there remain those who view it in this way. The justification for conservation – i.e. its 'worthwhileness' – is notoriously difficult to articulate, leading sometimes to its being viewed as somewhat elitist or non-inclusive. Part of the difficulty may lie in semantics. Over-emphasis on scientific terms – 'biodiversity' (nature's mix?), for instance – can be off-putting to the uninitiated.

It is clear, however, from the droves of visitors who come annually for the 'nature experience' that there is much more at play, particularly in the context of human psychological well-being.

When 'packaged' along with geology, archaeology, folklore, history and other aspects of social heritage, natural heritage constitutes one side of a quantifiable tourist framework. 'Ecotourism' is its current expression, and the Burren is being marketed as a classic destination for such enterprise. This designation unfortunately runs the risk of becoming just another tourism device, a 'product' or 'brand', not necessarily or genuinely connected to the ecology of the region. Nonetheless, despite these concerns and recent post-boom fluctuations, tourism remains of paramount economic importance, equalling or surpassing agriculture in many parts of the west. To many people, this is the Burren being used properly, i.e. justifying its existence – paying for itself.

Now that there is consensus on how this should occur in the Burren – with the 'necklace' of existing villages, rather than a new, potentially intrusive facility, benefiting – there is little doubt that ecotourism will continue to flourish, supported by growing numbers of the Burren's inhabitants, who see it as the way forward. A number of well-informed local guides are nowadays seasonally employed in the ecotourism industry.

Recreational activity, though embraced by tourism, really fits into a different economic category. Pursuits such as caving, rock climbing,

snorkelling and surfing are generally favoured by the young and fit, and though there are spin-off benefits – to the pubs, B&Bs, etc. – they are economically less significant than the more sedate activities of older visitors who favour the comfort of hotels to hostels. But can one measure overall benefits in such hard, monetary terms? Is substantial short-term gain more important than steady, moderate return? Ultimately, can a price be put on the long-term social gain of unconstrained youthful adventure on offer in the Burren? Perhaps the most important question is that concerning balance; given the potential for disruption to sensitive nature through 'recreation overkill', this issue is constantly to the fore.

And what of education? Each year, students from primary up to third level, scholars, teachers and lecturers come to the Burren, ostensibly to experience its rich educative potential. Some depart having had beneficial first-hand experience of its flora and fauna, its unique habitats and landscape, its remarkable archaeological record, its folklore and fables, and other aspects that comprise its educational gift. The taste of the place, however, is often slight and superficial, one capable of being experienced elsewhere, in less dramatic circumstances: to many, it is 'the cave, the cliffs and a burger'. This is a great pity, considering the sheer density of educational sites in the region. Hectare for hectare, where else can one find such an outdoor classroom?

The National Parks and Wildlife Service now runs educational programmes not only for adults but, during Heritage Week at any rate, also for children. Their Mini-Beast Hunt, for instance, is aimed at pre-teenage children, the age group most open to such a pursuit.

'The Outdoor Classroom' is the theme adopted by Burrenbeo in engaging local primary schools in the Burren's natural heritage. Thanks to the drive and inspiration of the late Ann O'Connor, who involved primary schools from the greater Burren region in a programme of environmental awareness, local children enjoy a privileged experience.

266 The Breathing Burren

What Use the Burren?

The programme, consisting of both field and indoor activity, has been running since the turn of the millennium, and is going from strength to strength. Dozens of schools and hundreds of pupils are now involved. The highlight of the programme is the awarding of 'Burren Expert' certificates to all participating children. To date, more than 1,000 young graduates have emerged from this programme. Brigid Barry, Burren Beo coordinator, has been at the forefront of new educational initiatives, including 'Burren Wild Child', the 'Young Burren Leader Scholarship', 'Ecobeo' heritage courses and, drawing on a historical precedent, a 'Burren Hedge School'.

It is encouraging to see local youngsters such as Cilian Fahy, winner of the Young Burren Leader Scholarship, involved in engaging his peers in a new social media project. Another local youth, Shane Casey, has popularised nature for children in his beautifully illustrated book, *Nature's Secret Adventures*.

At second level, the emphasis is more activity-orientated – rock climbing, kayaking, surfing and so on. This often takes precedence over nature study *per se*. But the Burren has so much more to offer teenagers in environmental terms, and this is too often overlooked in the (challenging) logistical demands of second-

level education. Despite the regular visits of universities and technical colleges, the fine field centre at Carron is often empty, particularly in winter, when the Burren presents alternative experiences connected with flooded turloughs and bracing hikes.

In a wider context, there is much untapped potential at all levels. Can we continue to ignore the positive effects accrued by children – inner-city children, for instance – exposed to the fun, freedom and learning experience available in the Burren? An outreach programme aimed at schools, particularly those situated in urban concentrations, would amount, undeniably, to a positive initiative. What about the reconciliation potential of bringing groups of young people from across the sectarian divide in Northern Ireland to this benign common ground where societal difference can be reduced to an irrelevancy?

In practical, economic terms, what would be the benefits accruing to local communities from a Burren properly marketed to third-level institutions in the UK, or further afield? At present, though the region is well known and visited by people of all ages, its use as a place of learning is mostly uncoordinated and sporadic; despite the wonderful work being carried out locally, it is undoubtedly a case of *underuse*.

Whatever about those employed in a practical sense, the Burren has been a spiritual magnet to a cohort of creative people. It has probably attracted, and continues to support, more writers, poets, artists, film-makers and craftspeople than any other similar-sized region in the country. The landscape, of itself, inspires: it is the stimulus for creative enterprise; it is *used* for art. The late John O'Donohue's oeuvre is a case in point. Brought up on a small farm in the heart of the region, John, in his short life, was to become not only a renowned priest, philosopher and poet, but also an author of international repute. The establishment of an art college in Ballyvaughan, in its out-of-the-wayness, may have seemed a most unlikely choice given the normal urban locations of such colleges. Paradoxically, its relative remoteness has proved to be its strength.

Perhaps, given the times in which we live, we can no longer afford an idealistic, postmodern view, such as that espoused above. Land, any land, must pay for itself, whether in producing food, providing sites for houses or other facilities, or supporting tourism, recreation, education or other human enterprises; simply doing nothing with it is a luxury we cannot nowadays afford. In a place as uniquely endowed with natural attributes, however, there will always be a strong claim for doing as little as possible to interfere with its extraordinary heritage – to allow it to continue to 'breathe'. Most agree that it is a question of balance: the heritage should be maintained as intact as possible, while providing for the continuance of the social dynamic. Both elements are fundamental and interconnected. Neither can prevail, however, if the resource on which they depend is seriously undermined. This will occur if the landscape is radically altered – by reclamation, random and inappropriate development, and above all by pollution of the precious water table. The fissured limestone bedrock of the Burren, in this latter instance, is particularly vulnerable. Unfortunately, there are signs that such degradation is already happening; the water quality, whether as a consequence of agricultural run-off or domestic sources, can no longer be assumed to be pristine. The inability to eliminate outbreaks of pathogenic pollution such as that caused by the bacterium E. coli and, more insidiously, by the parasite cryptosporidium has caused consternation to those inhabiting the limestone country; county council signs warning people not to drink from wells, and green algal blooms at water outlets to the sea point to the deterioration. The downstream ramifications, if this trend continues or accelerates, are obvious – abandonment of wells due to contamination, waterborne disease, wildlife degradation, biodiversity loss and the practical, knock-on effects of a decline in tourism.

And what of the rock itself? Would an increase in demand for limestone – for roads, buildings, artificial landscaping, etc. – result in new opencast quarry enterprises or the expansion of those already

in existence? Does the lack of regional protection render parts of the Burren vulnerable to the detrimental effects of ore exploration – the reopening, for instance, of former zinc, lead and silver mines? This may not be as far-fetched as it seems, given the impending gold explorations planned for parts of the north midlands.

Whatever about the various interpretations of *misuse* (one person's misuse is another's missed opportunity), that which most threatens is *abuse*. For those who live in the Burren and those who visit, a consensus must be agreed as regards a proper balance in its current and future use.

Concerns aside, isn't it wonderful that in these days of fluctuating economic fortunes and trial-and-error land-use policies, the Burren remains a relatively sound rock of potential?

How Much is the Burren Worth?

'How much would I get for this?' asked the little boy with the fossil. When I tried to explain that its value could not be measured in euro, I heard it being returned to the ground with an unceremonious 'clunk'.

While such a response is not rare, it is by no means the norm; the fossil is just as likely to be taken home as a precious memento by a young enthusiast imbued with a different value system.

How do we evaluate a fossil, a species, a place? Is it only in terms of what we can get for it? We can measure the sum total of the Burren's economic interests – agriculture, tourism, service and related industries. But is that its worth?

The application of economics to species and their habitats, including in places like the Burren, under the heading Natural Capital, is a new but growing phenomenon. When assessed thus, the worth of nature, formerly ignored or taken for granted, can be ascribed a graded and comparable monetary value. Such a process adds enormously to

the scope of economics; it renders the planet and everything in it subject to economic evaluation and casts economists in the unlikely role of environmental arbiters. Crop-pollinating honeybees in the US are worth billions of dollars for their 'ecological services' and Ireland's Natural Capital has been estimated at around €3 billion. Here, a salmon caught on rod and line is many times more valuable than one from a fish farm, due to the economic 'spin-offs' – fishing licence, bed-nights, restaurant and pub purchases, transportation, etc. Such analysis, used effectively by advocates, presents an attractive argument for the concept of Natural Capital. Highly 'useful' creatures such as honeybees or salmon win out in a cost-benefit sense, which may elevate them to iconic status along with tigers, polar bears and the like. Species that offer no apparent human benefit are an awkward fit: the mosquito, for instance. An economic model, intolerant of such a socially undesirable creature, presents the mosquito as *negative* capital, its role in the ecological food chain, however significant, regarded as inconsequential in comparison to its pest status and the expense involved in its control.

Multinational companies subject to fines as a result of environ-mental damage tend to be enthusiastic advocates of Natural Capital. Operational sustainability is often assured by the acquisition of credits gained through environmentally mitigating initiatives. The iron ore mining multinational Vale, operating in South America under long-term criticism for rainforest destruction, has been engaged in a highly publicised mitigation programme. Thousands of hectares of abandoned opencast mines have been replanted with replacement eucalyptus trees. Though ostensibly a commendable carbon-sequestering measure, this non-native plantation is of little ecological value; it does, however, constitute a valuable economic crop for the company. Carbon credits thus obtained are traded on the open market, ensuring operational sustainability. Other multinationals under criticism for habitat destruction and species eradication have assuaged public

concern by buying up sensitive habitats harbouring threatened species and creating nature reserves on their property. Though economically justifiable to the company as a positive community endeavour, such a measure is seen by objectors as an undesirable trend, even blatant manipulation of nature for the sake of public relations.

Outside the realm of business and profit, many view the commodification of nature as a deviance. This spiritual-aesthetic cohort takes the view that the natural world is sacrosanct and should remain beyond the scope of the economic value system. Attitudes range from the mildly protective to the deeply philosophical. Others, while espousing a 'sanctity of nature' view, see *pricing* as the only practical way forward. The oft-quoted comment (sometimes dismissed as somewhat cynical) is: 'People simply will not value nature unless they pay for it.'

So how much is the Burren worth? For those that live here, this has been a consistently important question, but one that has resonated differently down the ages. Mining for fluorspar and metal ores (zinc, lead and silver) was apparently a significant enterprise in late colonial times, and subsequently. Indeed, four Burren mines were still in operation at the time of the formation of the State. Abandoned quarries (one as old as the Neolithic period) speak of the continuous value of the limestone as a raw material. Fin and shellfish stocks, having been important for centuries along the Burren coast, saw radical decline due to overfishing, though the latter has seen a spectacular revival in inner Galway Bay in recent years. Milling, as evidenced in the ruined tidal structure at Doorus, also had its day. Other sectoral enterprises have undoubtedly come and gone without leaving an enduring mark. The perennial mainstays of farming, nowadays undertaken mainly part-time by farming families, and tourism, nuanced into businesses such as branded food production and related service industries, are to the fore. Other employments, in the fields of recreation, education and nature-based activity, though employing lesser numbers, are enjoying ever-increasing significance. The fact that a few thousand people

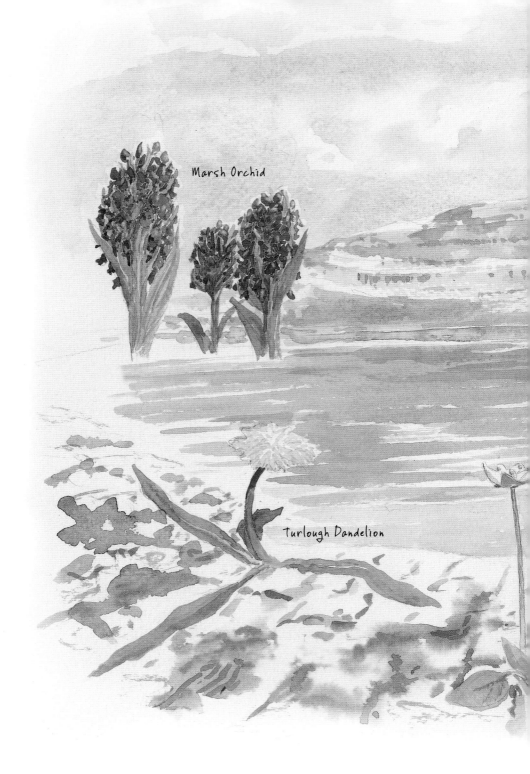

Marsh Orchid

Turlough Dandelion

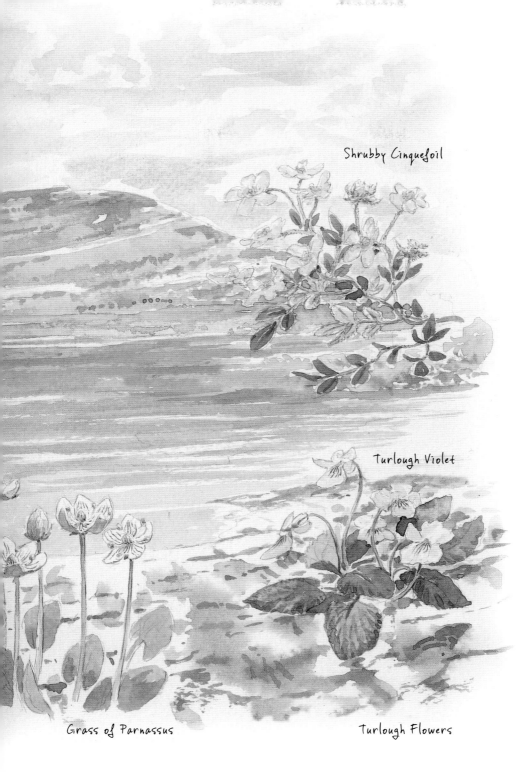

Shrubby Cinquefoil

Turlough Violet

Grass of Parnassus

Turlough Flowers

are gainfully employed within the bounds of the region, considerably removed from the nearest large centre of population, is undoubtedly more reflective of the enterprise and imagination of the inhabitants than of its glaring economic potential.

As is the case elsewhere in the country (and in the world), maximising standard of living is an unwavering priority. To many of the present-day inhabitants, the quality of life enjoyed (an unquantifiable economic consideration) may be regarded as fair compensation for moderate earnings. History has shown that agricultural fortunes have been subject to periodic sweeping changes, affecting both standard of living and quality of life. Cereals, which were once an intrinsic part of subsistence agriculture, are no longer grown; potato planting (manifest in surviving lazy beds) is also a thing of the past; since the mid-1980s, silage animal fodder has comprehensively replaced hay. Today, with the disappearance of European financial supports, factors affecting livestock are central. Currently, drystock farmers, confronting a steady decline in the beef market, and dairy producers, facing an alarming drop in dairy prices, are struggling. With tourism, is the Burren likely to lose its cachet to some other 'honey-pot' locality (as has been the case in many favoured locations throughout the world) or fail to keep up with increased demand due to antiquated infrastructure? Would infrastructural changes threaten the delicate natural values that tourists come to the region to enjoy? Above all, how will the gathering clouds of climate change affect the region and the disparate livelihoods of its inhabitants?

Whatever about fluctuations in occupations and fortunes, dependency on the quality of natural resources will remain a constant. While it is difficult to imagine anything (other than the unlikely scenario of prolonged drought) interfering with the current status quo, there is no doubt that the Burren has seen a decline in water quality since the 1980s: many of the wells and water sources are no longer potable. How much of this is due to livestock pollution and how much to domestic

effluent infiltration is yet to be determined; both may be culpable. Natural Capital cannot be taken as a constant. It will change in accordance with other factors such as agricultural and demographic pressure. The overall economic value of a Burren invaded by scrub (which is currently happening), for instance, is not comparable to one that is predominantly open grassland. In fact, the process of comparative pricing of nature's services could be construed as being counter-productive, causing a reduction in overall quality: enterprises of commercial value at a particular time being likely to be supported, with those seen as excess to current requirements being relegated or abandoned.

Despite such misgivings, interest in the concept of Natural Capital continues to grow. The first conference on the subject took place in April 2014 and was followed in June 2015 by the first Irish forum on Natural Capital. Its organisers, motivated by the alarming worldwide decline in biodiversity, emphasise the need 'to put nature on the radar of economic life or allow it to compete with the pressures of progress as is currently ongoing'.

But is it fair to express the worth of the Burren, the country, the planet in terms of 'resource' or of service to humanity? Is there such a thing as intrinsic value or value based on independence from people? Does a flower, a bird, a living entity have an intrinsic worth, regardless of its worth to society? The recently devised international Earth Charter, concerned with an ethical relationship between people and nature, suggests as much. Advocates argue that species have a right of their own to exist, that since they were not made by people they should not be treated (or valued) as a commodity, and that assessing nature in terms of Natural Capital or ecological services is essentially reductionist, even unethical.

What about a landscape? While many empathise with the right to life and survival of living things, many others draw the line with landscapes, concern for some particular landscape or other being seen as a subjective or romantic response. Landscape character is, however,

a universal concept, eliciting comparisons from one region to the next. It is one of the primary reasons listed by tourists for visiting Ireland. A landscape's character contains an expression both of its 'naturalness' and of human impact. It includes evidence of human endeavour and habitation, in the form of fields, walls, enclosures, houses, castles, etc. It is generally accepted, however, that landscape character is diminished when the human footprint dominates over nature.

The Burren's landscape, though superficially shaped by centuries of overgrazing, has been largely unscarred by modern development and has long been included in the national inventory of sensitive landscapes. It has, for instance, been bypassed by wind-farm development, despite being eminently suitable for this kind of renewable energy. (Not that I am advocating this.) The Burren's character is clearly perceived to be vulnerable to the trappings of modern technology, one that would be detrimentally compromised by rows of rotating turbines. This concession has been denied the Connemara flatlands visible from the Burren, north across Galway

Bay – a measure that has had the effect of reducing the landscape character of both Connemara and the Burren. Landscapes spared the distracting foci of turbines, masts, pylons, industrial chimneys and so on exhibit high-value regional character, where both natural and human impacts are assessed to be in balance. Natural Capital advocates will evaluate such landscapes in terms of tourist euros. But is this sufficient?

While the Burren comprises an impressive mosaic of protectorates, in the form of Nature Reserves, Special Areas of Conservation, Special Protection Areas (for birds) and of course the National Park, it contrasts with similar 'special' regions like the Mourne Mountains and the Glens of Antrim in Northern Ireland, which enjoy blanket protection under the Environmentally Sensitive Area designation. This designation, besides emphasising sustainable agriculture and biodiversity, protects regional character, safeguarding it from inappropriate development. At one stage (around the turn of the millennium) it was proposed for the Burren as a pilot, but this was shelved for the incoming EU-subsidised, agriculturally focused Rural Environmental Protection Scheme. This scheme in its various iterations has unfortunately come and gone without leaving the desired legacy of regional protection. We must hope that its replacement, GLAS (Green, Low-carbon, Agri-environment Scheme), combined with the admirable Burren Conservation for Farming scheme, will garner sufficient support to create the desired effect.

There is no doubt that the Burren's worth has been traditionally defined by its use. This of course will continue to be the case, but in these more enlightened times, can we make space not only for its practicalities but also for what it represents? Can we take account of the enriching, but unquantifiable, other worth that we all instinctively recognise, and which has long been the source of inspiration for artists, writers, poets, natural philosophers – and children's imaginations?

Burren of the Fertile Mind

J. R. R. Tolkien is reputed to have found inspiration for his epic *The Lord of the Rings* in the bizarre landscape of the Burren. It is hardly a coincidence that one of his main characters, the sinister Gollum, shares his name with a yawning cave mouth into the Burren's labyrinthine underworld. Fantastical stories, myths and legends are as real as reality to the innumerable storytellers who have been influenced and captivated by the place. Peists, pookas, pishogues and fairy trees, and those that have the temerity to ignore them, are still the subjects of reverential discussion in the Burren, though nowadays somewhat tongue-in-cheek.

In T. J. Westropp's time (at the turn of the nineteenth and twentieth centuries), fearsome creatures were very much alive and well in the Burren. According to the antiquarian, 'Probably no lake in County Clare was untenanted by a serpent.' In his folklore notes, he refers specifically to the peist of Shandangan Lough (near Corofin),

reportedly 'a brown hairy monster swimming and playing in the water with eyes as large as turnips'. Poll na bPéist, in Caherglassaun turlough, is the mythical home of a gigantic serpent.

Many of the myths and legends are connected to animals, both wild and domesticated, and the places they inhabit. One of the most famous of these concerns Kilcorney cave, a kilometre south-west of the famous Poulnabrone dolmen. The image of a herd of wild white horses charging forth from the limestone cave is certainly a product of the senses, though not of the eyes. The sound of the bursting forth of floodwater, amplified by the cave, has been transformed by the fertile mind into the clattering of hooves. No one knows how old the myth is, but it must surely predate the advent of artificial illumination. Westropp mentions that Kilcorney cave was also known for an enchanted bird, which, also heard rather than seen, spoke with a human voice when captured. A complementary horse myth from *Aill na Searrach* near the Cliffs of Moher concerns a herd of foals, which were seen to emerge from the sea. A farmer chasing the herd away from feeding in an oat field managed to catch one – a stallion – whose progeny were 'quality' animals, since the finest horses 'originated in the sea'.

The legend of Lon – the mythical one-legged, three-armed blacksmith who used his middle arm to steady the anvil while he worked at it with the others – is thought to be as old as (and symbolic of) the arrival of iron in the Burren. The legend of his endlessly milk-producing cow is also prehistoric, having its counterpart in Greek mythology. A famous ninth-century Irish poem connects the legendary Cormac Mac Airt with both cattle and the Burren. In it, the king demands 'two oxen from the Burren' as part of the ransom for the release of Fionn Mac Cumhaill. Interestingly, Slieve Elva on the Burren's edge is associated with the legendary battles of Cormac.

Some of the region's many holy wells have pishogues associated with them. Noticing the eel in the bottom of St Brigid's Well is assurance to pilgrims seeking a cure for some ailment or other. The

eel-in-the-well phenomenon is attributed to other sites such as St Molin's in Mullennakill, County Kilkenny. The pishogue is pagan, undoubtedly predating the Christianisation of the shrine.

A large number of the myths involve wildlife. The lizard, the newt (wart removers by touch) and the frog (varied-coloured weather indicator) are classical mythmakers. Sleeping with an open mouth invites in a lizard or a newt, neither of which can be removed without the greatest difficulty. Westropp's notes mention a reported incident of frogs falling out of the sky like rain into a field in the eastern Burren. Mammals provide rich themes. It is still widely believed that a pine marten or a mink will stab its prey behind its head and suck its blood with the hook at the end of its tail, while the stoat will spit poison if approached too closely. There is a Clare myth about vengeful stoats poisoning milk by spitting into it. The Clare response to encountering a stoat, a magpie or a red-haired woman is to bless oneself and to transfer anything held in the hand to the other hand. A badger, we are

told, will bite your ankle until it hears the crack of your bone; canny night walkers have a stick down their boot which, when the badger hears breaking, will cause it to let go. A demonic badger – the bruckee (*broc sidh*) – according to Westropp, occupied a den (Poulnabruckee) under a hill whence it sortied, 'killing men and cattle and resisting the prayers of six saints'. It was eventually killed by MacCreehy (a sixth-century saint) near Inchiquin and thrown 'deep in that forgotten mere among the tumbled fragments of the hills' – presumably a reference to the Burren. The mythology of bats – being blind, getting caught in your hair and associated with nature's 'dark side' – is, of course, universal. The Clare coast is apparently rich in the mythology of seals, many of which are variations of the well-known 'selkie' myth of Connemara, in which a seal is transformed into a woman and taken home by a fisherman. Westropp associated the Clare MacNamaras with such a legend.

The otter has been the subject of Burren mythology in more than one recounting. Tom Murphy of Kinvara tells a straight-faced tale about a pet otter that he once kept. The animal was so intelligent (and obliging) that on being released each morning it would habitually return with a fish for its owner's breakfast. Ballyvaughan's master storyteller, Martin Carey, once told me (over pints in Hyland's Bar) about a remarkable otter incident he had witnessed. One evening while driving outside the village in darkness, he saw what looked like a dead otter on the side of the road. When his headlamps caught the shadow of activity on the opposite side of the road, he pulled in and switched off the lights. On turning them on again a few minutes later, he saw two other otters approach the otter carcass. In a trice, 'they lifted the carcass onto their shoulders between them, and carried it off into the darkness. I tell you, it was an otter funeral.' I can picture Martin, one of a dying breed of 'imaginative embellishers', telling this story, or something similar, to other fascinated listeners who happened to come onto his radar.

Though the hare has been hunted and indeed seen as a food item (its bones have been found in caves, where they might have been discarded after a prehistoric meal, and Franciscan Anthony MacBrody mentions it as a quarry species in his 1669 description of Thomond), it has an alter ego in the Burren. Before being protected under the Wildlife Act in 1976, it was chased with hounds, as was the case elsewhere in Ireland. The hare, however, unlike the rest of the Burren's fauna, has cachet as a *poetic* animal. It has been traditionally seen as a shape-shifting changeling – part-time animal, part-time human. It is thus regarded respectfully, even affectionately. Woe betide anyone who would shoot a Burren hare. A collection of bones of young hares accompanying the Bronze Age burial of a child in Glencurran Cave suggests an ancient human-hare ritualistic connection. P. J. Curtis, the Burren's music guru, recalling his elderly neighbour the 'Witch' Mariah in the 1950s, refers to her power to turn a nasty person into a hare, 'the biggest in the Burren, to be never seen in mortal form again'.

Animals that are universal contributors to mythology – bears, wolves, boar, deer –must have at one time contributed to the rich folklore of the region. There must therefore be an abundance of nature myth and legend now lost to us.

Though nowadays seen as quaint, archaic and largely irrelevant, nature folklore provides us with an invaluable insight into the rural mind. We owe a considerable debt to T. J. Westropp for recognising this and, through his collection of a century ago, providing us with an irreplaceable record. Though our modern evidence-based preoccupation has done much to dispel speculation in matters of nature, as in other walks of life, and is to be welcomed in principle, it has come at a cost. Multipage reports replete with cold facts and figures relating to some environmental aspect or other defy the intrinsic warmth of the subject, and cry out for light relief.

There is no substitute for a personal response to an experience

or encounter in nature. At one time, storytelling, spiced with interpretation – the bread and butter of the rural *seanchaí* – filled that role; the stories informed us of a more intimate and observational relationship with nature. Many of the wild places that informed our corpus of myths and legends have been tamed since Westropp's time. Thankfully, the Burren still attracts its myth-makers, imbued with the capacity to transmogrify the ordinary into the extraordinary.

Sacred Mountain

At the outset, this book was imagined as a personal homage to the Burren. It would be celebratory, and matters of controversy would be avoided. Hopefully, this compendium of essays fulfils that aspiration. However, occasionally a controversial environmental issue intrudes, demanding consideration and comment, if only retrospectively. Without doubt, *the* issue 'on my watch' was the proposal to site a visitor centre near Mullaghmore Mountain in the Burren National Park. The plan, first mooted in 1991 with the establishment of the park, gave rise to a controversy that prevailed throughout the entire decade of the last millennium. The subsequent portrayal of the issue gained nationwide media attention, affecting neighbouring Burren communities. At the time, the divisiveness between those in favour of and those against the proposal cast a cloud over north Clare that, thankfully, time seems to have dissipated.

Conscious of the sensitivities, I am confining myself to a personal

overview, on the promise of positive outcomes. It is fair to say at this remove that the Office of Public Works' plan, with the offer of £2.5 million of EU money (75 per cent of the total required), to establish the Mullaghmore visitor centre engaged the public's imagination like no other such venture in north Clare. Almost immediately, a committed consortium of individuals – local farmers, conservationists, freelance scientists, musicians and other artists, philosophers, thinkers and 'alternative lifestyle' people – who disagreed with the proposal, voiced staunch opposition. An action group subsequently formed, coordinating those against the proposal. Despite the weight of opposition, which eventually grew to galvanise widespread environmental opinion, including that of international organisations such as Greenpeace, Plantlife and the World Wildlife Fund, the development was actually underway by October 1992, foundations having been laid and surrounding land cleared for wider infrastructural work. Legal proceedings challenging the issue of planning permission were in train by the end of 1992, initiated and taken on by the emergent Burren Action Group. As part of a consultation programme initiated by the Office of Public Works (OPW), documents emerged outlining the project, the reasons for siting it within the park (as distinct from one of the nearby villages), the benefits that would accrue (fifty jobs in the construction phase, twenty-five permanent jobs, increased tourism, etc.) and a fifteen-point questionnaire seeking public response. Despite this initiative, opposition continued to become more trenchant. With open communication and compromise no longer options, the project stumbled on into 1994. Meetings, which precipitated rallies, marches, music sessions, concerts and festivals, attended largely by those against, consolidated opposition but did little to ease the division, which continued to deepen.

The case for the abandonment of the project, taken initially to the High Court, proceeded ultimately to the Supreme Court.

On 28 March 1995, the Government announced that the partially

completed buildings of the proposed centre were to be 'dismantled', and 'all infrastructural work' was to be 'abandoned and reinstated as before' – at a loss of more than £2 million. Incensed by the decision, another group, an amalgam of business and enterprise interests in the locality, the Burren National Park Support Association, came together voicing concern at the potential loss of opportunity to the local economy. Months of meetings condemning the decision to abandon the project culminated in July 1999 in an oral presentation to An Bord Pleanála, but to no avail. The decision to abandon the project was not to be overturned.

It has been argued that the most important outcome of the unfortunate issue was the compunction on all State authorities to seek planning permission before undertaking any building project such as a visitor centre. However, the Mullaghmore episode will also be remembered as the incident that initiated the now well-established powershift from formerly unchallenged decision-making enclaves in the metropolis to rural regions. Its significance, in giving rise to an increasingly confident voice in dealing with local issues, began at Mullaghmore.

The developer's case was seen to have failed on a number of fronts – ecological, hydrological, touristic and aesthetic/spiritual. The ecological objection was understandable in the context of the remarkable and rare flora of the area. However, the trampling of plants underfoot would have a more damaging effect in other habitats like sand dunes than in limestone country where most of the plants grow in the fissures rather than on the 'pavement' itself. The hydrological argument, on the other hand, highlighting the potential for pollution to the adjacent vulnerable turlough system, proved crucial in the final decision. It was clear that a visitor centre, even one with state-of-the-art water and sewerage facilities, could not be guaranteed pollution-free in turlough country. Misgivings about the impact of greatly increased touristic pressure, with widened roads,

extensive car parks and coaches, also formed part of the argument. With the proposed development of the Cliffs of Moher Centre 'just down the road', it was feared that touristic links to a visitor centre at Mullaghmore would greatly reduce the quality of the experience for the park visitor. Nowadays, with a million visitors per annum at the cliffs, there are many who would express relief that the Mullaghmore project did not materialise.

Remarkably, it was the aesthetic/spiritual dimension in the objectors' portfolio that took many by surprise. Although much was made of the low-profile, unobtrusive design and its infrastructure, it emerged that aspects such as the light-reflecting characteristics of coach windows and car roofs would constitute a significant visual intrusion from viewpoints such as Glasgeivnagh ridge or from the mountain itself. It was all very well to object to the proposed development on practical grounds, but to stray into the nebulous territory of visual subjectivity was quite another. The cultural responses – art exhibitions, poetry, theatre – spawned by aesthetic concerns illustrated and emphasised their validity, which, despite growing opposition, refused to be downplayed.

Interestingly, the Burren's folded geological centrepiece has a history of evoking a cultural response. It can be no coincidence, for instance, that the mountain is overlooked from Glasgeivnagh ridge by a score of prehistoric wedge tombs and cairns, the final resting places of Bronze Age chieftains. Mullaghmore clearly represented a special focus for the important dead. Were its extraordinary sagging terraces seen as a gigantic series of steps to the otherworld? Animists are frequently criticised for seeking, and often finding, spiritualism in the landscape rather than from within human constructs. While such a belief system may no longer have the currency it had in pre-Christian times, is it reasonable to dismiss its espousal by modern-day pagans and others of unorthodox views as mere heresy?

What, then, are the lessons from the Mullaghmore episode? Firstly

(and to many most importantly), the State is no longer in a position to override or dismiss local concerns regarding development, as was more or less the case prior to its resolution. Secondly, visitor centres (if they must be built at all) should be tailored to local circumstances and be positioned to provide most benefit to local communities. Thirdly, developers must take more responsibility to reduce or eliminate the potential for community division and, through dialogue, invest more resources in gauging and tackling possible long-term negative repercussions.

As Ireland moves on into a new phase of economic and demographic growth, sometimes, unfortunately, at the expense of environmental integrity, the Mullaghmore saga remains a reminder of the profundity of the human relationship with the landscape and of the awkward transition from rural dependency to an independent vision of a desired future.

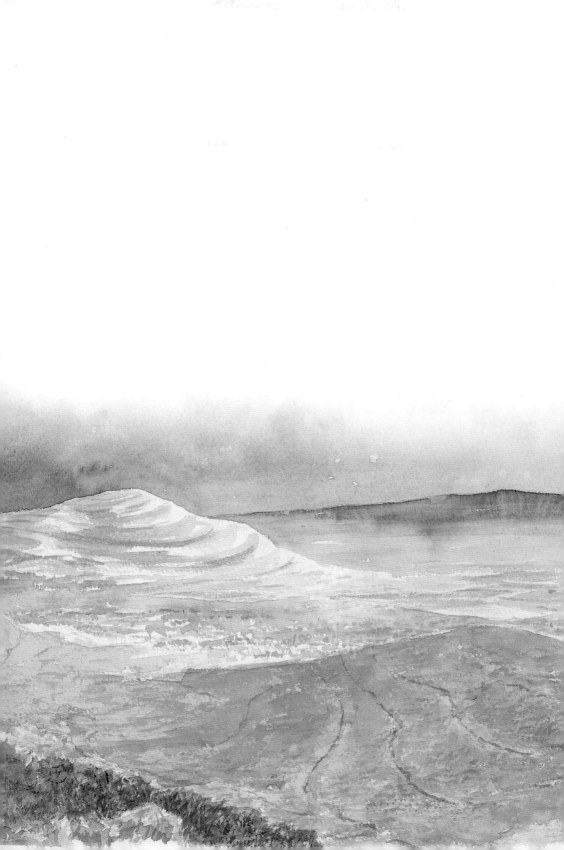

Repose

Beyond my back garden lies the long, muscular profile of a sleeping giant. He lies face downward, the back of his bald head just visible at Cappagh More, his long torso extending westwards from his shoulder at Slieve Carran. From his rump at Abbey Hill, his legs stretch the full length of Cappanawalla and Gleninagh, his toes dipping finally into the Atlantic at Black Head.

Other perspectives, from the Gort lowlands, from Galway Bay or from the Aran Islands, convey no hint of north Clare's Gulliver. Nor do the maps. His presence is reserved for those whose view is, like mine, off to the south, across the ancient territory of Hy Fiachra Aidhne.

The giant is very old, his body stark, his gaunt features weatherbeaten almost beyond recognition, from his long sleep. His clothing, however, changes miraculously with the seasons.

On bright summer days, when billowing clouds come sailing in from the Atlantic like Portuguese men-of-war and pile in upon one

another, his threadbare overgarment becomes a dappled patchwork of greys. Occasionally, in response to a peek-a-boo sun, shadows dart about erratically, disappearing briefly then reappearing unexpectedly, like children playing hide-and-seek. Such playfulness tickles the giant in his reverie. Unconcerned by the spray of a passing shower, he lies patiently while his back greens and spangles with sprouting growth. When the shadows finally link up before moving off overland, he shimmers in warm repose.

Autumn brings new ephemeral tints. Faded green and ochre are added to the palette, where his clothing is least worn. His garb may blanch briefly to lilac, but darken to indigo at the threat of a storm. After wind-driven rain lashes in from the west and trees bending in the maelstrom scratch at his leaden profile, the giant appears naked and lifeless.

On rare calm evenings, a milky pall of mist rolling in from the sea, enshrouds the slumbering behemoth. At other times, low cloud, sagging like great folds in slumber-down, occludes his outline.

As winter approaches, the giant looms broad and stolid, sheltering us from marauding south-westerlies. Rain and harsh sunlight create a startling effect; an illuminating flash after a squall steel-plates his shoulders, and he sparkles to life, clad in chainmail. The transformation is shortlived, and the low sun moves off to work its miracles elsewhere. Throughout the winter, the Gulf Stream weaves its tropical spell, soothing the giant's western flank, warming his hibernating heart. Wintering cattle swarming like ants on his long back do not disturb him. On rare fairytale days alone, when the air is still with frost and the trees stand rigid like swans' feathers, does he appear restless, as though straining to rise to shake off his dusting of snow.

The spring equinox heralds change. A softer light brings promise from the south. The giant stretches out comfortably now, his long profile tingling in the warmth of the generous sun. From early summer to autumn, he will lie content, his expansive form gloriously garlanded in a garden of his own making.

Further Reading

The following is a list of books and booklets relating to the Burren that may help the reader to expand on the information provided in this book.

The Book of Aran (1994), various contributors, Galway: Tír Eolas

The Book of the Burren (1991, 2001), various contributors, Galway: Tír Eolas

Clements, P. (2011), *Burren Country: Travels through an Irish Limestone Landscape* Cork: The Collins Press

D'Arcy, G. (2006), *The Burren Wall*. Kinvara, County Galway: Tír Eolas

D'Arcy, G. and J. Hayward (1991, 1992, 1997), *The Natural History of the Burren* London: Immel Publishing

Dunford, B. (2002), *Farming and the Burren*. Carlow: Teagasc

Hennessey, Dr. R., Dr. M. McNamara, Z. Hoctor, Dr. E. Doyle (2010–13), *Stone Water and Ice: A Geology Trip through the Burren*. Clare: Burren & Cliffs of Moher Geopark

Jones, C. (2004), *The Burren and the Aran Islands: Exploring the Archaeology*. Cork: The Collins Press

Lysaght, L. (2002), *An Atlas of the Breeding Birds of the Burren and the Aran Islands*. Dublin: BirdWatch Ireland

McCarthy, P. M. and M. E. Mitchell (1988), *Lichens of the Burren Hills and the Aran Islands*. Galway: Officina Typographica

Murphy, J. (2013), *Birds of Fanore*. Clare: Burren & Cliffs of Moher Geopark

Murphy, J. (2006), *Clare Cuckoo Survey*. Clare: Clare Biological Records Centre

Nelson, Charles E. (2004), *Wild Plants of the Burren and the Aran Islands*. Cork: The Collins Press

Nelson, Charles E. and Wendy Walsh (1991), *The Burren: A Companion to the Wildflowers of an Irish Limestone Wilderness*. Aberystwyth and Kilkenny: Boethius Press & Conservancy of the Burren

Poyntz, S. (2000), *A Burren Journal*. Kinvara, County Galway: Tír Eolas

Poyntz, S. (2010, ed.), *Burren Villages: Tales of History and Imagination*. Cork: Mercier Press

Ross, Helena (1984), *Catalogue of Land and Freshwater Mollusca of the British Isles in the Ulster Museum*. Belfast: Ulster Museum

Simms, M. (2001), *Exploring the Limestone Landscapes of the Burren and the Gort Lowlands*. www.burrenkarst.com

Spellissy, S. and J. O'Brien (1987), *Clare: County of Contrast*. Galway: Connacht Tribune

Webb, D. A. and J. P. Scannell (1983), *Flora of Connemara and the Burren*. Royal Dublin Society & Cambridge University Press

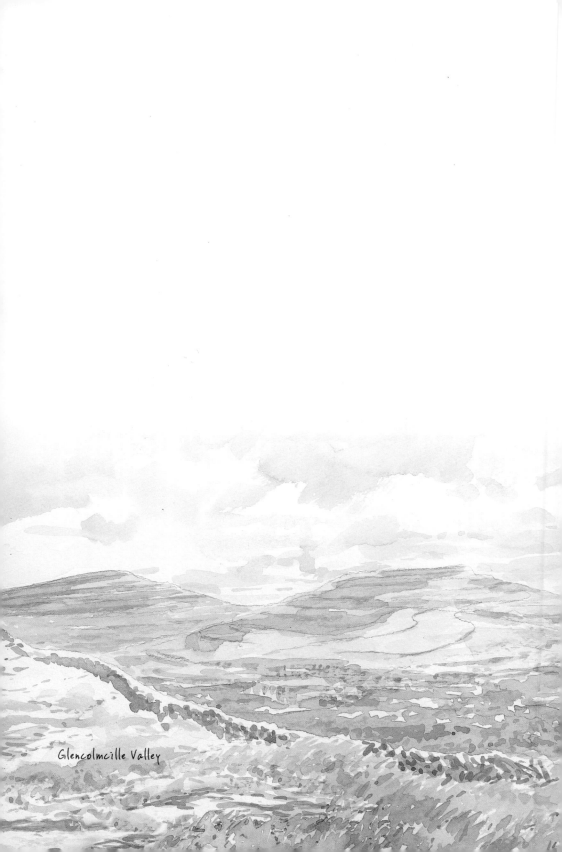

Glencolmcille Valley